# LANDFALL 244

November 2022

Editor Lynley Edmeades

Founding Editor Charles Brasch (1909–1973)

Cover: Neil Pardington, *Seacliff*, 2021, pigment print on photo rag baryta.

Published with the assistance of Creative New Zealand.

OTAGO UNIVERSITY PRESS

CONTENTS

- 4 Landfall Essay Competition 2022 Judge's Report, *Lynley Edmeades*
- 8 Lumpectomy, *Tina Makereti*
- 18 Pig Love Slop, *Maggie Sturgess*
- 30 navigating between pātaka, *Miriama Gemmell*
- 31 Pan-pan, *Zoë Meager*
- 33 Whakaahurangi, *Michele Leggott*
- 36 what the counsellor told me about grief, *Anuja Mitra*
- 37 Loin, *S.A. Muse*
- 40 Spell for a Significant Road Junction, *Claudia Jardine*
- 41 Maltesers, *Claudia Jardine*
- 42 Hospital Waiting, *Michael Hall*
- 43 chickadees, *Claire Lacey*
- 44 northern flicker, *Claire Lacey*
- 45 Beautiful Being, *Rebecca Reader*
- 49 Deep Colour, *Diana Bridge*
- 50 A Split Sky, *Diana Bridge*
- 51 Accidental Layout, *Cilla McQueen*
- 52 All Gone, *Kirsty Gunn*
- 62 Blue Moon, *Cindy Botha*
- 63 Vigil, *Cindy Botha*
- 64 Stella Alone, *Harry Ricketts*
- 65 Die Grosse Schlägerei, *Harry Ricketts*
- 66 Eketāhuna Baby, *Harry Ricketts*
- 67 Lucky, *Isabel Haarhaus*
- 73 Fish Poster, *Ruth Russ*
- 74 They Say Children Don't Come with Instructions, *Ruth Russ*
- 75 The Sick Dog, *Elizabeth Smither*
- 76 Voices, Roses, *Richard Reeve*
- 77 Break, *Frankie McMillan*
- 78 My Mother Who Flew Under the Radar, *Frankie McMillan*
- 79 murray aynsley hill, *Lyndsey Knight*
- 80 ART PORTFOLIO Pūtahi/Confluence, *Neil Pardington*
- 89 Under the Estuary Bed, *Lucinda Birch*
- 97 The Way Back, *John Dennison*
- 107 Orange Blues, *Mikaela Nyman*
- 108 Night-time Activities, *Joanna Cho*
- 110 Team, *Tim Upperton*
- 111 Herd, *Claire Orchard*
- 112 Play Dead, *Claire Orchard*
- 113 Our Little House, *Erin Donohue*

| | |
|---|---|
| 115 | Ghosts Have No Feet, *Jess Richards* |
| 122 | The Order of Things, *Jessica Le Bas* |
| 123 | I Am Reminded, *Sophia Wilson* |
| 124 | Lemons, *Mary Macpherson* |
| 125 | Afternoon Nap, *Gerard O'Brien* |
| 131 | Hum, *Harriet Salmon* |
| 133 | you wake to the fire of his temple on your lips, *Rebecca Ball* |
| 134 | The Lovers, *Peter Bland* |
| 135 | Hot Shower Time Machine, *Liz Breslin* |
| 136 | Talking in the Corner with the Miniature Golf Course Designer, *Erik Kennedy* |
| 138 | Camouflage, *Janet Newman* |
| 139 | Catch and Release, *Angela Trolove* |
| 141 | Mt Eden Dubstep, *Madeline Reid* |
| 142 | An Apparition of Books, *David Eggleton* |
| 143 | Frost Cloth, *Ruth Hanover* |
| 144 | ART PORTFOLIO  By and by (returns), *Madison Kelly* |
| 153 | Port Side, *Rachel Connor* |
| 154 | Uncles, *Tim Jones* |
| 156 | Julia, *Jonathan Mahon-Heap* |
| 160 | Sea Change, *Jan FitzGerald* |
| 161 | Where it Returns, *Victor Billot* |
| 162 | Visiting Cerberus/Cerbère (excerpt), *Anne Weber (Translated by Jana Grohnert)* |
| 165 | Caselberg Trust International Poetry Prize 2022 Judge's Report, *Glenn Colquhoun* |
| 168 | Not What You Wanted, *Yvette Thomas* |
| 169 | Self-portrait, Nude, *Margaret Moores* |

THE LANDFALL REVIEW

| | |
|---|---|
| 170 | Landfall Review Online: Books recently reviewed |
| 172 | KATE DUIGNAN on *Mary's Boy, Jean-Jacques and other stories* by Vincent O'Sullivan / 177 EMMA GATTEY on *Kārearea* by Māmari Stephens; and *Fragments from a Contested Past: Remembrance, denial and New Zealand history* by Joanna Kidman, Vincent O'Malley, Liana MacDonald, Tom Roa and Keziah Wallis / 182 LAWRENCE PATCHETT on *Devil's Trumpet* by Tracey Slaughter / 186 AIRINI BEAUTRAIS on *The Verse Novel: Australia and New Zealand* by Linda Weste; *Escape Path Lighting* by John Newton; and *Song of Less* by Joan Fleming / 191 LAURA TOAILOA on *Sweat and Salt Water: Selected works* by Teresia Kieuea Teaiwa, edited and compiled by Katerina Teaiwa, April K. Henderson and Terence Wesley-Smith |
| 202 | CONTRIBUTORS |
| 208 | LANDFALL BACKPAGE: Sam Kelly |

LYNLEY EDMEADES

# Landfall Essay Competition 2022 Judge's Report

'Once a work begins,' writes essayist Kate Zambreno, 'there is the assumption that it must end. That it cannot exist in process.' In favouring process over finality, Zambreno urges her reader to do a double take: while we read the fixed print on the page, we're urged to think about those words, still in flux; that her writing of this and our reading of it are still zinging with life. To read something, she intimates, is to see it leaking out into our own experience of the world, which is also in flux, momentary, at odds with finality.

This permeability is, by and large, a trait of the contemporary essay. I have found myself measuring the success or failure of an essay on its capacity to urge openness or refuse finality, to eschew the mastery of neat and tidy conclusions. I read this as something of an antidote to the atomization and splintering that seems to govern our current emotional dispositions; essays can offer a salve from the dominant and dominating individualism of our age, by showcasing its antonyms: relationality, vulnerability, hospitality. A place to come out from hiding.

I went into this pile of essays looking for writing that housed and perhaps even pivoted on vulnerability. At the same time, I was hungry for the kind of gritty realism that Australian cinema is so well-known for: those uncomfortable stories that expose the dirty laundry of our culture and allow us to finally have a conversation about all that is being swept under the carpet. An essay that might cough up what lurks just below the surface. An essay that deals with leakiness rather than containment.

As I read through the anonymous pile, I developed an imaginary checklist of all the things the winning essay would and would not do: it would be personal, but not self-indulgent; it would be political but not didactic; it would be aesthetically innovative but not showy. About halfway through the pile, I realised—embarrassingly—that I was looking for the kind of essay I fantasise about writing myself, that I haven't yet written and probably will

never write: the essay that collects many of my thoughts, winds them up into a tight spiral, where they unravel and fray across the reader's imagination to perform and exemplify the kind of imperfect ongoingness that I have come to love of the form. I'm embarrassed by this because I realise my reading was driven by my own ego: I wanted to read something 'relatable,' that most prosaic of all literary descriptors. While I was busy thinking about myself, I had fallen down the rabbit hole of algorithmic life, where we are only ever impressed by something that is slightly better than the last, and where we're constantly searching for an iteration of what we already know and think.

As the 'to read' pile got smaller and my 'maybe' and 'come back to later' piles got bigger, I started to realise I was doing it wrong. Instead, I needed to just read, listen—push my projections aside and tune in to what all these essays were saying. It was then that I read an essay that messed with my algorithms, that took me places I hadn't been and that I couldn't identify with directly, but that held my attention so tightly I had no time to think about myself. It bounded out in front of me, but not because it ticked all my boxes. Instead, it simply walked up to me and offered me a really strong handshake. When I finished it, I went straight back and read it again. I scribbled 'winner?' on the top left-hand corner.

**Tina Makereti**'s 'Lumpectomy' tells the story of surviving breast cancer. But like all essays of a high calibre, it does so much more than that. It reflects on a society in which cancer is so prevalent and wants to know why. It asks questions about the kind of society that produces and celebrates 'hard workers', the type of person who is likely to suffer from high stress, the contemporary disposition that can be attributed as the cause for up to 42 percent of breast cancer cases today. This is all so interesting. But it doesn't stop there: like the author herself is prone to do—as we discover in reading—the essay continues to push further. 'It is only after the physical danger has passed,' says Makereti, 'that I am able to analyse my own overwork compulsion at a deeper level: I am a Māori woman at the top level of her field, and what I feel about this, a lot of the time, is shame.' She traces her suffering—the cancer now, and the overwork and stress that is the cause of it—to her shame. 'I am whakamā, all the time,' she says. 'Who am I to do well when so many do not? ... It is suddenly clear that this deep whakamā is one of the conditions that caused my cancer.'

We cannot take this statement lightly. It is one thing to say that we need to address the conditions that cause such high rates of stress. It's much deeper and more imperative to say, instead: we need to address the conditions that cause particular races, genders, sexualities, and classes to suffer from the stress that causes such high rates of cancer. We're in the realms of mortality now, where political rhetoric and the culture wars don't fucking matter: these are the conditions that cause terminal illnesses. There is something bigger here than the often-misunderstood cry that the 'personal is political', where the 'personal' is simply made synonymous with 'political' by virtue of putting the self in a poem or an artwork. This is a personal story that can't be anything but political because of the way the author has so skilfully woven the threads of her story with the story of a people who have been pushed to the limits in a world that requires hyper-productivity with no social security.

In my search for what Zambreno refers to as 'ongoingness,' I shied away from essays being 'complete' or 'finished' in the traditional sense, and went in favour of the leaky. But 'Lumpectomy' pushed me beyond that: it's a story about leakiness but it's also about containment. It's a story about having to be contained, to have to 'keep everything at bay with [the] body—the ancestral body, the Hinenuitepō body, the thickset, fast-twitch genes body, the stressed-out, sleep-deprived, overfed body.' It's about trying to contain the world and its dangers but having the body tell the story. It's also about why we constantly try to contain and be contained, and yet it manages to do so in such a tight essay-container that I have had to suspend my disbelief. It's true, I read it several times looking for faults, and couldn't find any. This essay actually doesn't leak, but that doesn't mean it fails. It succeeds by pushing beyond yet another binary that I've used to articulate my thinking here. That I think in binaries like this is part of a larger problem, which Makereti's essay exposes in a very forgiving and hospitable way. I am grateful for both the exposure to my limitations and the manaakitanga of Makereti's method. This mahi is, to my mind, the very pinnacle of ongoingness.

**Maggie Sturgess**'s 'Pig Love Slop' is, as the title suggests, very leaky. But sloppy it is not. Sturgess echoes some of Zambreno's sentiments by allowing the form—fragmented, inconclusive, curious—to mirror the subject matter. It's an essay about memory and traces, about how they manifest in our

complex and curious psyches. It's about the challenges we face in trying to write about these complexities and curiosities. 'What happens if I write from my anger,' the writing student asks their teacher. 'A person can lose track of the deeper story,' the teacher replies, before the author quickly skulks away under a rock and we, the reader, lose track of the deeper story. Elsewhere, Sturgess writes, 'now I know not to trust my own memory,' before going on to tell us that 'it's been a long time since [they've] cleaned the bathroom mirror.' It leaks playfully and does so with great skill and craft. There is so much in here to enjoy.

Competitions are crude things, really. There was so much other great work in that pile that I loved reading and re-reading, and that I look forward to seeing published one day. I'm sorry there can only be one winner. I wish it were leakier than this. But the conversations are ongoing—and must be—and I'm grateful to these writers for inviting me into theirs.

**Highly Commended**
**Nadine Hura**, 'Māreikura'
**Claire Mabey**, 'THIS DARK COUNTRY: Being an account of an "anonymous character which is baffling and puzzling in the extreme"'
**Gill James**, 'Mothers and Daughters'

**Commended**
**Michael Moore-Jones**, 'Ikons and Assets'
**Charlotte Doyle**, 'How to Shuck an Oyster'
**Jessica Ducey**, 'Securitising Gender'
**Maddie Ballard**, 'Reasons to Learn Cantonese'

TINA MAKERETI

# Lumpectomy

For a while, I call her Frankenboob. After surgery, she has three gnarly scars, if you count the one in the armpit where the sentinel lymph nodes were removed, which I do, plus another lighter mystery wound where something else happened, who knows what. She is also bright blue in one big patch, from the radioactive substance they injected to find the sentinel nodes—a sentence I can't write without thinking of *The Matrix*. Much later, when I'm beginning radiotherapy, they explain there are titanium clips throughout Frankenboob too, placed there by the surgeon to indicate where cancer has been, or is likely to develop, so they can boost the area with extra beams of targeted radiation if they deem necessary, which they do, since I am young. One of the surprise benefits of cancer is how often people tell me I'm young. The oncologist and the registrar share an affectionate giggle when they note how blue my breast remains several weeks after surgery. They are both immigrant women, and I'm pleased to be in their company. This is what women can do, no matter where we're from, laughing about a blue boob—with no men to concern us.

It started, as it always does, with a lump. And then a mammogram, which showed nothing untoward, according to the attending doctor. It was the technician doing the follow-up ultrasound who identified some problematic masses, which meant she had to consult with the mammogram doctor and he had to have a feel. Having started the day thinking the appointment was going to be routine, I hadn't shored myself up for some invasive touching, so it was deeply alarming, but at subsequent visits, I get used to it. The appointments always go like this: can I feel it? Did a mammogram find it? Did you find it? No, I always reply, the mammogram didn't find it. Yes, it was me. No, I wasn't doing a routine check. Maybe I was showering, or tweezing or something, I can't remember. One day it was just there.

'We always do a biopsy when we find masses like this,' the mammogram doctor said, in such a reassuring way that I assumed everything was fine. By

this point I was pretending very hard that nothing was happening anyway, so I quietly chose to ignore the technician's expression.

At the time, it seemed unlikely. No one in my family has had breast cancer. I breastfed two children for nearly two years each, smug in the knowledge that this would decrease the likelihood of getting it. In 2020, I spent a large amount of money on an integrative medical doctor who conducted a barrage of tests to try to pinpoint the cause of my chronic stress and ongoing fatigue (aside from, you know, work). We tested my blood and my breath and my poop, re-engineered my diet and took inventory of my life from birth. There were some red flags in that, to be sure, but no cancer.

For a few days, I went on with my life. I was too busy to worry. Then my GP called and left a message in a sad voice saying she was there if I wanted to discuss anything. She ended the call with 'I hope you're okay.' I was suddenly, alarmingly, *not* okay. I called her back, and she patiently answered my questions, both of us somewhat concerned that the mammogram doctor hadn't made it clear that there were definitely Things To Worry About. A day or so later I received the first report of many via the *Manage My Health* website. 'Findings here are probably malignant', it said for one lesion, 'this is also suspicious for malignancy' it said for the other. Despite my propensity for optimism and my denial that this could possibly be happening, I knew it was unlikely to be wrong.

'I love my breasts,' women with breast cancer often say when explaining their decision to seek breast-conserving surgery or have reconstructive surgery. I know that one of the reasons I found it hard to imagine that I had breast cancer, one of the reasons I wasn't entirely sure I believed it even when I was having treatment for it, is that my breasts have been, on the whole, benevolent: forces for good, not evil; nurturing not only children but relationships and body image and identity. Long before I ever contemplated the possibility of losing my own breast/s, I found that Tig Notaro joke hilarious, the one she made after her double mastectomy, about how her breasts got sick of her making jokes about their size, and decided to kill her. How else do we come to terms with murderous breasts, but to laugh?

★

At the biopsy appointment, the specialist pulled up the imaging of my breast from the previous appointment, and was helpfully definitive. 'This is a very clear cancer,' he said, circling an area on the screen, 'and it looks like there's a smaller one here you wouldn't have been able to feel.'

Well, that's it, I thought. Tears came then, just a few, rolling quietly down my face. I reached for my husband's hand. The specialist and specialist nurse waited patiently. They must see this every single day, I thought.

'You did well catching it—it's very early,' the specialist said. I will be told this often, and I certainly felt the truth of it. Nothing else would be conclusive until more tests and surgery and testing of what they removed during surgery, but because we'd found it early this kind of cancer usually had high chances of survival—85 to 95 percent over five to ten years. But I hadn't yet contemplated the possibility of nonsurvival.

The rest of the appointment was somewhat jolly. The surgeon made fun of my profession and my parenting decisions as he used ultrasound to pinpoint my malignancies and inserted massive needles with scissory tips to snip a bit of flesh for the biopsies. I was up for the teasing, tried to give as good as I got. Anything but pity. My husband focused on breathing and not looking. 'Sympathetic nervous response,' the surgeon said, nodding towards him, 'It's often the husbands who have stronger reactions'. We both averted our eyes but the needles were long enough to flash into my peripheral vision anyway, and despite the blissful numbness brought on by the local, there was a lot of prodding and shoving.

'There's quite extreme variation in the density of women's breasts,' the specialist nurse told us. She was very good at explaining everything that happened. 'Some are like butter and some are like rubber car mats.' The implication was that mine fall towards the rubber mat end of the spectrum.

The test results were 'good', by which I mean non-surprising, by which I mean that it was definitely the big C, but it wasn't nastier than we had anticipated. I had the most common form of breast cancer, hormone-positive, 'easy' to treat. The thing to do was cut it out, and once they cut it out, the cancer would be gone, even though the conditions that caused the cancer would still be there. Most of the time, they dealt with that by 'sanitising the area' with radiation, or a systemic approach using drugs. It was likely that I wouldn't need chemotherapy, thank all the gods. And then the medical

intervention would be done, even though the conditions that caused the cancer might still be there.

<div align="center">*</div>

I was completely surprised, and yet I was wholly unsurprised. Life is paradoxical—grittily, hungrily, wonderfully and painfully so—and an utter mystery. The mystery that found me in February 2021 said, so, cancer huh? What's that about? Within weeks of my diagnosis, I discovered Dr Gabor Maté's *When the Body Says No: The cost of hidden stress*, and was relieved to find that my gut feeling about what was going on had some scientific backing. As Maté describes:

> …women with a history of breast cancer were asked what they thought had caused their malignancy. Forty-two per cent cited stress—much more than other factors such as diet, environment, genetics and lifestyle … No other cancer has been as minutely studied for the potential biological connections between psychological influences and the onset of the disease. A rich body of evidence, drawn from animal studies and human experience, supports the impression of cancer patients that emotional stress is a major contributing cause of breast malignancy. (73)

Maté notes that women are rarely asked about this aspect of their lives in treatment. This was my experience. In fact, that first specialist had a good old laugh when I tried to explain how overwhelmed I was by work. I teach at a university, and my work is in arts and creativity, which in my opinion is essential for life but must be quantifiably less stressful than say, medicine or law, so even I am a bit confused about why it gets so stressful. Compulsive overwork is a habit in academia, almost a requirement, and few of us say no. Although there is more to it. Says Maté:

> Research has suggested for decades that women are more prone to develop breast cancer if their childhoods were characterized by emotional disconnection from their parents or other disturbances in their upbringing; if they tend to repress emotions, particularly anger; if they lack nurturing social relationships in adulthood; and if they are the altruistic, compulsively caregiving types. (76)

I could tick all of those boxes, at one point or another. And 2020 turned into a particularly toxic year at work. In the three years leading up to 2020, it wasn't unusual for me to go months without a weekend. Sometimes I would plan how we were going to manage at least one day off a week, but it rarely

happened. I was burning out every year or so. I chronically underslept and overate to keep myself moving, I drank regularly to relax, I was always wired. If my chronic stress was a likely cause of cancer, then the way I dealt with that stress only exacerbated things, for sleep and food and alcohol have an effect on hormones too, and:

> … one of the chief ways that emotions act biologically in cancer causation is through the effect of hormones. Some hormones—estrogen, for example—encourage tumour growth. Others enhance cancer development by reducing the immune system's capacity to destroy malignant cells. Hormone production is intimately affected by psychological stress. (75)

I always wonder, if I had known this, really known how toxic stress can be to the body, would I have let it get as bad as it got? Because my work is personally rewarding and satisfying, and because I felt privileged to have it, I found it almost impossible to limit my commitments. Even when I had been diagnosed with cancer, I found it incredibly difficult to let go of work until my colleagues told me to leave it, that it wasn't my problem anymore.

It is only after the physical danger has passed that I am able to analyse my own overwork compulsion at a deeper level: I am a Māori woman at the top level of her field, and what I feel about this, a lot of the time, is shame. Who am I to do well when so many do not? It takes cancer to show me my shame. It takes cancer to show me that the way I have been dealing with that shame is to work myself into the ground. It is never enough to work for myself or my family—somehow I make the profound need for more Māori in my field my responsibility too. The shame says I am not worthy. The shame says I am not 'Māori enough', even though I tell others, constantly, that the only thing that defines us as Māori is whakapapa. I am whakamā, all the time. It is suddenly clear that this deep whakamā is one of the conditions that caused my cancer.

It was not until I was wheeled into recovery from my own cancer surgery that I saw Government minister Kiri Allan's announcement that she had stage three cervical cancer. I was heartbroken and shocked for her in a way I hadn't been for myself. At stage one, my condition was barely comparable to hers. As Allan revealed in the *New Zealand Herald*, her predicted rate of survival was 13 percent because she is wahine Māori.[1] The rate for non-Māori for the same cancer is 40 percent survival. 'The total-cancer mortality rate among Māori

adults was more than 1.5 times as high as that among non-Māori adults', and at times it is much higher.[2]

When I think about Kiri and about academic and writer, Teresia Teaiwa, who is sadly and sorely missed, as well as others who have been sick while working in high-level, high-stress environments, I wonder if I should write about the cost of success for Māori and Pasifika women, even though I can't tell anyone else's story but my own. In a session called 'Fast Burning Women' at the 2018 WORD Festival in Christchurch, Selina Tusitala Marsh and Tusiata Avia talked about how to manage the demands of success on our time and wellbeing, the strategies we must use to place limits on what others ask of us. It's a frequent conversation amongst Indigenous Pasifika and Māori women: how to keep success from swallowing us up with its demands on our energy and our voices. The cancers that grow in our bodies, and the other illnesses we manifest, tell us that it is a life and death conversation.

★

An Adverse Childhood Experiences (ACE) score is a diagnostic tool, and one that doesn't tell us everything, but is known to be a fairly accurate predictor of higher risk for health problems later in life: a high score means more likelihood of addiction, cancers and other diseases, and mental health disorders. My ACE score is 8 out of 10 if you include things I can't remember, but which I know to be true. By this or any sociological measure, I shouldn't be where I am today. Sometimes a high ACE score can be mitigated by a caring grandparent or other caregiver, but I didn't have those as a child either. It was creativity that saved me, and some sort of fierce mentality that refused to believe what I was told about life from a young age. But there's only so much you can keep at bay, and while I kept my mind intact, I seem to have absorbed a whole lot into my body. We can call this trauma, or traumatic stress or chronic stress, but it's more complex than a single label. I was relieved to escape from that childhood, though I immediately walked into a relationship that replicated those conditions, and then I became a single parent.

For a long time, I thought I could absorb it all, everything that came at us, me and my daughters. If I could just hold everything together with my mind, all the shattered pieces, and just keep everything at bay with my body—the

ancestral body, the Hinenuitepō body, the thickset, fast-twitch genes body, the stressed-out, sleep-deprived, overfed body—then I could keep us safe. If I just stayed awake long enough, was hyper-vigilant enough, was persistent enough, strong enough, clever enough, healthy enough, good enough, present enough, available enough, both soft and hard enough, if I could just be enough, I would come between my daughters and all the hard things and all the hard people—the ones we know and the ones we don't know, the systemic violence, the lateral violence, even, sometimes the raw old-fashioned emotional and physical violence. But I was kidding myself. I didn't stop the world getting through. Heck, some of the time I was the one who brought it in.

And then, quite far into adulthood, things came right. Life got good. I started writing, seriously. I found community. I put down my weapons, disassembled my imaginary walls. Writing requires an openness and vulnerability that I wouldn't have if I was still in survival mode. But the thing about healing is, the further along you go, the better equipped you become to deal with the stuff that was left undone in childhood or even adulthood. Sometimes I believe if I can just get it together enough I won't have to deal with it all circling back around again and again. And again. Trauma is exhausting this way: put full stops against it all you like but it will come back when it is least expected.

Maté describes how in most cases, there is a clear precursor to the onset of disease—some kind of acute stress or fracture in social relationships. Against the backdrop of all the conditions that were already primed in my life, encouraged by my own actions and those of others, the thing that tipped the scales for me was an incidence of lateral violence.[3] Our judgements of each other can be harsher and more painful than anything the coloniser can dish out (maybe I just don't care about the coloniser's opinions). When we take each other down, for our mahi, our creativity, our intellect, or for taking a risk and amplifying our voices, we act out the worst of what colonisation has done to us. This experience is not unusual, yet we fear to talk about it openly because it detracts from the real fight. It's powerfully insidious: the wounded feel isolated, alienated and undermined.

My uncle Sir Mason Durie introduced Te Whare Tapa Whā in the 1980s, demonstrating the four aspects of health for Māori: tinana, wairua, hinengaro, whānau, or physical, spiritual, mental and emotional, family and social. Some

models add whenua or land/roots to this structure. The whare needs all walls of the house, and its foundation, to stand. When hurtful action comes from within the marginalised community, it causes deep fracture for the marginalised psyche: it's like taking a wrecking ball to the walls of our whare tapa whā. And what we are left with is an intensification of whakamā.

<div style="text-align:center">*</div>

I have two good friends in other parts of the country who have much worse cancers than me, one Māori and one Pākehā, one male and one female. They are both kind and concerned about my diagnosis but I share it with them mainly in solidarity with their own, because connecting with them is always an exercise in helplessness and inadequacy. I feel very sure about what my cancer means to me, but when I see it in other people, it makes no sense. It seems extremely unfair. Making meaning from this disease is something that works for me. But my conviction shouldn't be mistaken for arrogance about what cancer is or why anyone else has it: I didn't think I'd ever be here, and I don't understand why my friends are.

By the time my diagnosis comes, despite everything that has preceded it, I am better off than I have ever been, and that makes it easy to see my particular diagnosis as a gift: a nudge, a quiet talking-to, a sharply focusing lens.

'It's okay,' I told my sister, when she fretted for me from overseas, 'I'm so lucky. It'd be different if I was alone.' For a long time I *was* alone, or with people who were the opposite of my husband. 'Moea he tangata ringa raupa', the whakataukī says, 'marry someone with calloused hands'. The implication: they'll look after you. Somehow, eventually, I did, and he does. Being married to an emotionally healthy individual is, on the scale of things I expected to see in my life, a miracle. He is simply willing to do the work, whatever that work is, even when the work is on himself. Recovery is much harder without a crew like this.

'Reparations!' my eldest exclaims when she sees her Pākehā matua whāngai / parent doing this work. Nothing gets past anyone in this house. It's true, his efforts are making up for transgressions that go beyond either of us. There is a clear understanding in our home that much of the damage we still carry is directly attributable to a family history that microcosmically replicates the colonial process. Colonial violence has fed into the lives of my children

through both sides of their heritage. As Resmaa Menakem explains in *My Grandmother's Hands: Racialized Trauma and the Pathway to Mending Our Hearts and Bodies*, trauma exists in the body rather than the emotions, and is routinely passed on from person to person, generation to generation. Whatever we're dealing with has been there for a long time, and likely began long before us.

<center>*</center>

Frankenboob changes everything. The way I eat, the way I sleep, the way I drink. How I think, how I speak, what I give my attention to. But none of this is because of treatment or what I have been prescribed. Every practitioner I meet at the hospital is exceedingly kind, gentle, and clearly hard-working. They ask me how I am, but they mean how my body is, particularly the areas affected by treatment. I can access counselling if I wish, through the Breast Cancer Society, though access to Māori counsellors is notoriously difficult. It's been forty years since we've known about Te Whare Tapa Whā, but in several months of treatment, no one asks me about my whānau. No one asks about my wairua or hinengaro. I wouldn't even have minded if they did this the Pākehā way. They could have talked to me about my diet, coping mechanisms, exercise, support systems. I'm fine because I have good access to information, and I'm a researcher, but I think a lot about people who only do what the doctor prescribes. People who don't have the time or energy or easy access to research, people for whom English is not the first language, or who have a big family waiting for them to get home with the kai. It's the only thing that worries me—that our treatment is limited to the body parts in which the cancer has grown. And it would make a difference, to have someone ask about our lives as a whole. The evidence is clear that the way we feed and exercise and relax ourselves can make a huge difference to our outcomes. The evidence is clear that we should pray or meditate, deal with our chronic stress, make amends and decide how to respond to those who have harmed us. The evidence is clear we should forgive ourselves, most of all, and live in good community with others.

During the three weeks of radiotherapy, my breast became uncomfortable and itchy and sore. Lost some skin and received a radiation tan. But mostly it's the fatigue people talk about, and that was the hard part. Still, there's

nothing quite like cancer as a legitimate excuse to *not* work. By the time my convalescence was over, I'd gotten used to something called rest, and I've become unwilling to forget that it means life.

    I'm still figuring out how to deal with the conditions that caused the cancer. It's all of the above and then some, with some element of chaos and free radicals and the way the fucking world is right now. At my one-year check-up I was given the all clear—the name Frankenboob faded long ago with her scars, though there might still be a tinge of blue. The oncologist said it takes one year to recover from surgery, two to recover from radiation. I wonder how long it takes to recover from the conditions that caused the cancer. It could be generations, but there's no reason it can't start now.

**Notes**
1. 'Kiri Allan reveals grim cancer prognosis', *New Zealand Herald*, 4 May, 2021, www.nzherald.co.nz/kahu/kiri-allan-reveals-grim-cancer-prognosis/4Y5PTU7COFCIJVA2OGQULNWLQA/
2. 'Cancer', Manatū Hauora–Ministry of Health, 2 August 2018, www.health.govt.nz/our-work/populations/maori-health/tatau-kahukura-maori-health-statistics/nga-mana-hauora-tutohu-health-status-indicators/cancer
3. Lateral violence is displaced violence; that is, anger and rage directed towards members within a marginalised or oppressed community by their peers rather than towards the oppressors of the community (Wikipedia, quoting Geraldine Moane, 2011).

MAGGIE STURGESS

# Pig Love Slop

I began attending auctions religiously, finding the ritual of it soothing. I'd found a room where objects and belongings rushed in and out like a tide. As if the world's possessions were an ocean, and I could muck about in one bit of muddy estuary.

*

'Sighs, the rhythms of our heartbeats, contractions of childbirth, orgasms, all flow into time just as pendulum clocks placed next to one another soon beat in unison.'—Lucia Berlin

*

'I'm worried you're a hoarder,' my mum told me as she moved my things into my new house. This was a gross exaggeration; it wasn't *that* bad, just a few old pairs of shoes with the leather scuffed and worn; yellowed pillows, stiff from old age; paperbacks with torn covers and mildewed edges; a box of kitchen utensils I'd bought from an auction. I knew what most of the things were, knew where they went, though some strange appliances sifted around in kitchen drawers catching dust.

*

For my birthday, my friends give me a copy of *A Manual for Cleaning Women* by Lucia Berlin. 'Wait,' I say, confused, 'why are the women being cleaned?'

*

In my university paper about memory, we learn that most memory problems are not an issue with retrieval, but with storage. In other words: if you weren't there to experience the thing in the first place, for example, due to dissociation or stress or distraction, then there's no trace left behind to be remembered.

*

*The problem with a numbered list, my writing supervisor, Pip, says, is that it implies a forward motion. It makes it harder to return to prior threads of the narrative.*

★

There are no comfortable chairs in my house growing up, not a one. The dinner table is a long and narrow wooden thing, a wide and dark stained piece of wood in the heart of the kitchen, two hard upright seats at each head, and backless pews along the sides.

I do my Kumon homework at this table, maths problems that centre around repetition, learning through a sequential memorisation process of addition, subtraction, multiplication, division.

My writing has a troublesome way of etching into the table's waxy surface. When I look down at dinner I can see the faint lines of my working, the answer reached plus the steps of how to get there.

★

On one of my stories, my writing teacher Elaine notes: 'I prefer my writers (and psychologists) to have the aura of magicians about them, and not show how the trick is done …'

★

I pluck a book from the shelf in my hall, Mary Oliver's *New and Selected Poems*. I take it upstairs, lie in bed with it next to Sean. 'Can I read you a poem?' I ask.

'Sure.' He sounds tired.

I open it and on the inside cover is a handwritten note from my dad. Blue biro, his writing an elegant slant, angled against the page. I scroll my eyes through the contents, separated out into time periods, the various volumes of Oliver's work.

I scan the titles, searching for a bird poem in the hope Sean might like it because Sean likes birds. 'Wait, she's got a poem called "Egret" and then another called "The Egrets"? Can you do that? Name two poems the same thing? I can't pick a poem. You choose.'

I pass Sean the book and he thumbs along the pages until it catches and falls open.

'Let me see!' I say, peering over at what he's found. 'Egret' it reads at the top of the page. I make witchy fingers at him and a 'wooooo' sound.

'Stop that,' he says.

\*

My mum can't sleep without earplugs, and she keeps them in a little paua shell next to her bed, bullets of orange foam that she uses to block her ears. She has trouble throwing the old ones away, so it's a graveyard of them, a pile of silence she's accumulated over the years.

Every afternoon, she takes a nap. She did this when my brother and I were kids, corralling us into a circle of her words while speaking in a Very Firm Voice: 'No *noise*. I am lowering the Cone of Silence!'

The Cone of Silence was never to be lifted, it was a precious and sacred thing from which no sound could escape. A bell jar for naptime, impenetrable, and we were all stuck inside of it for the next thirty minutes while she dozed. We crept around the house. It was always so tempting to shatter the glass, but I knew it wasn't worth it. I tried to pipe down.

\*

I've always thought I'd be a good plumber. I take a secret pleasure in the blockage of a sink, the knowledge that my skills will soon come in handy. I wrap my hands round the thick white pipes and then twist the sturdy plastic loose. I place a bucket underneath to catch any overflow, and then reach my hand in, turning one end of me into a small white claw, scratching at the insides to dislodge gunk which I shake into the bucket's wide green mouth waiting patiently where I've placed it.

\*

I deliver a training programme to district court staff on behalf of a sexual violence prevention NGO. The training is called 'Recognise, Respond, Refer'. I'm flown to Christchurch and put up in a hotel. The room I'm in is very small, with a mirror entirely filling one wall next to the bed. It's a very modern set-up and reminds me of those public toilets that play songs as you pee—usually a cheery piano rendition of 'What the World Needs Now Is Love Sweet Love'.

The hotel room is too smart for its own good, with a control panel next to the door that's difficult to operate. Though I press the 'bedtime' setting, a light above my head turns on at half-hour intervals throughout the night. Each time, I roll over with a groan to press a series of buttons, a complex morse code trying to shut it off. Then I go back to sleep.

*

I present my clean laundry like evidence, the tangled mess of it in the rattan basket that lives in the hallway outside my bedroom. The handle's fallen off, but it's still good, carrying the bits okay if I keep my arms hugged round it tight enough. After the handle falls off it, I think: *well, guess that's it then*, but more bits of wicker continue to flick off and I find them in the laundry closet, sitting on top of the washer. 'How'd you get in here?' I ask the thing, frowning at it with my hands stuck on my hips in disapproval.

*

I start to notice that my classmates' stories have affect contained in them, emotions I can feel while reading their words. Perhaps I am occupying their minds, or maybe holding a small animal part of them in my palms.

'This story feels a little numb,' I announce, or 'I love how much energy's here, it's really coming off the page.'

I start to doubt myself, wondering what I'm projecting onto the work and what's actually there. I know there isn't any true way to separate the two. I often have the feeling that something else is trying to get through the words, another story lying underneath in wait, hoping to be discovered. I share this thought, then wonder if it's wanted. *What's reflection and what's projection?* I think, gazing around me, the once solid world starting to waver.

*

Elaine tells me to choose either italics or quote marks for speech, not to use both. But *what if I want to use italics to suggest a more internal speech and quote marks to be more external?*

'Pick one,' she says.

*

My friends Matthew and Gus make up a game in which two objects are introduced and you pick which one you are. The original choice was 'olive oil or sea salt' but it's moved far beyond that now. After you pick, everyone else gets to weigh in, which sometimes results in strange debates.

'You are *not* smoked salmon,' I laugh at Gus, rolling my eyes. 'You're cream cheese through and through!'

It's fun to show someone how ignorant they can be to themselves. Who do they think they are, claiming to be a rattan wastepaper basket when they are so clearly an industrial-sized paper shredder?

*

I take one of my assessment reports to my clinical psychology supervisor. I've used the term 'true self' and she questions me on it: 'Can you explain to me what you mean by that here?'

I find it difficult to articulate and she gently suggests I not use psychoanalytic terms that I don't understand.

*

I stay at my mother's place for the weekend, and she says if I help her clean out her closet she'll give me any clothes she gets rid of that I want. The thought of organising someone else's shit is weirdly enticing, and I agree, standing on a stepladder in the darkened length of it, reaching towards 80's sweaters and holding them up to decide which pile to throw them into.

'But what if I want that later and I no longer have it?' She worries, citing an old boyfriend's jacket that she threw away forty years ago as a terrifying reminder that a thing, once discarded, is gone. I groan and try to convince her to loosen her grip a bit, hoping we might make the give-away pile larger, reducing the strain on the already precarious stack of keeps.

*

I am watching the trailer for *Memento*; it resonates. I stare open-mouthed at the screen while my right hand blindly takes another sesame cracker, freeing it from flimsy plastic. I go to dip it in my hummus and see another cracker already sitting there. Right where some part of me left it. I laugh and look around, but there's nobody there.

*

I find a Post-it note that I tucked away in a drawer, a scrawl of black pen on dark pink. It reads: 'Childhood is a land I cannot return to; I am homesick for it.'

*

'Writing isn't therapy, Maggie,' Elaine says gently, then hands me a stapled print-out; a *Guardian* article with a smiling woman on the cover, an author who's written a 500-word essay saying the same thing.

★

'Your mind works in mysterious ways,' my high school geometry teacher, Mrs Aarons, tells me, shaking her head.

Mrs Aarons has Bell's palsy, and half her face is drooped on one side. She's slicked it with clear lubricant to keep her eye moist as it no longer produces tears. She is a strange woman with a small family—a husband and a blonde, surly toddler I don't like.

Also, there's a strange smell to her, a savoury scent that wafts from the end of the hall, infiltrating the entryways of the rooms nearby.

★

I clean the garlic press last, knowing it will reek, and it does. I scrape the thick heel of indented vegetal peel free with my fingernails and then poke through the press's silver holes with a dish brush.

After, I'm infiltrated, my skin a porous border for the stench. I stink even after a shower, my skin red and raw from scrubbing at myself. I bring my fingers to my nose. Still there. I can't wash it off.

★

I'm standing at the whiteboard of the courthouse, marker pen poised. 'Okay, so what are some signs a person might have experienced trauma?' The group quickly gets the most common ones: feeling fearful, not leaving the house much, isolating from friends and family, alcohol and drug use. I smile and nod, affirming all the answers, repeating them back so each person knows they've been heard.

'What about dissociation, like things don't really feel real,' a goateed man offers.

'Yep!' I mumble *dissociation* under my breath as I scrawl it on the board.

A middle-aged white woman raises her hand: 'What about cleaning a lot? OCD type stuff?'

I pause, holding the dry end of the pen to my lips. 'Hmmmm, I'm actually not so sure about that one. I haven't heard of that before.'

★

Friday night sees me with a yellow Chux cloth in one hand while the other presses play on a podcast I've recently discovered: *Tuesday Toolbox*, ACA, which

is an adult child of alcoholics recovery group that meets weekly in Cobble Hill, Brooklyn.

Each episode opens with a few bars of clangy piano riff and then the voice of Ann, who describes herself as 'a Tuesday Toolbox member and an adult child.' She speaks in a soft sing-song voice, which makes it sound as though she is herself a child, but also an adult speaking gently to that very same child.

I am cleaning the back doors that lead into the garden because I want to be able to see the green. As I remove the dust and muck, the white paint begins to chip away. I have to be gentle, to try and clean without removing too much as the wood's already leaking and when rain comes in hard from the side a thin line of wet sits at the lip of the window. Sometimes I have to take a towel to it, wiping the moisture away.

⋆

> 'She steps into the dark swamp
> where the long wait ends.' —Mary Oliver

⋆

'Just make sure that the anger doesn't do the writing,' Elaine says to me one afternoon in her office. I'm trying to stay with the conversation, but I've had a migraine all day, and the window behind her seems too big. Looking out of it feels like pressing on a bruise.

'Why? What happens if I write from my anger?'

'A person can lose track of the deeper story.'

⋆

My classmate brings in a poem by a writer they admire. It's written entirely in computer programming code. *Someone* has bothered me and I'm crawling out of my skin not saying the goddamned thing. The poets discuss the piece thoughtfully, offering possible meanings one morsel at a time like unhungry monks. I want to bite off the poem's legs. I want to spit bloody code from my mouth. A poet speaks and the other poets nod. I can't hear over the ringing in my ears. *Can't someone in this room be honest for once? Can't someone just say what they fucking think? Do I have to tell everyone that I love everything? Do I have to tell everyone that I love them?*

I don't say any of this. Instead, I fill my chest with air like a proud bird and say: 'Could I put a potato on the table and call *that* a poem. Huh?'

The walk home is a shameful walk, a dog leading itself to the pound, head down and eyes looking dolefully up. Part of me wants to sink like shit into the bowels of the earth, but instead I puff myself up hot and full of air. My steps are getting pouty.

'But that was a *bad* poem,' I say to my friend as we walk down the hill.

I tell Sean about it later, trying to pass it off like it's funny. He laughs, but there's a nervous edge to it, like maybe I've fallen over the lip of something. Gone too far.

⋆

'Memory can be thought of like a filing cabinet,' I say to the attendees in the courtroom. I'm nervous but my voice strides ahead of me. 'When something traumatic happens, it's like the cabinet's been tipped over, and all of the files get scattered across the floor. A therapist's job is to help the client put the memories back in order.' I pause and give a little smile. 'Now obviously, that is not *your* job and we aren't asking you to do that. But this is just to give some idea of why a customer you're dealing with might be a little erratic, or seem confused, or agitated.'

I think I've said this okay, but it doesn't quite make sense even though I know the words off by heart. The metaphor keeps getting jumbled in my mind.

⋆

I'm *very literal*, I tell the poets in apology. Elaine has asked what the washing machine image in someone's poem means and I say 'washing machine.' It just blurts out of my mouth I can't stop it.

⋆

I do laundry like it's breathing. Cycling it in and out and in and out, quietly opening the door to the laundry cupboard to check on it as it spins round and round, the frothy bubbles a reminder that it's not done. *I'll come check on it later*, I say to myself. *Don't forget!*

⋆

When asked if she likes something, my mother says: 'Do a pig love *slop!*' Her words are thrown out with dramatic relish, the roof of her mouth happy to usher the syllables out.

<p style="text-align:center">*</p>

    'And forever those nights snarl
    the delicate machinery of the days.' —Mary Oliver

<p style="text-align:center">*</p>

I play a game at Matthew and Gus's place where we all go round and share a saying our mothers used to say, something that doesn't make any sense outside the language of our family. I choose: *It doesn't make my socks roll up and down.* It reminds me of the Wicked Witch of the West, her striped socks curling her up beneath the fallen house til there's no trace of her left.

<p style="text-align:center">*</p>

I locate the little girl's shoe, tired and brown and weathered, in the top drawer inside the laundry cupboard. *I think this belongs with the house,* the prior owners wrote in their handwritten note.
    It's right where I put it, under a toolkit and series of screwdrivers – Phillips head, flat, and square. The shoe's very dusty, shrivelled with a little button on the side, receded into the rest of the leather. It is disgusting. I must rid my architecture of all foreign bodies. *Perhaps,* I think, *this is an opportunity!* I must give the shoe as a sacrificial offering to whatever wrathful whatever I've whatevered.

<p style="text-align:center">*</p>

My mum's got a stuffed animal that she keeps on her bed. She's had it since she was a kid, a folksy little pig sewn in a thick pink fabric. The pig's wearing wide-wale green corduroy overalls. It's getting a little old and frayed nowadays but it still goes. It's still good.

<p style="text-align:center">*</p>

It's cumbersome, moving the shoe with one hand while holding the stick of burning sage with the other, a steady stream of smoke wisping into the cobwebs that line the ceiling of the laundry cupboard. It's under the stairs, so the ceiling slants down at the same angle I ascend to bed each evening.

I take the shoe into the kitchen where the vibes are better, place it on the floor over the spot where I've heard the rat scratching. *Only god lives here, only god lives here*, I say, circling the sage round the shoe some multiple of times until I am some semblance of satisfied. I walk with my items— shoe, sage, and lighter (the sage needs to be continually re-ignited with a flick of tiny silver wheel)—outside and can hear my neighbours playing dubstep two doors over, low male voices rumbling in non-conversation. I can practically hear the slurps of beer.

<center>★</center>

'Your right eye is almost perfect,' my OkCupid date tells me. We are sitting at a picnic table outside a café in Berlin and he seems disappointed that I've ordered orange soda and not a lager. 'The right side is your masculine side. But,' he pauses to peer at me, 'your left eye is drooping slightly. This is the feminine side. She looks a little sad.'

<center>★</center>

Now I feel uncertain. Where is the best place to put a cursed child's shoe of yore? The leather has shrivelled up so much that the sole of the thing sticks out beyond the upper, which has receded like a gingivitis-ridden gum. I am desperate to throw it over the fence into the back of the preschool. There is some symmetry to this, and my gut tells me *yes, do it*. But what if it lands on the roof? In many ways a good outcome: out of reach of small, jammy hands. But also bad: from that vantage, perhaps it could rain evil down. Surely corrugated iron would not serve as a proper shield?

There is nowhere to hide it out here, the back fence erected proud and strong with not a nook nor cranny to be seen along its length. The side fence is a little shoddier, and I opt for tucking it under. There, it sits in a corner and I pray a quiet apology under my breath to the neighbour: *sorry, sorry, I'll come back for it, promise!*

<center>★</center>

I message Matthew and Gus to ask what they call the game, the one where you pick the thing that you are. Now I know not to trust my own memory. Matthew writes: *We call it 'Each to their own.' And also 'To each their own.' Pretty interchangeably*. He says they've been playing a lot lately and poses me one: astrology or astronomy?

\*

It's been a long time since I've cleaned the bathroom mirror and white dots of toothpaste are splattered all over it. I can only see myself through the stars, like I'm flying through space, the mirrored version of that old screensaver we used to have on the desktop in Dad's office. Only now I can see myself in the solar system, my milky face hovering in the way.

\*

I watch a YouTube clip of Oprah talking to her life coach, Martha Beck. Beck reminds me of a Muppet, her smile so broad and available it looks like her head might hinge right back so a song can spill out. Beck tells Oprah that the best way to do a psychological self-portrait is to think of the room in your house that you would least like someone to see, and then use three words to describe it. I immediately think of my closet. *Messy, dirty, shameful.*

I tell Sean about the video. 'It's kinda like the house is a body. So if that's the case, what do you think my closet represents?' It's a rhetorical question, what Oprah might call a 'teachable moment.'

Sean grins. 'Is it your asshole?'

'No,' I say, exasperated, 'obviously it's my heart.'

\*

My haul from mum's closet is pretty good; a long corduroy skirt that makes me feel like a Mormon who's started listening to Shirley Manson, and a lilac turtleneck that I'm on the fence about but decide to take. But the best bit is the sweatshirt, blue and faded, soft from wear. On the front is a diagram of an artificial heart in shades of white. It depicts the heart itself, and then a row of stitches across it, discs and wires stuck in the three valves and sans-serif lettering that reads 'JARVIK-7™.' Centred on the back are two lines of text, bold and blocky capitals, followed by a mysterious ellipsis:

> AND THE BEAT
>   GOES ON …

\*

I read Sean another Mary Oliver poem: 'Picking Blueberries, Austerlitz, New York, 1957.' It concludes:

> 'rising out of the rough weeds,
>     listening and looking.
>         Beautiful girl,
>             where are you?'

'What do you think the poem is about?' I ask, his arms around me.
   He smiles, 'Picking blueberries, I guess.'

★

I snap half a sleeping pill and put it in my mouth. I take a swig of water, then turn out the light.

MIRIAMA GEMMELL

## navigating between pātaka

all the world's a storehouse and we are merely may i
break waiting
learning from the wrist slap
what lines to say
in the right light
pages swiftly turning left
left
avoiding eye contact
parirau gliding
rationing spoons

until the island chaining
may hold hands againing

ZOË MEAGER

# Pan-pan

I put my boy in the bath and he has that look on his face again like he's going to drift away and he says to me mama, look I found the beginning middle and end, and I watch as he points to the tap, the bath water, and the plug hole and I think where did this kid come from, this boy who won't sit down on his bottom in the bath and will only ever crouch there, wide-eyed as a baby bird on a nest, and I say to him my boy, don't you know the bathtub isn't like the sea, you can't get lost in the bath, and then I know I've done it so I say hey, let's make a magic cauldron and then we conjure bath bubble mountains and wizard whorls of pink purple clouds and with soap crayons he presses blue runes into his skin and from nowhere his old toy boat appears and bobbing it he says what's daddy catching today and I say oh I dunno probably crayfish or kahawai or long-finned eels and I make my arm into an eel that squiggles all around the bathroom til he squeals and squirms and bangs the boat into the bathwater and says mum there's three men inside the boat isn't there and I say oh yeah three tiny wee men and they can't wait to come home safe and sound but then the bobbing boat has been arrested and pushed to the bottom of the bathtub and my boy says there's three men in there eh mum all their guts are locked up in jail he says as air bubbles blob up from the cabin and pop pop pop in gentle salty goodbye kisses on the surface of the sea, one for each of the men who has ended elliptical with a dot dot dot and I want to tell my boy something as I think of his dad as a stingray, easily stepped on as he smiles at the ocean floor, something about his tail is a trident so good at spearing things and so easy at losing hold, something as I think of his dad as a seagull caught in a net that was never his, as I think of the slick of the deck as I think of the snap of the rope as I think of the cut of the blade and then I want to tell my boy I want to tell him: get out of the bathtub now because it goes down forever because you are too small to be in there alone, because every day is written in a wavering hand, squid ink on a page of white sand,

because the plug hole grumbles as it swallows the entire sea and there is something dark down there which makes the howling sound that rises in panic until it is voiceless words that run off the end of the page

MICHELE LEGGOTT

# Whakaahurangi

we were coming round the mountain
dog in the footwell    playlist old favourites
we were driving six white horses
through Tataraimaka Ōkato Warea Rāhotu
Carmelita Spanish Stroll Tipitina
through Pungarehu Ōpunakē Pihama
Dallas Talk to Me of Mendocino Who Do You Love
a summer morning to ourselves    coming round the mountain
which has its cloud cap on and changes shape    with each twist of the dial
A Case of You Black Coffee    Prince and KD Lang
Hickory Wind and Our Town    Gram Parsons and Iris DeMent
we turn inland across the plain to Eltham    mountain still on our left
the cheese factory isn't open    it's Saturday
Erma Franklin Piece of My Heart    Aaron Neville Tell It Like It Is
we turn north for Ngaere and come to Stratford
Grace Jones La Vie en Rose    Bettye Swann Then You Can Tell Me Goodbye
follow Pembroke Rd to the Mountain House and the Plateau
Etta James At Last    Amy Winehouse Love is a Losing Game

she came from New Plymouth to Stratford on the early train
set out on horseback in a party of nine up the mountain track
for Lady Shoe Camp on the edge of the Plateau    close to Te Popo Gorge
she collected wildflowers    sketched and painted not at all
five days and then the horses came to take them back
through the burning season    trees on fire
understorey cleared for pasture    smoke choking horses and riders
she wept in the saddle and took her flowers into the sitting room
of Emma Curtis    who with her friends Sarah Arden Mary Bayley and Eva Dixon
had climbed to the crater from the eastern slopes the year before

33

returning to camp with Mary's ruined shoe that was nailed to a tree
did my great-grandmother Elizabeth climb the stairs to Emma's sitting room
to admire the paintings the artist made from her mountain flowers
during the week she stayed on in the town   primula buttercup
pearly everlastings pale blue harebells small white celmisias
not enough coins in Elizabeth's slender purse to buy a picture
but she drank in the delicate membranes rendered in watercolour
remembering the flowers of her own Welsh valleys

Fire and sword   chaos and ruin
the child drowned   dead of malnutrition or dehydration
the forest recklessly destroyed   there has been such grief in this place
I am in your hands
a wide-brimmed hat floats down on the books the rohe the child's dark head
such grief   so many shadows
Here you are   she says   I have been waiting all this time
I am in your hands
a small flower in the crevice of a rock   face turned to the sky
desire path in the dark faintly luminous
I am in your hands

Ruaputahanga was a high-ranking woman of Pātea
travelling with her followers to the east of the mountain   on her way
to marry a Kawhia man
sometime later   leaving a husband and son
Ruaputahanga journeyed back to her people
the party camped one night on the slopes of the mountain
Ruaputahanga lay looking up at the summer constellations
falling asleep with her face to the sky
her followers withdrew not wishing to disturb her rest
the campsite was known thereafter as Whakaahurangi
and the old trail became the Whakaahurangi Track

the word slips away and is replaced   innocently thoughtlessly carelessly
see you later alligator   in a while crocodile
What's the story morning glory   never mind roller blind
a hat floats down on the books   the map   the child's dark head
where is that rohe   memories futile arms
what's the word hummingbird   all for love mourning dove

they drive to the maternity ward in Miranda St
he waits for hours   until their daughter is delivered
near dawn on a spring morning in Stratford
fourteen months later he guns the truck south to Levin
leaving the child with a beloved aunt   turns north again to be at the hospital
before the second baby comes
the third trip in the truck   I remember
dropped with our grandmother in Brecon Rd
my brother and I hear about the new sister next day
from a phone in the Waitara maternity home
it is a frosty morning in Stratford   a kerosene heater roars
the mountain stands out sharp and clear   waiting for its travellers

ANUJA MITRA

# what the counsellor told me about grief

after my father died I saw him
everywhere. any old Filipino man
on TV would bring me to tears,
it didn't even matter
what he was selling.

it was irrational, she said, I know that
now. outside, tūī raise the alarm
for the end of this season,
nestled deep in high trees
where the wind moves through
like rushing water.

so the birds don't stop
for the storm.
so nothing makes sense
in grief. and who can tell
if it's rain

or the trees talking back to the sky,
asking *how much more*
*do we have to hold?*
when autumn passes, I'll mourn
like a mother. I'll keep all that hurt
in me the way ice keeps a river.

I'll love everything that leaves
and call it living.

S.A. MUSE

# Loin

My mother has pain in her kidney.
    She says, 'Your father married me when I was a child.'
    She grabs my wrist, 'I was a child.'
    She only says this when the pain is bad.
    'Ya Rab, Ya Rab, Ya Rab,' she tilts her head back. Her eyes begin to water, her nose does too.
    'Ladan!'
    I am already on the phone. City Taxis has replaced the operator with a machine. In ten minutes, a sedan will take us to the New World across the road from the hospital. City Taxis does not like it if you are sick. Once the operator heard her screaming and said, 'Get an ambulance,' then hung up.

<p style="text-align:center">★</p>

The vending machine in the waiting room is broken. A man with his arm in a sling kowtows before it. He offers his remaining arm into its stingy mouth. He returns to sit with nothing to show for his troubles. My mother holds her head between her knees, a vomit bag full of spit and tissues hangs from her thumb. Behind the plexiglass the receptionist looks bored. She recognised us, either by face or by the alert flashing on her screen. My mother is a 'Frequent Flyer'. This means the hospital thinks she is a whore.

<p style="text-align:center">★</p>

The nurse calls for us. She holds open the heavy emergency room door with her foot. Our cubicle is partitioned by sheets of periwinkle plastic. She gives my mother paracetamol and ibuprofen. We watch the pills dissolve against her rubber shoes. It takes her five tries to draw a tube of congealed blood, black like molasses. She puts a urine pottle and two suppositories on the tray. My mother says she can place these herself. The nurse wilts with relief. In the bathroom I lean against the doorknob. I can feel the first caress of a bruise. There is a cancer poster above the sink. My mother passes me the foil wrapper

followed by a warm pottle. The poster is pink and saturated. It has the ring of a salutation: some good news about dying.

*

We get the latest intern. She appears gaunt in her ill-fitting scrubs. She leans her torso back. Her lips curl to hide two rows of discoloured ceramic braces. She only looks up from her scrap of paper when she becomes alert to the precise way I relay the story.

'The pain is in her left loin. It comes in waves and makes her sick. She doesn't have a fever or blood in her urine.'

She says, 'Are you medical?'

I say, 'No.'

I have heard how her predecessors tell the story to the man they call Boss. Boss pretends he does not remember us and shakes my hand. He always squeezes hard. He has an accent full of bubbles and smiles through his words. There is nothing in the urine. The latest CT is only a couple of months old. The bloods are within normal limits.

'Her kidney is fine.'

He gives her a thumbs up, 'Tell her she has good kidneys.'

*

My mother sends me to bring back Boss. I tell the nurse we need to talk to him. She sends the intern instead.

My mother points at the intern, 'Ask her to take it out.'

There is a thick scar across the bottom of her belly where I was taken from her; when the bleeding did not stop, her womb was taken too.

The intern looks at me like I've lost my mind. Her face becomes soft.

'It won't get rid of the pain,' she says.

I do not bother translating this.

'But it will get rid of her kidney.'

The intern's face closes off. She shakes her head at her terrible miscalculation. At ever thinking I was one of them.

*

My mother does not eat meat, but she eats offal. She gags at the sight of braised goat or beef stew. Tripe, liver and kidney—these she will have. In the taxi home she rests against the sharp edge of my shoulder. Her script balled

up tight in my fist. At home, I pull the old futon from behind the couch. She poses herself like a corpse on the living room floor. I slice red onion and okra. I work slowly. The oil begins to fume. I think about going away.

<p style="text-align:center">*</p>

I have three half-brothers around my mother's age in San Diego and Seattle. Once a year their voices come across the Pacific on a wave of static. They call me Our Girl and tell me how much they miss me. We have never met. At the end of each call, they remind me to 'pray for Daddy' who died in the war. Before that he married my mother when she was a child. Every time she tells me, I imagine her on her wedding day as whatever age I am at that moment. The first time she is eleven. Now I am twenty-nine. For many years it has not seemed that bad.

CLAUDIA JARDINE

# Spell for a Significant Road Junction

o Significant Road Junction connecting State Highway Seven and Sixty-five, o motel, gas station, café with a penchant for hastily made signs: PLEASE DO NOT OPEN THE DOORS—WE WILL SERVE YOU—PLEASE FLUSH—LOST/TAKEN—YES, WE ARE OPEN—PLEASE USE THE OTHER DOOR—PLEASE TURN OFF THE TAP—FREE MAGAZINES—PLEASE DO NOT PUT ANYTHING IN THE TOILET—PLEASE CLOSE SLIDING DOOR—o pleases that still result in a rudeness, o dry bread, o sallow pastry, o prolific use of cling film in a small town with nowhere else to take my business, o PMS, o thoughts like frigates on a French canal, o internet, whence I learn THE BEST THINGS TO DO IN SPRINGS JUNCTION: drive forty-four kilometres northwest to the Reefton Visitor Centre, drive ninety-four kilometres southeast to Hanmer Springs, or take a piss in the transportable public toilet, rest your hot head on the toilet paper dispenser, reflect on Springs Junction as the PMS of southern vistas, read the graffito on the back of the door, a phone number which avows: 'CALL ME 4 A GUD LICK OUT.'

# Maltesers

last week my mum ticked off a whole museum for displaying a map of the
Mediterranean that had a label for Lampedusa but not Malta, a surprise given
that the latter is a larger landmass by some two hundred and ninety-six
kilometres squared, but it's not their fault our heritage has been eclipsed by a
sphere of malted milk coated in chocolate—and that story you told me, which
I can never get away from, of the time when you were a girl, eating Maltesers
in Malta, and you thought they seemed a little chewy, so you bit one in two,
and realised you had been eating chocolate-coated maggots—it's hard to get
away from feeling like you are the fly, doing the best you can for your young
on a crowded ship

MICHAEL HALL

## Hospital Waiting

Like the perplexed
door
that slides out
and slowly judders
back in
each of us
has time
to think
The universe is small
You are forgotten
Eventually
you are met
behind uncertain
Perspex
with latex gloves
and quiet
efficient eyes—
the mouth
in the mask
making a tiny
tent
of your name.

CLAIRE LACEY

# chickadees

my mother used to say pick up your feet so you don't wear out your shoes
I hear her clucking every time my leg drags
neuromuscular backfire—a car, a gun refusing
forward motion, a glitch that yanks my knee, crimps
my hip sends a flare up my side: distress, distress
gimpy leg, I overhear the word retard
from the teen girls draped around the swingset
I keep my glance close, practised from my own teenhood
ignoring *butch* and *dyke*, but I stumble and startle
*ah* into the dirt
they flick over, fluttering
are you okay, do you need help
and they give gentle escort to bench,
should we call an ambulance, are you okay
no no I'm fine I'm fine thanks so much I'm sorry
what's wrong, are you sure
I have a brain injury, I hit my head
oh that *sucks*

when I start the shuffle home they remain perched
on the bench,
feeling their eyes
I look back and they wave, ready
to swoop in

# northern flicker

A woodpecker's tongue curls all the way around its brain, cushioning soft matter. It drills into bark seeking bugs, hammers into soil for ants, drums on drainpipes for the heck of it. I found a flicker dead on the ground once, claws curled, freckled body rigid beneath a window it had struck with its pretty little head. The concussion killed her.

What is the difference between sleep and unconsciousness? I awake in decorticate posture every morning, stiff and hurting, my neck and head in too much pain for movement.

The body does its best.

It takes patience, there is no choice but patience. I left the bird for scavengers.
Silent.
Unruffled.

REBECCA READER

# Beautiful Being

In Goddess pose, I'm embracing sweet souls everywhere when Salvador's brows appear over the fence. The fence is six foot high, and Salvador isn't. He's hanging on to a rhododendron. Each November the rhododendron drops scarlet flowers over my vegetable garden saying for Salvador what Salvador won't say for himself. His eyes locate my phone and speaker wedged in the alpine rockery.

'Could the yoga happen on mute?' he says.

'How would I know what to do if Todd didn't tell me?' I say.

'But it's always the same. "Feel Mama Earth beneath you. Embrace her. Embrace the opportunities she offers sweet souls everywhere."'

My thighs hurt. I rise out of Goddess.

'Don't you like embraces?' I say.

'Mr Downward Dog's? No. He makes love to Mama Earth so the whole goddamn town can hear.'

'What about my embraces, Salvie?' I drop into Puppy pose—my bottom is my best feature, and this is an opportunity.

There is a splintering sound as whatever Salvador is standing on gives way. I pause Todd and check on Salvador by climbing onto an upturned planter I keep by the fence for this reason. His shin is grazed.

'What about my embraces, Salvie?'

'Hold on to those.'

He drags the broken branch to his shed, walking backwards, unable to take his eyes off me.

What I love about yoga is that it fills each day with possibility. I didn't believe Todd at first. Todd kept saying, 'Feel every cell in your body wake up to life's potential. Sense new possibilities.' But when I looked around my life, all I saw was my jigsaw collection totalling half a million pieces and a backlog of Roy's Real Estate flyers I couldn't be bothered to deliver. I had no room for possibilities, so I burnt the jigsaws and the flyers right there in the back yard,

and a whole new psychic space opened up in a sooty circle on the concrete.

I turn Todd back on to ground myself. Todd closes his eyes, sticks his fingers in his ears and hums to massage himself at the cellular level. I watch him and stroke my lips, even if my own cells suffer for it. Todd films from his bedroom in Colorado. His window is a stained-glass rainbow, but if you pause the video and look closely, the rainbow is peeling off. A fern on his windowsill shivers whenever he does star jumps. I rewind those bits and watch them over and over.

Todd always says, 'If you fall over, don't beat yourself up. Laugh. Play.' So, whenever Vishnu's Couch makes me flip backwards and forwards like a worm skewered on a garden rake, I freeze Todd and throw gravel from my rockery over the fence, timing how long it takes for Salvador's patio doors to slide open. When Salvador finishes sweeping and goes inside, I throw another handful. If I fall out of Warrior Three, I freeze Todd and watch Salvador through the fence. He deadheads his lavender with nail scissors and doesn't even sniff the clippings. All those little moments of joy he denies himself. In Wide-Legged Forward Fold, Todd gets his face right down to the ground, possible only for Todd or a baby giraffe. Todd says, 'You don't have to look like me. Find your fullest expression.' I have found that my fullest expression almost always involves gravel and an underarm throw.

Today, my gravel clears the fence at a record-breaking height. Salvador shouts, 'Don't push it!' and I say, 'That's exactly what Todd says, Salvie. He says yoga is not about self-improvement. It's about self-discovery.'

'Then discover this,' says Salvador, and a sack of all the gravel he has swept up is slugged over the fence and onto my sweet corn. The sight of the crushed cobs brings on my lower back pain and I book an extra appointment with Kyle at Divine Spine Chiropractic. I've bought Kyle a yoga mat to thank him for brutalising my lumbar region. Kyle doesn't do yoga. He does kickboxing or 'aggressive dancing'. His words. But he's basically a yoga teacher with a sadistic streak. He says, 'Lay on your front. Forehead on the rest. Deep breath in. Now breathe out.' Then his fingers jam so hard into my vertebrae that my legs jerk upwards and, oh my goddess, namaste. Kyle has very long fingers. The pure sight of him makes me lift my ribcage and reverse years of slouching. Every time, he says, 'It's normal for clients to start spacing out visits,' and I say 'Kyle, I just don't trust my vertebrae.' Then

he presses the activator into my neck, and I imagine it's his tongue.

    Clearing Salvador's sack of gravel has aggravated my herniated disk. I should confront him about this but instead I turn on Todd, who has uploaded a new video. He's cross-legged on the mat as usual but—woah!—I clap my hands over my eyes then part my fingers. He's in his briefs. He says you can only truly sense healing air all around you when almost naked. The video has had 30,000 views in five hours. Todd has a great body, and the briefs are pink leopard print. He swings his legs round into Table-Top and says, 'Grab the new day ahead of you. But first, let something go.' His exhale tornadoes down the mic. I ditch my clothes. My quadratus lumborum reaches for the coy sun peeking over Salvador's satellite dish. A day has to want to be grabbed. It has to say, 'Here I am, take me,' like a nudist in Fallen Angel, like a nudist falling out of Fallen Angel. I pause Todd and press my eye to the fence. My first eye must be lying. I press my second to the fence. Salvador is in Chair pose, arms to the sky, weight in his heels. He rises, starts up his lawnmower, and eau de mow fills my being with wellness.

    Salvador isn't especially kind to Mama Earth because he puts his grass cuttings in his binbag rather than composting them. The reason I know this? Every Friday I wait until he drops his binbag on the verge and leaves for work. Then I take his bag to my garage and jam my rubbish down tight against his, reducing plastic waste and loving the planet. That's why I also know that Salvador takes statins for high cholesterol, cuts the labels out of his clothes, and wears seamless trunks until the elastic goes at the waist. He lives by paper To Do lists that he tears in four when the dos are dones. Knowledge, they say, is power, but lifting binbags full of knowledge has given me wrist-ache. A while back I searched up Todd's wrist-free yoga. The morning after I spied Salvador's glutes poised over his invisible chair, I lay my nakedness down, wrists lifeless on the mat. In Bridge pose my femininity kisses the candyfloss of cirrus clouds overhead. At Salvador's bedroom window the curtains twitch open then shut, as if a hearse just passed by.

    Salvador puts his bag out today and goes to work. Strangely, he returns an hour later while I'm in the garage with the door wide open gleaning knowledge from his garbage. He pulls into his drive. I grab a tin of paint, spanner and brush and wham the garage door down behind me. I lever the lid off the tin.

'Has your rubbish ever vanished?' says Salvador, striding over my crazy paving. A fault-line in my heart slips and I drop the lid paint-side down.

'Yes, every week.'

'Before collection?'

'Many things vanish from my life, Salvie, but my rubbish generally sticks around.'

'Where?'

'My amygdala, mostly.' I stir the paint. Gloopy bubbles rise to the surface and burst.

'Not in my binbag in your garage?' he says. His brows approach each other cautiously like centipedes with social anxiety. 'My bag, please. I have things to do.'

'And I've got a planet to save, Salvie. Imagine the To Do list for that.'

'You've read my To Dos?'

I dip my brush in the paint and press it onto the wood, fat mahogany drips dotting the crazy paving. 'Let go of rigidity, Salvie. The earth may be round, but life is angular. There are countless angles to explore.'

He holds the back of his head with both hands, becomes his own chiropractor, opens himself up to persuasion.

A week later, at Divine Spine, Kyle returns the yoga mat I left for him at reception, lowering it into my arms like it's a life-long obligation. Kyle can't see that all anyone ever needs is a mat and gravity's hug. We are loved. Who we want to be is exactly who we are, right here, right now.

I'm the sweet imbalance that brings good things. Through the fence, Salvador's limbs are so knotted in Standing Eagle that when gravity hugs him too soon, he bounces off his decking like a shy lover. I fetch Kyle's mat from my spare room and ease it over into Salvador's yard. Minutes later, a handful of lavender spatters my rockery like rain after a heatwave. 'At sunrise, beautiful beings, find your most dynamic pose and hold for five, four, three, two …'

DIANA BRIDGE

# Deep Colour

Somewhere down there in the aquarium, gleaming
like a bit of neon, the tiny floating scarf of a fin.
Deep colour, the words for it are out of range—
that much I can tell you. What I cannot say
is how a life gathers its themes.

The twist of colour twirls, it comes to me
like a lost strand in the plait of ancestry. Should I try
and pin it down or avoid it on account of what might
lie there? They would tell me not to know is loss.
Would they send me back to yesterday?

I have no attachment to that opaque throng,
only one or two of whom stand out from the murk
of the tank. The atrocities of the past lie there,
compacted to a single bed. Day after day
the past waits for the present to fall

into its hands. One truth will soon displace
another; I am left with this. A life gathers its themes,
some of which it may never weave. Deep colour
twirls in the tank, standing in for what I didn't ask.
Now she is gone and not to know is loss.

# A Split Sky

I stand to one side watching as shadow
fills the shallow basin of the lawn
taking the great trees with it

trees that were her backdrop
I would be content with outline   sharp
in the light   to speak of her now

requires precision    I call on splinters
of conversation   snippets
of scenes   re-open them to view

then piece them back into some new
assemblage   which works only to expose
fresh vacancies     images of separation

possess our landscape         a disc
bisects the evening blue
its pale curve heavy     the split sky

solid    the scene above      our heads
material in a way she cannot be
again      the joining and

the severing endlessly renew

CILLA MCQUEEN

# Accidental Layout

Miss X died in good health, not a mark on her. Waiting at the corner she didn't see the four-wheel-drive cut across the kerb, the driver laughing on the phone.

It sped away; Miss X performed a pirouette, shot through the air and collapsed on the florist's steps.

Joan was rearranging scented lilies when a woman hovered briefly at the window, seemingly ecstatic at the miracle of flight. The thud of a body on the front doorstep set the brass bell tinkling

KIRSTY GUNN

# All Gone

She put her hands in deep among the baby things to where the guns were. There, beneath the sleepsuits, the tiny cotton t-shirts and the laundered nappies fresh from the washing service, she could feel them: the smooth polished barrels of the Sig Sauers, the hook of the trigger on the P238 with its blunt snout and the round opening where the bullets would come out. Everything was in place—the position of the weapons, the box of ammunition beside them. It was a kind of relief, she said, to touch the various shapes, to be familiar with their contours and outlines, and afterwards she could breathe again. 'That was it, exactly,' she told me. 'Just by reminding myself they were there, I became so calm.'

No one else would know where she'd kept them. At the arrest, in all the papers ... Her secret never came out, that, tucked up among the clean muslins she would use to wipe Bobby down after he'd sicked up her milk and under piles of Laura's little pyjamas and miniature knickers and Tim's prep school shorts and socks and shirts, a pair of Micro Compacts were ... *nestled*. That was the word she used. The cold metal touch of them after the softness of all the baby stuff giving her such pleasure, she said. Pieces that, in their weight and size, embodied perfectly the melding of form and function. 'And it's strange, don't you think'—she cast her eyes around for a second as though looking for the answer to her question, then smiled, her brilliant lovely smile, and laughed—'that after all I've gone through, I would still find them now as I did then, attractive, interesting objects, and that using them was going to be—absolutely—something I wanted to do.'

I didn't know where to look, of course. But this story, report or whatever ... Well, it's not about me. It's about giving a clear picture, a portrait of the kind of person who would do what she did, who would take her thoughts that far.

'Did you ever think about sending them back?' I asked her at one point, after she'd said straight out that she'd made the purchase for a very definite purpose. 'Did you recognise that your thinking was dangerous? That it could

only finish with an ending of one kind?' I remember she put her head down as though praying, and for a moment I believed I was going to see evidence of some kind of regret, that she would become the fully comprehensible version of the woman she'd always been—responsible, trustworthy, a loyal friend and good neighbour, the attractive wife and mother who had moved to our street when she was pregnant with her third child, as open-hearted and generous as the next person.

But no. She looked at me and yawned, tucked a strand of blond hair behind her ear. 'It was great,' she simply said. 'I knew when I put the order in to the guy who had the friend with access to the website that those particular items were going to be my "get out of jail free" card.' She laughed. 'The whole thing,' she emphasised, 'my decision, what I did … one great, exceptional feeling of escaping for good a situation I found myself in and wanted no more part of—believe me, it's all fine.'

The 'guy who had the friend with access to the website' is no one they have been able to trace so far. I've read about these kinds of people, of course, the dark web and all that. I've seen the articles and books that show how it's big business, how everyone is up to something or other; people talk about it now. That you can buy anything online with little in the way of questions asked. And so in this instance: she'd met someone, she said, through a pornography site she used, which she had learned of from one of the mothers in the Thursday morning coffee group for toddlers and babies that she went along to when Tim was at school and Laura in the nursery next door where this whole story, you might say, finds its focus. 'Cause and effect', as she liked to put it. One thing leading to another, and a complex aftermath gathered up by a first thought that had preceded all others and which rested in turn upon a certain kind of life with its rules and order and expectations that, on the whole, had always been met. Nothing more dramatic than that, see? She was always reminding me. 'Nothing.'

Certainly, the transaction itself couldn't have been more straightforward. She'd simply withdrawn cash in various increments from her own account and deposited it into another she'd been given details of in an anonymous email—quite a bit of the 'slush fund', as she called it, for the week's shopping, which her husband gave her every Monday. 'Well, a massive amount, actually,' she confided. Such a sum was to cover all her domestic

needs, and this was 'one of those needs,' she said. It was that kind of marriage. Charles was generous, she added, and the amount had only increased as did his time spent away from her, accelerating from the occasional late night at work, to most nights, to the odd weekend as well, along with 'business trips' and 'vacations with US clients' … She hated all that, but the women she counted as friends said the same about their marriages, she told me. It was just the fact of a certain kind of lifestyle, choices made. 'You make your bed; you lie in it. Ha ha,' they agreed. 'It doesn't need to be a big deal.' And so, perhaps, it didn't. Or she had learned how to stop allowing it to be—with the deep breathing she was learning in her one-to-one chakra realignment sessions really helping, along with treating herself to something special from Bond Street or Harvey Nicks when she needed to. For there were lots of things she 'needed'. A lot of women are like that, I know. And so, in turn, the money went out of her account without her husband even noticing, in the way that none of those husbands of her friends might notice what was being spent and how, into some sort of holding reserve, some financial service somewhere. Then that payment, too, must have gone through because the package duly arrived on a cold March morning—a special delivery company she didn't recognise—and heavy it was to take from the young man who handed it to her, looking her in the eye. 'You got that?' he asked, when she'd placed it on the hall table and had her pen poised above the form he'd clipped to a board for her to sign. He tapped her on the knuckle three times with his long index finger. 'You gotta sign, sweetheart,' pointing to the blank space for her signature, 'here.' And before she'd whisked the box up to the linen cupboard to hide it away there, she did. She signed.

By then the reaction she'd discovered in herself following the incident with the little Pakistani girl at Laura's nursery had become a marked thing. For yes, she said, that was certainly the catalyst for everything else that followed; where this story, as I wrote before, 'finds its focus'. Because although weeks had passed since that day, she kept finding the smell of the other child, the family, on Laura's hands. In the bath at night she'd scrub her daughter all over, her hands especially, using a brush on her knuckles and fingers and under her nails, rubbing at her upturned palms with Laura peering into

them—'All gone, Mummy?'—until the child began to cry, 'No more dirty!', trying to get out of the water, slippery like a fish and no one could have caught her. It seemed as if something in her daughter, too, had changed, she told me. That awful expression, 'No more dirty'—and realising how Laura continued to be in touch with the girl in the hours they spent at the nursery together. It made her shudder. Thank goodness, she told herself, the baby and Tim hadn't become similarly infected. Bobby was with her most of the time, he was still at that age, so she knew he was alright; and Tim's class was full of nice, proper British children ... But it was indeed starting to feel like a 'disease'—her word—since she had realised, back in the autumn, that there were foreigners moving into their special part of the neighbourhood, coming into the nursery next door to Oak Street Preparatory 'if you please', as the mothers had taken to saying, as if those people expected their children to begin their education along with their own sons and daughters whose names had been on the waiting list since birth. It was shocking, they all agreed. The way there were so many of them, suddenly, with their strong-smelling foods and chattery languages none of the 'home mums', as they started calling themselves, would ever understand. 'I'm beginning to feel as though I'm the one who's the outsider,' Caroline Williamson had said just before Christmas at the drop-off by the front gate. 'After all, I'm the person paying to be here, and speaking the language others don't.' She'd laughed at that, she said, and she laughed again, loudly and for a long time, when she told me—though, as it turned out, none of it was funny.

The fact is, the people were there. They'd moved in and were growing in numbers, all come through a charity that had been set up in association with their own nursery, she'd found out, which was educating them—'for free, with our money' as Sam Crighton Smith put it—along with providing housing in the big block of flats down by the children's park. 'How does that work, eh?' Sam had asked, point blank, shortly after a group of home mums had been to see the head of the nursery, lovely Mrs Alexander, who they might have thought would be on their side. For how could non-English speakers come in and take up places that were supposed to be reserved? That was not what they were paying private school fees for, was it? 'I mean, you go private to be ... well, private,' was the way she put it—because none of the mothers could believe that this was happening here, in their part of Clapham, the

really good part, where one expected to be protected from … 'all that'. But Mrs Alexander had just talked to them about understanding and patience and the need to open one's doors with generosity and grace, and a month later more of the foreigners had arrived, and by January there were seven families in all—from Syria, Afghanistan … Wherever there'd been some war or revolution those people were always having, only now here they were in Clapham—and God knows how many children between them. Seven families! 'That's about seven times seven!' the cry went up at the book group. And half the women pregnant again, you could make it out under their robes or whatever it was they wore as they stood in the street with their prams and buggies taking up so much space it could be difficult to park your car. 'Actually, would you mind,' said Lara Veale, after they'd finished the last international bestseller set in Calcutta by a Commonwealth prize-winning author, 'if we just read some nice ordinary English novel next week? I kind of feel up to here with multiculturalism.'

I remember how she put her head back when she told me that and laughed another of her strange loud laughs, her mouth wide open. I felt my heart skip a beat. 'Look at me,' she said afterwards, when she'd regained her composure. 'I should be ashamed of myself … Except—you know what?' She looked down at her beautiful hands, one laid on top of the other in a way that was posed, considered: 'I don't care one bit.'

This was on one of my early visits. I'd been trying to press her further on those friends of hers, her close neighbours with their book groups and cinema outings to *Fifty Shades of Grey* and the coffee mornings and yoga sessions designed to get back their pre-baby tummies. I wanted to know whether the sense of unease that was building—I meant generally, among the mothers in the street and surrounding area—gave a sort of … context, I suppose, for the strength of her own reactions. Those 'What has the country come to?' kind of remarks that had started a while back, when she realised she was by no means the only one in our street to have voted Leave, gaining traction with the recent developments? But no. She always returned to the same version of her narrative; that it was all her decision. Her plan. That she'd known for some time that something about her nature meant she needed, absolutely had to have, a specific sort of order to her days; to be in control, with everything in its place. That it really was only her idea, and that

it was most definitely the foreign child, and the smell of her, an odour she couldn't bear, now transferred to her own daughter, that was the 'trigger', as she put it, and made a little gesture with her two fingers, pointing them together at me as she mouthed the word 'ka-pow!'

That was it, as I record it: This woman. This neighbour. This friend. A simple case of 'cause and effect'—as she herself would put it—that eventually, unbelievably, played out on that late spring morning in April, which in turn had been set off earlier in the year when she picked up Laura at lunchtime as usual and Laura asked if she might go home with Tami, the little girl she was holding hands with, to Pakistan for a playdate. 'Pakistan!' She couldn't believe what she was hearing. That her daughter even knew such a place existed, let alone wanted to spend time with a child who might have come from there. 'You can't go to Pakistan for a playdate,' she'd said. 'Don't be silly.' But Laura had held onto the child's hand, saying, 'Please! I want to go to Tami's! I want to!'—and yes, she told me, it was then, precisely, that she recognised how a kind of judgement she'd always held but that no doubt had been made worse by the changes taking place in the neighbourhood had collected around that moment, with her own daughter holding the filthy hand of some little scrap of a girl and not letting go, the mother standing there beside them in a greasy-looking black robe and the gold in her nose and all the rest of it, nodding and grinning, 'Okay? Okay?' like some kind of performing monkey. Her having to deal with that, she said, and having to say to Laura, 'Not today, sweetie,' and then again, louder, because Laura wasn't listening, the two little girls swinging their hands together and talking their heads off and laughing. 'God'—she shook her head when she first told me this part of the story, when she spoke about it for the first time. 'I relive it'— the feeling of all the pieces that she had put carefully in place in her life being smashed out of order, something happening that, to her mind, never, ever should have. It had taken 'ages', apparently, to get Laura to let go of the other girl and come with her, by which time there'd been tears and a massive row in front of everyone. She'd found herself short of breath as they got down the street, trying to put the situation behind her, because she'd had a sensation, 'just here,' she told me, touching her solar plexus, 'when Laura asked, you know, if she could go to this child's house, with the mother standing by and

'… There was this smell. Coming off the pair of them. Passed from the other girl straight onto Laura. I can't describe it. But I can tell you it made me feel sick.'

As I say, that was sometime around the middle of January, when she first registered the shift in herself as something physical, thoughts lying low but already sensible to her by then, insistent. There'd been her catch of breath, a lack of air, the tension in the upper part of her torso with the feeling of her daughter being drawn away from her, as though she was pulling away from her own mother. And never getting the smell off her afterwards was how it seemed, no matter how much she tried, scrubbing and scrubbing to try and get her clean, the way the child reacted to her when she came near at bath times, 'No, no, mummy, please!' backing away, 'No more dirty!' like a little animal.

And all this was well before she'd even thought of taking the next step, figuring out that she was going to need two guns and so on, that there'd be no time to reload and how the guns would have to be small. I've been clear about that in my notes. 'You see, I realised I couldn't stop my daughter playing with the Pakistani girl,' was how she put it. Laura continued to talk about her when she came home after nursery, 'Tami this, Tami that.' And though she no longer saw them together—such was the sure effect of her threat of punishment if she did—she knew the friendship was there, embedded. Out of sight, maybe, within the nursery grounds and walls, but alive and growing—and not only between Laura and the other, who had both started it, she knew, her own daughter the first to let it in, but festering by now among all the children, multiplying and getting stronger while they were playing together, sharing food and toys and glasses of juice …

These were the sort of ideas, you understand, that were present in her mind and ran amok there. I'm simply reporting them, the circumstances surrounding this one woman who we all liked and got on with, who had lovely manners and was beautifully turned out and so on—and thoughtful, always helping out with bits of shopping or taking someone else's child for the morning while the mother was busy … To put in all the details as though to come closer to the facts surrounding the most awful facts. For though by now the whole story is 'dead', as journalists would say, and because she has

no one else coming to see her I have been allowed to meet with her, once a month in prison visiting hours, just to talk. It's something someone at our church first recommended, then our vicar got on board. 'Go in there,' John said to me when I was discussing the matter with him after one of the morning services—this, days after the thing had happened and everyone was in shock, the church open all night with prayer vigils and so on. 'You were someone who knew her,' he said. 'She needs to know that despite it, despite everything, the Church is open to her. That we, her congregation, despite the magnitude of her crime, still love her, can forgive.'

Not everyone can, though. Not her husband. He was the first to move away, his mother having taken the other children to Hampshire, I heard. Not Pam Lawrence or Susan MacLeod or Jennifer Morris or the Caxton Taylors or the Williamsons or any of the other families we know who were affected. Not a lot of people could consider it, even, or come close to understanding her by having any kind of sequence of events laid down on paper, the background to the fateful day, the outburst itself that left two children dead and seven injured, Catriona Morris without an eye, the little Williamson boy still in hospital and no one knowing if he'll ever come out. Though John was right, it is something we need to find out about, the whys and wherefores. And so yes, I might not have been in the group she was close to—those women with their at-home Pilates lessons and pedicures and all the rest of it, their online porn and shopping sites and the husbands with big financial and legal jobs in the City—still, she and I had started chatting at St Cuthbert's when we used to teach Sunday School together and I need to remind people somehow that, you know, everyone around here always thought she was lovely.

And it was never Catriona Morris and the others that she meant to hurt—you might have guessed as much, of course. It was something, rather, that she only wanted to 'nip in the bud' for herself, she said, to do with the particular odour that was spreading and infecting—all these phrases of hers—as a result of circumstances that should never have been present at a three-and-a-half-thousand-pounds-a-term nursery in the first place. For anyone could see where it would all lead, she told me. The next thing, the same charity helping these same people get into the classrooms next door. Taking up the teaching allocation with special lessons for them to learn English—and then what would happen when it came time for the 11-plus for

the British children, what then? And after that? With secondary schools and university? Oxford and Cambridge and all the rest of it? When it came to jobs and careers and security? What then? What then? Anything could happen, anything … was where her own thinking was headed, she told me. And truthfully? It had been taking her there for a very, very long time, with nobody around to talk to about it, not really, and Charles never there to listen or discuss anything … only away, or working every hour God gives at Merrill Lynch along with all the other husbands in the street, working twice as hard as they should have to because of Austerity and China and the Asians coming in and getting the top finance jobs, and a lot of companies relocating back to the States or Europe after the no-deal mess London was in … And it had been compounding and amassing, her way of thinking, building up for months beforehand, for months and months, years even … Until there appeared before her, out of the chaos, the little girl who wouldn't let go of Laura's hand and Laura herself—this the worst part of all, she said—not wanting to let go.

So alright, that's where we've got to, as I told John. Putting together so-called unrelated events, as they described it in the papers, and trying to make sense of how those seemingly disparate factors might pile up and end with the story of a woman who opened fire at her daughter's nursery while the children were outside on an Easter egg hunt in the garden, the two young women who were looking after them that day calling out 'warm!' and 'warmer!' as the children roamed around the flower beds and beneath the trunks of trees, looking for the foil-wrapped chocolates that had been placed there. 'Hot!' they may have shouted, as the first gunshot rang out. 'Scalding!' before they realised what had happened.

Because 'unrelated'—no. Nothing is without consequences or goes forward without the drive that lies behind. All of us know that. 'I just wanted to be able to breathe again' was how she put it, how she described being in that linen cupboard of hers—the kind you see replicated all over those big double-fronted houses in South West London; 'leafy environs' is the wording on the estate agents' glossy brochures. A beautiful walk-in linen cupboard, as she has told me many, many times, so generously proportioned there was even room in there for a little stool that her mother had embroidered the cushion for when Tim was born, in cross stitch, with a flower border and *Where do we live but in the days?* worked in a panel in the centre. During some of

her own days, she told me—this long before any of it, before the purchase of the guns, before the families came, before Bobby was born, even—she would go into the cupboard to sit on that little stool and close the door and stay there, quietly, on her own, for some time in the dark. Just to have a sense, she said, of everything being gathered up, and clean and orderly in the same way that the laundry service would deliver clean nappies on a Monday and the neat stacks of all her children's clothing would be there on the third shelf, piled up every week in tidy rows, every week the same … Was that such a big ask? To want everything to be as she'd planned it? A whole life arranged according to the values she'd always believed in, with nothing to expect but what she'd asked for, and all traces of unpleasantness gone? She looked at me when she said that and smiled, but a sad smile this time, there was no laughter in it. 'Remember,' she said, and this right from the outset when the whole project of assembling this story first began, with John and the church arranging my prison visits, my getting to know her more and more as she talked about everything that had gone on in that low voice of hers that is modulated and well educated, reasonable and low: 'I shot my own daughter first.'

CINDY BOTHA

# Blue Moon

Once, in my indigo room, you said poets choose to misconstrue moon
and stars. You'd know: your domain's the dark, your whore the voodoo moon.

Between us anticipation trembles like some wild thing in the grass—
your breath on my wrist, my hair a sigh, and the sheets a pale billow, moon-

struck and cool. But, like the birds, you hold sky behind your eyes. And like them
you take flight, rising out of our shadow. I'm left to foolish mooning

as café lights pick you from the night like a plum. I can taste your skin,
its bloom still on my lips when you leave. Your path lit by that two-faced moon.

The shape of your going feels dangerous: at first light, I fill it in
edge to edge. By midnight it's bristling with blades, whetted as the new moon.

I paint you from memory, and my wall carries your image like a scar.
Leaning into it, I feel your heat. I miss my name in your mouth. I mourn.

# Vigil

They've twisted flowers into my mother's hands.
The clamorous gerberas and yellow lilies
would be better outside, beckoning bees with their syrup,
than folded in this cold grip.
Will it be easier to breathe if I open a window

but what about flies, this mild autumn afternoon?
Past their season perhaps.
My mother's nightie is a skin shrouding the poke of ribs,
her jutting shoulder bones.
Over her whittled scalp, the hair's combed back

and because her face is unbearable
I stare at those bright blooms
until they blur to an extension of her own yellowing skin.
I try to summon a butterfly lured by sweetness
but the chill from her flesh is pervasive,

the utter stillness unsettling.
This room harboured no living thing
until I drew a chair to her bed.
I could sit here for hours and quite possibly have.
I'm not even sure if the clock's still going.

HARRY RICKETTS

From The Stella Poems

## Stella Alone

She sits, barricaded by books:
on the right, *The Waste Land*;
on the left, *Svendborger Gedichte*;

in front of her, *Orlando*, *Lotte in Weimar*,
*Conundrum*—none of them any help.
She nurses the same discontents,

keeps them warm on a low flame.
The sun is not her friend;
it flashes through the skylight,

catches the glaze of the blue and white
mug from Siena, her father's broad-bladed knife,
the notebook in which she has written in pencil:

*Jetzt musst du die Grammatik des Grämens lernen.*
She crosses it out, writes: *Now you must learn
the grammar of grief, the exact syntax*

*of suffering.* Love has done a bunk,
is hanging out with the weka on Kāpiti,
that island all edges, a piece looking for a puzzle.

## Die Grosse Schlägerei

Opinions vary as to who started it.
The short entry on Stella in Te Ara

by Jacob Schwül lays the blame squarely on her,
claiming she accused Lisa of having sex

with their neighbour and chased her round the kitchen
table, waving her father's broad-bladed knife.

All accounts agree on the chase round the table,
the knife. But others claim Lisa called Stella's

father 'a dirty Nazi spy' who deserved
his years on Somes Island. Whatever the truth,

there was a hullabaloo, and the neighbour
had to intervene. Lisa left that evening

with a black eye. Afterwards she worked for DOC,
lived on Kāpiti. There was no rapprochement.

# Eketāhuna Baby

Stella sits, listening to the cicadas
of time silently click-clacking away.
Maia has asked her to write lyrics

for a track on the second Sheilas album.
It's to be called 'Eketāhuna Baby';
they've got the title, bit of a riff.

Stella goes on listening to the cicadas.
She looks up the name Eketāhuna
in one of her father's old guide-books.

In a rush she has a couplet for the chorus:
*Once we fitted together like a hand
in a glove / but now we've run aground*

*on the sandbank of love. / Eketāhuna,
baby, it's Eketāhuna, baby,
it's just Eketāhuna, baby.*

She tries to come up with more words, but she's stuck.
She sends the lines to Maia. The long track
begins and ends with them. In between

it sounds quite a lot like Iron Butterfly's
'In-A-Gadda-Da-Vida', though the drum
solo in the middle is way longer.

ISABEL HAARHAUS

# Lucky

When I met Hermione Williams, her parents were in the former Soviet Union adopting two girls. We were new friends and working hard to impress each other, listening to PJ Harvey, drinking red wine at Verona. I was cynical, even though of course I'd seen the footage too.

'That sounds like a dumb idea,' I said.

'Mummy just wants to give back.' She really said that—'Mummy,' I mean. She was a private-school girl, the most expensive sort, and was newly emerging into the world.

I was invited over to meet the adopted orphans at the family's Victorian villa. The dog bounded around the large garden where flowers and vegetables grew smugly alongside brick pathways. They had chickens and catering-level food. Hermione's parents, Susy and George, were very good hosts and modelled themselves on the Merchant Ivory films they devoured; and now added to the scene were the two pretty Russians. And apart from the terrible burns on one, they *were* pretty: Elena (the younger one) and Natasha. Sisters. Supposedly.

During the year that followed we heard on and off how tricky it all was. Not as easy as simply adopting and absorbing these godforsaken children, so lucky—so lucky!—to be here, so lucky to be taken in by these kind people who just want to give back. But they weren't grateful, not at all. They were resentful, hostile, violent even. Their little 'Please take me' notes had turned to 'I want to go home' and lately, 'I hate you.'

Their new mother needed a break, and I was invited to look after the girls while the rest of the family went on holiday.

'You'll enjoy it,' Hermione assured me. 'You're very lucky, it's a beautiful house.' Sure, the Williams' house was bigger than my small flat, but it was also a little dirty and dark in that old villa sort of way. Those sticky corners and that mean Victorian plan—two rows of shut rectangular rooms coming off a long dark spine and no way for the light to seep through.

Being moneyed foodies in the 1990s, the Williamses had opened up their kitchen and decorated it with brightly striped soft furnishings and cheerful pictures in the French country style. Not everything about it was cheerful, however. Moments after I arrived Susy rushed out to the street where the taxi was waiting. (Really: *rushed* is the verb—as if escaping something.) She clearly couldn't stand to be in that yellow kitchen a moment longer.

'She really needs a holiday,' George said, as if confiding or by way of explanation, his eyes darting, his moustache damp. 'She hasn't had a break.' And why should she linger? What else was there to say or do? She'd given me an envelope of money and a little well-thumbed book listing the names and phone numbers of everyone I could possibly need: the cleaner, the taxi company, neighbours, a cousin, the school deans, the doctor, the dentist, the ballet school, the speech therapist, the psychotherapist and more. (But where were Susy and George's numbers, their itinerary? I wondered, later, after the car had pulled away.)

So, there I found myself, left to it in a big house in Epsom with a dog and two cats and the chickens. Plus the two little girls, of course: nine and eleven now and already fluent in English. Not 'retarded' or 'unsalvageable' at all.

First up they told me they weren't sisters, that it had all been a ruse to get the parents to take them both. The Williamses only wanted one child—but which one? Each girl accused the other of being the appendage.

Then came the stories to explain how Elena was burned. Her father had poured petrol on her and her mother had set her alight. Her father had tried to burn the house down with her mother in it and forgot, or didn't care, that his daughter was in it too. Elena had set herself on fire in the orphanage. Another child in the orphanage had set Elena on fire. Every tale was about somebody setting someone on fire. The word *accident* wasn't in their lexicon. They told each story with greed, scanning my face for evidence of horror, the details more gratuitously fleshed out each time they repeated them. I worked hard to arrange my face as if I were used to this kind of thing, as if they spoke of childish things, children doing childish things, nothing with murderous intent.

Natasha had her turn too. She had watched her father kill her mother with his bare hands. She had passed her mother the gun with which she shot herself in the head. She had seen her father swinging in a tree.

And all this over breakfast.

'We're not even sisters,' they kept telling me, giggling conspiratorially, watching my face for fault lines, gunning for me to crack. 'We actually hate each other!'

They certainly didn't share the sorts of physical characteristics you would expect between siblings. Elena was petite and flighty, the energy coursing through her, pinging off her, whereas Natasha was solid and strong, her feet firmly on the ground. They were both pretty in their own way and they knew it. George knew it too, and they knew that he knew, and all that had started to become a problem—that much I'd gleaned just in the quick handover before Susy ran out the door (literally, *ran* out the door).

'She really needs a holiday.'

I wasn't having much of one. I'd been dipping into the books about PTSD and attachment disorder Susy had stacked up beside the bed, which didn't inspire me with confidence about my situation, so at nights I drank the Williams' wine, wandered aimlessly around the place and started going through their stuff. There were a lot of beautiful clothes to try on: woven woollen coats with Susy's long golden hairs curled on the collars, silk dresses, lace underwear. There were expensive toiletries to try, school reports and prizes to scoff at, expired passports, bills, cuttings of articles about the family's successful shoe business, the hand-wringing adoption papers, more cuttings about the waves of former Soviet Bloc children arriving in Auckland, and family letters and photographs to rifle through.

But it was the photo album of the adoption that I found most compelling, and I kept going back to it. First, the grim grey orphanage with all the little white faces staring up at the beaming Western saviours. Then the cramped meeting with babushkas sitting at tables covered in colourful doylies and orange cordial in paper cups, the girls in matching hair ribbons, the boys in matching shorts and braces. And then, magically, pictures of the two beaming girls in pleated dresses with a whole new family in Fiji arranged on bright sand under a palm tree. The transformation was miraculous and disturbing in equal parts, and I couldn't stop looking at it over and over in my drunken haze, like someone stupidly pressing a bruise. The story of their arrival was a weird Dadaist collage of bits torn from historical textbooks, catalogues for bright dresses and windbreakers, scraps of tinsel and rusty cage wire.

Some nights I would look up to find one of the girls watching me on the floor as I frowned and exhaled into some drawer or box. They would come in on a rehearsed banal pretence—hunger, nightmare, a sore stomach—and weirdly ignore the fact that I was snooping to quickly cut to the chase: to score a point over the other. They lived in a state of fierce competition.

'She wasn't really chosen as the principal dancer.'

'She helped her father strangle that mother.'

'She was the one who lit the match.'

I would be crouched there, a bit out of it, my hand in some private place, the only adult in the house, rousing myself to look in charge, trying to feel in charge, hoping the child would just back away and pad down the long hall in her freshly laundered pyjamas and go to sleep and dream a nice dream—a nice kid's dream, not one swarming with rocking huddles of black-eyed ghouls and filthy ties on iron cots.

And then the next day we'd try again at breakfast.

They liked to toss me the grim stories at the threshold, at moments of transition: the cleaner arriving, or as they left for school, for example. Then they'd hit me with a pearler. Nice and vivid.

The weeks wore on. I missed my boyfriend, who was under strict instruction not to stay. I wasn't allowed anyone over. According to the experts, the girls struggled to relate appropriately in personal situations (clearly), and the more that was expected of them, the more strain they were placed under. Instead of social relationships, then, their lives were a baroque calendar of appointments: burn doctor, ballet, speech therapy, reading recovery, art as therapy, piano lessons, gymnastics, cognitive behavioural therapy. They didn't seem very interested in any of it, other than the ballet and the boys (boys!) at gymnastics, who wanted to fuck them apparently. No, really, they did! (What would I know?)

The girls never asked about Susy and George and, on the rare occasions when Susy or George called, they in turn never asked about the girls. Instead, they asked for updates on the minutiae of household administration: the exact figure of the power bill, the specific chores completed by the cleaner, the name of the driver taking the girls to school. They asked about the animals and what and how often I was feeding them. Initially I found it weird, but gradually I realised that their laboured ledgers of accounts and seed for

the chooks, the wet and dry for the predators, were fussy decoys to avoid thinking about the girls.

Their other great omission was money. What they had left me for the month was nowhere near enough. They had left a wad of cash, but when I unfolded it I counted only $400. One hundred dollars a week for the three of us wasn't going to cut it, and at first I felt resentful. I didn't even know where Susy and George Williams were, but you can bet it was somewhere fancy. These people didn't slum it. They liked the European cities and the provincial countryside.

I started to ration our food and make flatting meals: lentil surprise, nachos, spaghetti bolognaise. The girls liked it. And they didn't seem to mind or even notice that I was a bit drunk at night, maybe even liked that too. About a week or so into our time together we made up some games we all enjoyed, played really loud music—Nirvana and Pixies were still big then and they liked Kris Kross—and danced our heads off in the garden.

We also liked to paint late at night. One of us would say, 'Get the paper out?' and that meant layering the lawn with butcher's paper and letting rip with fence-painting brushes. We liked the Jackson Pollock style of marauding around the paper, dripping and spraying our paint like dogs leaving their marks. Sometimes we dragged great globules of thick colour around with our bare feet, even rolled around in it a little if we were really going for it, or one of us might get figurative and make a great creature, crouching, running, reaching, and the others would have to guess what it was, like picking the patterns in clouds. We threw the conservatory doors wide open and turned the speakers so the music crashed through the garden. I'd turn on all the lights so the house was a blazing lantern. The old stone wall crouched around us and the great chestnut tree threw animated patterns on our paper as we painted, wildly, physically, slamming into each other, fighting for space and brushes. When we were finished, one of us would gather up the paper and squash it into the compost.

Towards the end of my four-week tenure I was getting used to it and no longer cared whether Susy and George called. The money ran out and I started spending my own. I had begun to feel quite comfortable with these two children. I still didn't really make eye contact with them as much as compete to hold a gaze and trap a darting expression. And conversations

never moved on much from the game of me feigning nonchalance while they told me something really terrible. The challenge was not to flinch, no matter how shocking.

I let go of the admin well before the end. It was all the most ridiculously inconsequential drivel anyway—who cares about appointment times when you've passed your own mother a loaded gun, felt your father's cold feet dangle over your crown, smelt your own skin burning?

But Natasha's alleged 'confession' about what happened to Elena was hard to hear—'Now I'm going to tell you the truth, Ruth' (the rhyming refrain brought mirth to her eyes).

'One night when everyone had gone to sleep and the old women had done their rounds and locked all the doors, I took the petrol can I had stolen from the washhouse and poured it all over Elena and lit the match. Then I watched her burn. The only reason she didn't die is that Izidor, who slept next to us and loved her, threw himself on top of her. He died instead, and for that I will never forgive her. I loved him more.'

She told me this one morning over cornflakes. Elena sitting right there. One of the cats sat on the table, the dog sniffed around.

And that was that.

I fell out with Hermione a few years later in Berlin—that's another story—but when Natasha died, I went back to the house. She was only 21 and had three children. Her little firm body, a wax doll, lay in the open coffin in the sitting room that opened onto the garden where we had danced to Pixies blaring 'Where Is My Mind?' Her toddlers crawled around her while the older boy held court at her head, patting Elena's chest and saying, 'Pretty mummy, look how pretty she is' to the little ones and any listening adults. That day the sun flooded in to bathe the Russian girl. But even inside the warm halo she looked cold—freezing deepest darkest Russian cold.

RUTH RUSS

# Fish Poster

To the delight of Kiwi viewers of that UK show (contestants bring their own prizes) Rose Matafeo brought a fish poster. Everyone who has leaned against a greasy wall waiting on the deep fryer knows the fish poster. Impatient kids study the fish and argue with their siblings over which is the ugliest or scariest. You'll find the poster hanging in a bach by the beach or down the sounds, where the rooms are too small and the bunks piled high. It has that holiday perfume: a mixture of not being here enough and a dash of Grandma's old blankets and couch covers. You don't need anything fancy here. You don't need a flash new ice-making fridge; just chuck some fizzy in a Tupperware cup with a spoon and pop it in the freezer. You don't need cell phone reception. Just go to the loo, stare at the fish poster for a few moments, then head out for a wander along the narrow quiet roads. Find an old rope swing hanging by one of the tracks. Find the edge of the inlet that curves around and just keeps going and going.

## They Say Children Don't Come with Instructions

but dead ones do
a big list of them on A4 paper
a copy of a copy of a copy
typed in a font that was popular 20 years ago
telling me that the container I've brought home
should be buried within 48 hours
or, alternatively
should be put in the freezer
until a suitable time is found
the instructions make sure to warn me
the contents of the container
are the products of conception
they don't resemble a baby
because after all
it was measured in millimetres
and yet
for something so small
it could have had a heartbeat

ELIZABETH SMITHER

# The Sick Dog

*Pyometra:* the uterus fills up
with pus. It's fast and can be fatal
you tell me on the telephone
12,000 miles away from Jess
your faithful Border Collie

home again, wearing a lampshade
starting to eat a mouthful. 'Dogs,'
I say, 'can't be forced to eat.' Where
did that dry biscuit come from?
I only knew your earlier Tess

bounding beside me down your driveway
trained to round up the Suffolk sheep
she worshipped by sticking her head
under the fence wire. Running
wide as Bach to your whistle

music and dog and sheep on a green field
dog in a lampshade gingerly walking
given an injection not pills to heal her
since she won't swallow an antibiotic
teeth clamped as though she's grinning.

RICHARD REEVE

# Voices, Roses

After years under the hedge plum, the knotted spine of a rose,
planted before my time, before the hedge plum took over,
peers into the sunlight, wobbly like a foal just born.

Couldn't stand up, yet we kept it, clearing away all manner
of other items, buried shopping bags, cleaver, garden pots,
the rose supported by a stay of rope from the fence

where weeds ruled before Wiremu cut the plum down.
And now it blooms, its petals brilliant Westland sunsets,
red then pink-orange then yellow, fading into night.

I am filled with sad joy for the flower and failure of life.
What is this rose but a pathway into the heart of the labyrinth?
Layer folded on layer, flamboyant yet obscure,

it resists interpretation, another simple fact of the now,
its thorns indiscriminately reaching out for victims,
nodding to the sky like a prisoner freed after thirty years.

Memory, the startling pain of 'having a look around',
seeing that it will all pass, however sacred or prized
the item or person, this is the gravity of the rose,

the potency of its scent, its sweetness the heartbreak
of consuming, total loss that is everywhere about us,
in the news and in the garden, standardly ignored.

I breathe in a flower's fragrance. Hear voices I do not hear.
Meditate the gradual decomposition of my cat's body
into featureless earth, as though she never happened.

FRANKIE McMILLAN

# Break

There were wild horses in the Kaimanawa ranges—if only Billy and me could catch one, throw a rope around a front leg, force the horse to lie down—we'd stand over it, so that horse got used to someone higher than itself, got used to a boy stepping over its back as it lay all shuddery and steaming on the ground and that boy would be me I want to say here, because I was the fastest, I'd have my legs over the horse before the horse knew it and all the time we'd be saying *friends, friends, horse, we are all friends here*, our hands steady and sure, and if the horse cocked its ear, the ear closest to us, we'd know the horse was listening, but if the horse's ears were both cocked away from us we'd know that horse was stewing, *how the fuck am I going to kick these fellas away* and just then Billy grabs my ear and we roll over and over in the tussock, me kicking and bucking and Billy trying to force my face in the dirt, so he can ride me, ride over the great plains down to the sea, but it's too hot for that, so I lie there, I tell Billy my knees haven't finished closing, I'd be a dud horse if I got ridden too young and Billy says true, as if *he* knows all about breaking horses and then our minds turn to rope again, like *I bet we find rope down at the wharf* and it all seems easy but then dark clouds come rolling in, it starts raining so we jump up, say we'll look for rope later but we never get far with the plan, once we're home, drying out on the couch, we're like those big ships you see, crippled by bad weather.

# My Mother Who Flew Under the Radar

My mother was not the sort of woman who liked funerals or men in suits or uniforms telling her what she could or couldn't do, and if they knocked on the door with their clipboards, their documents or census forms she was not the sort of woman to comply, she was outside of things she said, she was flying under the radar, she was not the sort to be pigeonholed but rather kept pigeons, great mangy flocks of them that swooped over the neighbouring houses, dropping poop over driveways—fresh washing on the line, white sheets ruined—and *never* she said, *never* let the dead lie alone in those first three days but sit with them, play the accordion, and if you were to ask what sort of woman plays the accordion to the dead she'd say she was that sort of woman, the sort of woman that hauled her dying mother over the snow in a sledge to Moldova, the sort of woman who stood on a ward chair so the soldier lying in bed could get a better view of her legs, the sort of woman who felled a tree at the age of seven, the sort of woman who opened her house to the refugees, who fell in love with Julius who spoke no English but who offered her pieces of cheese, but she was not the sort of woman to be fooled by cheese, she was the sort of woman who was feral, who flew under the radar, who was undocumented, who, in the end, had her children bury her using spades and shovels while pigeons squawked overhead and the sexton sat idle on his digger.

LYNDSEY KNIGHT

# murray aynsley hill

i'm climbing the wide stone steps
up and up to the old orphanage
trying to   but losing   count

i'm peeping through the fence at them
they're running and laughing
with no mothers    i want them to cry

one child stands apart from the throng
her face squidged in the sun's glare
a small girl about my own size   staring back

her dress   like my dress   her hair   like mine
I'm trying to squeeze the tenderness in my heart
up to my eyes to leave with her when I go

NEIL PARDINGTON
(KĀI TAHU, KĀTI MĀMOE, NGĀTI KAHUNGUNU, PĀKEHĀ)

# Pūtahi/Confluence

1. *Aotea Lagoon* 2022.
2. *Huatoki Te Awa, Ngāmotu / New Plymouth #1* 2021.
3. *Huatoki Te Awa, Ngāmotu / New Plymouth #2* 2021.
4. *Fuel Storage Tank, Kaiwharawhara Te Awa, Te Whanganui-a-Tara / Wellington* 2021.
5. *Kaiwharawhara Te Awa, Te Whanganui-a-Tara / Wellington* 2021.
6. *Seacliff* 2021.
7. *Seacliff Lunatic Asylum Ruin* 2021.
8. *Waikouaiti Te Awa (crossing)* 2021.

Pigment prints on photo rag baryta, dimensions variable.
Courtesy of the artist.

Te whenua carries her stories in her belly—that great store-house of emotional memory—making a mockery of the settler state's modus operandi, the *art of forgetting*. In *Pūtahi/Confluence*, Neil Pardington turns his gaze towards the sites of buried histories, both colonial and environmental. These images force pause on otherwise overlooked sites of decay and disrepair, on infrastructure that lays itself across the land like a beached container ship. The built and natural environments continue to meet and touch, but they never quite merge. In witnessing the juxtaposition between the two surfaces—the made and the found—we are reminded of the great chasm between exploitation and manaakitanga, between mastery and vulnerability, between appropriation and attunement. *Pūtahi/Confluence* is a metaphor for the meeting of two peoples in one land, and a reminder of the manifest ways in which our histories refuse to disappear. —Lynley Edmeades

LUCINDA BIRCH

# Under the Estuary Bed

I woke up this morning with a fat lip. My boyfriend got pissed last night. The inside of my top lip is torn where it's made contact with my teeth. It throbs. My angry boyfriend gets angrier when he drinks. Sometimes it's hard to get out of the way, sometimes I leave myself in the way because I know hitting me will make him feel worse.

We live in a grove of nīkau palms, ring-striped trunks topped frog green and incessantly dripping. Big arching fronds fall onto the roof with a smash and a clatter and lie around the house like dead giant centipedes. There are real giant centipedes here too, alive and biting, and carnivorous snails galore with flattened brown shells. Behind the house the real bush starts. It is dense and dark, more black than green, it swarms up the hills and gullies that rise steeply from our small clearing. The forest crawls and slithers and drip, drip, drips. The mountain looms behind.

My boyfriend has taken his four dogs and gone hunting overnight. It's peaceful without the dogs. No whining.

In the evening I walk down the track that leads from our house to the road around the inlet. The inlet is a long landscape, a wide seascape, a pungent sludge-scape. I have a spot I like where, at high tide, the road is a narrow strip with ocean on either side, and when the tide is at its lowest, the road crosses a lake of shining mud. Channels of water wend and wind their way like twisting eels across the mudflat towards the sea, now distant. Where there have been ripples in the water the sandy mud has folded into identical wavering stripes that catch the light of the lowering sun. I sit on the grass edge of the road and dangle my feet above the mud. It's winter, so there's unlikely to be any traffic.

I sit here most evenings. I talk to nobody. I watch the sun go down behind the hills on the far side of the inlet and the deep water in the far distance turn to inky-black. I sit as still as I can and eventually the crabs appear, olive green, small as peas and busy. I smile, which is a mistake. My lip pulls and stings. I prod at the wound with my tongue.

The mud in front of me shifts. It wobbles and shivers and shakes like jelly. Earthquake! I think without thinking, and I jump up. Nothing happens, nothing else moves. I sit down quickly when it occurs to me that I probably shouldn't have stood up in the first place. The mud is still. All the crabs have vanished. Everything is very quiet. The sun goes down behind the western peninsula and the air seems to thicken. It's so cold I can see my breath.

When I get up in the morning there's a pile of mud outside the front door, as if a pig has been rooting there. I sit on the front porch with a cup of steaming coffee and look closer. Oddly, there are tiny shells in the mud, as if it has come from the estuary.

My boyfriend doesn't get home at midday like he said he would, but this comes as no surprise; sometimes he stays away for days, especially if he's feeling guilty about hitting me. I don't know why I stay with him. If I could figure out a way to leave him but still stay here, I would. I love it here. I don't mind the rain. I like the way everything glows when the sun finally breaks through the incessant drizzle. I like the rhythm of the inlet, the breathing of the sea. Sometimes, when I sit very still outside our house, I imagine my fingertips turning green, my feet sinking into the earth and moss growing up my legs.

Today I walk to the inlet by following the stream that passes beside our house. Through the kahikatea and marsh ribbonwood that open up into rushland, a valley of oioi; slender swaying sticks reaching up to my chest, a lake of brown and orange. Oioi, I chant out loud as I push my way through it, oioi, oioi, oioi. A grey heron, all snake-neck and stilt-leg, explodes from the marsh in front of me. Dark brown water squelches to the top of my gumboots. Oioi, oioi, oioi. I skirt around the edges of the inlet until I get to my place by the road.

There's a slurry of sandy mud where I usually sit, and trails of silt across the road. I perch on a rock and look out over the estuary, and wait for the crabs to forget that I'm here. Then it happens again. The mud moves. I sit tight, and it moves again. It lurches. It erupts. I slide backwards off my rock and try to crawl out of the way. The mud is standing in front of me. The mud is a monster. My mouth opens and closes and opens and closes. The mud leans towards me. I scramble to my feet and turn and run as fast as I can, across the

road, up our track and straight into a pack of barking dogs. He's back. My boyfriend. He grabs me by both arms.

'What the hell are you running from? What? What is it? Get it, go get it!' he yells at me and the dogs. They stream down the track, baying and snarling, then suddenly stop, turn around and run back past us, tails clamped tight between their legs.

'What the hell?' my boyfriend says. He holds his rifle at hip level and strides off down the track.

There's nothing there of course. And I know better than to say anything stupid, like I saw a monster made of mud.

'I fell asleep, and when I woke up I saw … something,' I say when he comes back. 'Stupid of me, sorry, I thought I saw something in the mud. Like a giant eel or something. Yeah, it must have been an eel, but it was fucking huge.'

It seems to work. He's not that bright. The dogs know of course, but who are they going to tell?

I don't go back down to the inlet for three days. This isn't difficult—the weather turns nasty, rain and wind swat the forest, the dogs hunker in their kennels, the nīkau palms rattle and slap, bang and clatter. I keep busy cooking, cleaning, chopping wood. There's always something to do that will keep me away from him for as much of the day as possible. He sleeps and eats and drinks and cleans his guns. The days pass. I talk to nobody. When the weather clears he heads out bush again. The morning after he has gone I wake to find an enormous eel, fresh but dead, a lustrous brown curl on the front porch.

I walk to the inlet and I sit by the water and wait. It's a beautiful afternoon, glass calm after the rain, the low winter sun white in the clear sky, the tops of the hills gold-edged and darkly shadowed. I wait.

'Hello?' I say out loud, 'Hello, is anyone there?' A breeze stirs the grass on the side of the road and sends shirrs and shimmers across the water. 'Hello?' I talk to nobody. 'Hello, hello?'

A long way out in the estuary the mud wrinkles and forms a mound. The mound rolls towards me, little waves in its wake. The shallow water breaks, a head appears like a rock, a body like a tree trunk, seeping arms, oozing legs, knee-deep in the mire. It must be over two metres tall. The monster.

'Oioi,' it says. My heart is thumping in my throat, it's hard to talk.

'Oioi,' I reply.

'Hello,' the monster says, its mouth a gash in its blank brown face. Its voice gurgles. It sounds like a blocked drain.

'Hello,' it says again.

'Hello,' I answer.

The monster's mouth grins wide and a crab falls out. 'Oops,' it says, and we both watch as the crab burrows into its leg. I take a step back.

'Sorry,' it shrugs, and wet sand slides off its shoulders. 'Just a mo.' It bends over and feels around in the silty water at its feet, straightens up and pushes two black pebbles into its face where its eyes should be. 'Ah that's better,' it grins again, 'Clear as mud.'

The monster is joking. Its eye pebbles are dark and shiny and there's a glint in them as if they are real eyes. One of them is bigger than the other which makes it look slightly mad, but it's funny and I haven't laughed for so long, and now I'm standing on the side of the road with a monster made of mud, and I'm giggling.

'Call me Swampy,' the monster says, and holds out a soggy hand. 'No? Too obvious? What about Aquathing? Or … I know—Godzilla, do I look like a Godzilla?' It raises its arms over its head and smiles so broadly its face splits in half and its mouth collapses.

There's a muffled roar behind me. I turn to look. A ute appears, speeding through the cutting, down towards the inlet. I turn back to the water and there's nobody there. The mud monster has disappeared. The thin water shivers.

The ute stops and our neighbour, Kevin, leans out the window.

'Ya right?' he asks.

'Yeah, fine,' I say.

'Right. See ya.' He drives away.

The next morning there are cockles on the doorstep. A great heap of wet glistening cockles, all alive.

My boyfriend arrives home late morning with a corpse on his back. A headless gutted deer. He cuts off the legs, hatchets them into pieces and feeds them to his dogs, then strings the legless carcass up in an old beech tree

beside the house. It'll hang for a while so the meat can ripen. I've steamed the cockles, they're sitting on the bench when he comes inside. He glances at them and frowns.

'Where'd you get the cockles?' he asks.

'The inlet,' I nod towards the sea vaguely.

'What? Here? There's no cockles here,' he says. 'Did someone give them to you?'

'Yeah … Kevin. Kevin's been round at Shelly Bay. He drove past while I was down at the inlet. Gave them to me, said he had too many.'

'Kevin huh? Not like him to give shit away.'

'Good day yesterday, eh?' I try a smile. He looks hard back at me. Not smiling. Not a hint of a smile.

He finds the eel later. I hadn't thought to hide it. Stupid. I'd filleted it and smoked it and left it in the food safe—rich brown, smelly and chewy and tasting of mud.

'Who gave you this fucking eel then?' he asks.

'Nobody … Told you I saw an eel. So I caught it. So what?'

'Fuck off, you can't catch shit.' We're standing in the kitchen. He's holding the plate of eel. He shoves it towards me. 'Who fucking gave it to you?'

I edge backwards towards the door.

'Well, what? You seeing some other prick?'

If only you knew, I wanted to say. 'No,' I mutter, 'no, I'm not seeing any other prick, just you.' And I turn and reach for the door. He throws the plate of eel at me, hard. It hits me on the back of the head. The plate shatters and slices my scalp, pieces of eel rain over my shoulders and onto the floor. I run.

I run down the track towards the inlet. The monster is walking up. It strides straight past me. It has no eyes, no mouth, no face. I run to the water's edge. High tide, the water endless and flat calm. Everything's reflected in it—sky, clouds, trees, me. There's no sound from the house. Even the dogs are silent. Little rivulets of blood trickle down my neck.

The tide's on the way out when the monster appears again, surprisingly, in the middle of the vast estuary. It's a long way away across the draining mudflats but it swims through the thick tidal mud as if it were water. It

splashes a lot. Sand flies. It reaches the road's edge in a leisurely sidestroke and then stands up tall in the muck, towering over me.

'Boo!' it says. It's got scallop shells where its nipples would be if it had them, and a skirt of dangling bristleworms. It does a little hula. The worms continue writhing even after it's stopped.

'Like it?' it asks.

'Your eyes?'

'Oh, sorry.' It picks up a stick and pokes two holes in its face. The holes fill with something that gleams.

'Okay then, how'd you like my swimming?'

'Amazing,' I answer truthfully. But it looks crestfallen anyway, and its eye holes fill with water and overflow.

'I can't do butterfly,' it whispers.

'No,' I say, 'that's okay, nobody can.'

'Look, there's something in your collar.' It brightens and reaches forward and with its big mud hands it gently picks the pieces of smoked eel from my clothes and from my hair and pushes them one-by-one into its torso. It leans closer, 'Mmmm, you smell nice and fishy.'

I step forward and put my face on its chest. I can hear the roar of the sea. I put my arms around it and lean into the mud. It's warm and comforting, like sand baked in the sun. The mud monster puts its hands on my shoulders and pushes me back.

'You have to come with me now,' it says, 'I just need to pop you out of the way for a minute.'

'Okay,' I say.

'Cool,' it says, and we walk into the estuary together, me and the monster. The mud is thick and gluey, and my gumboots are pulled from my feet in the first two steps. Sludge squelches between my toes. One more step and I sink thigh-deep and stuck. The monster chuckles. It puts an arm around me and lifts me onto its back and lies face down in the silt. And then I'm kneeling on a swelling of mud and crabs and worms and water and we're rolling out into the inlet. I hold tight into the oozy being beneath me, my hands buried up to the wrist in mud. I'm surfing on the back of a monster. The mudflats roil, a gelatinous wake arrows behind us. In front of us out in the inlet is the crumpled silhouette of Shag Island.

The monster deposits me on the shores of the bare rocky island. The resident colony of cormorants spread their black wings in welcome, and the monster turns and melts back into the estuary. It's very quiet out in the middle of the wide inland sea, there is lapping, there is my heart beating. The shags resume their preening. Water shining jade blue sips at the gravelly edge of the island, and under the water triangular shadows turn into stingrays and undulate past.

Still, I wait and watch. In the far distance I see the mud monster as it emerges from the estuary and lumbers up the track towards the house. I hear a faint rumble. The mountain above our house looks like it's vibrating. A few boulders tumble, I hear bangs like gunshots. I hold my breath. The mountain moves again. The rocks on its bare flanks crumble and melt and gather and a new shape forms. Another monster, rock and stone, grey and chunky and robotic in its movement, stands tall and ROARS, leans out from the mountain and dives, whooping like a teenage snowboarder, smashing into the cliffs below, shoulder-first and rolling. The mountainside disintegrates. An avalanche of rock and gravel pours downhill and explodes through the forest, trees crack and bellow and fly, and the rocks and stones and splintered trees tumble and scream all the way to the estuary and smack into the mud. A massive wave rises up. It boils and churns across the inlet, a tsunami of silt and water and pieces of house and whole nīkau trunks that look like toothpicks. The shags take to the air, squawking and flapping. I stand up. I watch as the wave grows. Bigger and closer and louder. The sky darkens. I have nowhere to run, so I stay.

I wake on the edge of the inlet, curled into a nest of debris. I'm completely coated in mud. My mouth is crusted full, my tongue stuck to my teeth with dirt. I get to my knees and thick clods of dried mud fall from me like an outer skin. There's the echo of an earthquake in my ears, and it takes a while for me to realise it's the growl of an engine. Here comes my neighbour Kevin in his beat-up ute, speeding down the road, screeching to a halt at the edge of the huge landslide that's obliterated the way through. Kevin opens the ute door and stands leaning on it with his mouth open, looking up where the road used to be, where the house I lived in with my boyfriend used to be. There is only devastation, and a new landscape of dirt and rock and broken trees.

Kevin shakes his head in disbelief, then turns to look out at the inlet, and notices me for the first time. I stand up out of the mud and he starts with fright.

'Jesus,' he says, 'I thought you were a monster.'

JOHN DENNISON

# The Way Back

I
You cannot say it enough, in clubrooms
and sports fields, in raised pedestrian crossings,
after-hours library returns, the patience
of pharmacists, bins rolled curbside
weekly ↓THIS SIDE TO ROAD↓,
the territorial call of lawnmowers,
blow-down of barbeque smoke, jogger
spit on footpath, while cars huddle outside
squash/badminton/rugby clubrooms *'It's not
just a game, it's about belonging'*, and ducks
cluster and shit beside the stream falling
into itself, churches cracking open
like flaxseed in the long dry.
Say it to this place, to its neighbourly
touchscreen face, to its careful platform manner
and sports-bar rile, in a quiet moment
after the third one (hands steady now,
throat still aching) while something
plays in that dark uncurtained room (the heart!
like a small scared face, a window)—
say Community; Community;
Community; Community, say
it to the train-fed clusters of roof and section,
to the dead farms along George Grey's
road of fear, to every dry gutter:
it is all grass, all of this is lawn,
long for the cut, and dry—each blade
quietly splitting in the heat—as seed heads

nod, and blackberries look back
from their empires of shattered clay.
                              School is back:
learning is that boy shoving, that one falling,
that boy's carefully blank look, as the adults
rage about respect for each one
each one please give an example from your own
experience, about care and what we value
in our classroom (listening; the value of
connectedness) as we value and shove, shove
back. Shove. It was just a joke O
my god, don't take it all so seriously.

It's all so dry here at the moment.

Nights come and go, never a simple
dark but rich feeding for tic-like thought,
self-beliefs working out from under
the skin leaving trail of anxious excreta,
the bins out early, bodies up
before 6 running themselves into
the ground, which answers dry to their dry,
a thirst; community—say hello
and check yourself. Check yourself. Death
is looking younger and younger these days, has gotten
close, is relatable, even, like when
after a binge; and heaps have just left
the thread, gone offline; and then—like right
then—there's always a fire eh, like that car
in the park'n'ride, like a bin at Grasslees, and that house
on Oxford Street eh, like a totally random
fire by the railway, in the student carpark at college.

II
*Whakarongo!* At the Linden shops the footpath
is a prayerless labyrinth with trains *Warning!*
headless and buffers running right through
the guts of it; and ring again *another* ringing
*train* the bells ringing *is approaching* and it
is not good: still people cross,
burning with urgency—it works in their throats
like a mute child lashing out and hey
we're only trying to help. Breathe a bit
faster now are you breathing a bit
faster than normal? It's the air, it's
a bit dry, drying my lips are like
totally stuck together carefully press
them together and stick, shut your tongue
in its dark living room and unseat the heart,
let it go wandering after in dry streets
under trees that prematurely drop
their leaves to scatter like with ash the gutters.

It's high time: bring them out. Banned
under by-laws re: emissions, air
quality, bring out the incinerators.
Drag them into sunlit patches gently,
the softly sooted cranium set up
and unlidded, ashy mouth open.
Now we might kneel before the dry
lip, our own mouths adhering to post-
war observances (say nothing),
remembering to build a small pyramid
(memorial) first before—once lit—adding
larger items. That's my tongue in there!
O my god what's my tongue doing
in there? Shit! Help me to get it, help me to—
*Whakarongo! Warning! Do Not Cross!*

III
From here, you can see small figures
crossing driveways, backyards, going to
and fro from the dark drums that rise, like
upturned wells, into the vague light.
Skeins of smoke run up to pool and drift
down the valley—an inverted water-table.
Your shoes are mostly dry from an uncertain
dewfall. You can lean on the cemetery fence.
Look, one nearby has removed all
her clothes to dump them in the smoulder; another
sets his face in the fume and tries hard
(too late) to cry. Too late.
Ash flakes, black as cell phones, shine
and slew, settle (community) the ground
about. Ash fall, no dewfall,
the newly acrid dry. Somewhere: shaking
shoulders, sharp laughs, the hopeless sound
of bathroom showers, as, by small fires
mingled, our exhausted hivemind
tries to talk (my tongue!), petition
the sun who cannot anyway be moved,
who moves and shines and runs anyhow faithful.

Take this down: the sun, yes, somewhere
anyhow you suppose above. Heedless,
the smoke, that thick in foetal billows tucks
into the wound of morning. Take this down:
discard and longing, faithfulness to uneasy
goods and faithfulness to fearful thought
and faithfulness to the wretched authentic self,
striving for excellence as moving forwards
we give it our best shot genuinely vulnerable
look always confident of what we have
to offer be true to what you imagine you
might or may or could or hey the future

(now in small gold flakes. Pass them
around take one in the morning with food. Do not
swallow but roll anxiously in the mouth).
So dry. No one look at the sky; no one
look at the earth (it has started to burn); heedless,
find yourself touching other bodies.

Each, each knows the song we
voiceless sing, sad the voiceless sad
how can you hear it, sing it with me?
Lift this: how is it so many are gone—
community—ushered by their own
hands, throats, and how stumbling we
are drawn to such high places the elsewhere
yearn and unreal how the community
rallies around at such times while fallen
stuff compacts like gutter-clog and down
it all goes down the dry storm-
water dry drains down to the river
(river rejected, the still-glad river).
If only; if only how if only maybe
how the call (will someone put through
a call?) will they one, one, one,
one, one, one, someone: fire—
and how the siren (this place) how it churns
the air *now* somewhere trouble! Troubling
it draws breath winding the pole-perched
churn doubling how in the heedless exhausted
hopeless how it draws from the morning urgent
it churns dry choke to thickening yearn
how this yearn—my tongue!—how it fattening
articulate speaks loosening spool of raw
in unhindered reach how it says:
now—now—now—now—now

IV
Now let us sing: can you hear us
sing we're rising up this place we belong
hello this place home is where we hello
we hope sing with me.
                    I can't hear you.
We hope to go to a better place that is
we wish this would end do you remember
the bit about the river? Hopeful, let's say,
these engines that are now now everywhere
engines unhousing the future with spumes of now
spumes of smother (no water, it's so dry
here at the moment). No water, but handy:
there's a layer of ash right through, old ash
from old fires way back the way back when,
back when there was a way but *large patches
of cleared land are making deep inroads
into the forest, and the whole aspect of the country
is being rapidly changed* a better place
and that's handy large patches of ash
large patches rapidly the country the whole
is this the way back? the hopeful inroad:
cleared. And now to and fro the small
figures, the engines. And the singing of
everyone singing 'How?' And oh look
the sun's gone.
                    But for you, strange,
there is light. And the voice again says:
come up here, and I will show you someone
whose life has been waiting to speak. Take this down.
Kneel down. The ashy grass is still
tender, remembers rain still. Do you
feel the stone? It's Joseph Bartlett's, dead,
found two days after, face down
in the parlour, the afternoon shine strained
through the drawn sackcloth and the flies' drone

mounting, warning. Do you see the crack?
Crack across the memorial like a slaughterer's
cut. Reach down don't shrink
back reach down and bring him un-
finished up and sorry: for he is.

    Ah now, I'm yes, I'm sorry. My mouth is dry—
    you see my throat? I just need to sit
    a bit and catch my breath. You tell my sister—
    oh Betty, I'm sorry—

    your hand reminded me, your hand that voice
    like hers (she'd always be up first) 'Get up!
    Get up, Joseph! It's morning!' Out back, the stream
    was always alive,

    and mist rose off the bush all round and made
    the sun rise late, and everything was wet
    with dew. There's ash on your face. I'm sorry, I don't
    know your name.

    So damp it was, those early years, the bush
    all close and wet; seemed like the bit we'd use
    to warm the house would only leave it colder.
    Each tree was a shade,

    and the valley was ours by rights, and the stream was trouble.
    But I grew up amidst the bush on fire,
    each acre cleared and piled and set on fire,
    the valley on fire.

    Our idea was grass—to grass the valley to graze.
    The light would fall and life would rise and us
    with it, our happiness the realisation
    of this idea,

our own idea. And grass spread out like fire.
I remember a large and looming tree, its crown
already dead. Too big to fell, the men
heaped logs and fired him.

I was five at the time. And I danced and called before
the burning tree, and the fire entered me.
And ever since I believed in the strength of my hand,
its power to fell.

The crash with which they fall is tremendous.
You mustn't look at me. There's ash on your face.
I believed in the strength of my hand, and what entered me
was grass and fire,

and my tongue was an axe, and Betty upped and married,
and the farm was mine, with the stream still out the back.
Morning, and the sun was streaming in, and I drew
the parlour blinds,

and I cursed myself to heaven. *Blessed is
the man that walketh not in the counsel of the
ungodly, and he shall be like a tree planted
by the rivers of water,*

*that bringeth forth his fruit in his season; his leaf
also shall not wither; and whatsoever
he doeth shall prosper.* But I brought the knife to my throat
and felled the tree.

The neighbour found me. As he turned me over I saw
his face, the ashen dawning of unbelief;
but I was already down. And where I fell
the grass grew up.

I've nothing more to say. I believed in the strength
of my arm. Would you sing for me? My throat
is sore. I'm thirsty. Whoever wants to live
should pray for rain.

V
Strange: for you, the light, as if the morning
among the eastern hills was Mary who,
weeping, bends to look into the tomb,
who sees the angels, their brightness actual in the gloom:
*why are you crying? why are you crying?*
And at their question we turn and rush and strange
the risen up and breathing one in the valley
of morning, looking at us like a gardener,
saying our names. And this is where I get
to speak at last, my mouth burning not
with the burning grass but with understanding,
the knowledge of what we have made of our strength, burning
with Joseph Bartlett and the felling of trees and the falling
of ash in the dry—my mouth, burning
with understanding. Sink down you weeper,
sink down in the grass beside your neighbour
and be still: the siren is gone from your throat,
and your understanding mouth, it burns. O my
lovely, look up: like the liveliest kissing is prayer
is understanding, is how readily
the dew adorns you, how it behoves us
(community) to look up at the lofting
day to kneel among remembered trees,
among our voiceless dead neighbours, is a better
placing of things beside the living waters.
It's not just a game, it's about belonging:
like the liveliest kissing is prayer. Sink
down; be still.
                O light

on my face you brace you make me stand
on this burning ground. My yearn, you cloud about us
as if this one and that one (community)
were trees and the heavens drawn down and everything
wet with dew. In whom all things O you,
most true analogy, in you our dry-split
life kisses the axe's edge, suffers
the deepest cut, into the stream that runs
anyhow faithful: the broken fact of you,
it makes this clear-felled body your open
home and now is moving day. Here,
I kiss you (I pray):
                O you in whom all things,
you are my way through the burning valley,
my morning mist, our birdsong canopy.
Forgive my unbelieving arm, my withering
hand; like grass, I thirst—long for the cut,
and dry. But you have made my tongue a bright
leaf, a bud (reforest now)
and I have thought you were the gardener
so reconciled is the day. O restore:
reforest, refloor this unhoused
meant (our own idea), make tall an unfired
stand and this ground be glad and trees
all sing (community) the northerly
in their easy throats. O you in whom all things
you sing in us this difficult song the gardener's
voice that speaks a better way. Though it
cost me all willing ears I pray: re-
forest this unremembering place, restore,
let fall, make fall your rain.

MIKAELA NYMAN

# Orange Blues

*after Mary Ruefle*

There's no *if*, our oceans *are* a warmer blue.
So let us swim among marine mammals, poets
and silvery fish while a westerly herds clouds
that bring rain without an acrid tinge of singed
koala fur, marmalade skies layered with black,
blanket of ash and a coat of dust on Mt Cook.
Let us peel back stubborn layers of ourselves,
any peevishness stripped of clothes and pretence
(and dairy and wine and bees and innocence).
I'm perennially thirsty now. You were right
to toss that orange up in the sky. Cannot be re-
constituted, a ball of threadbare flesh, bitter pith.
(But thank you for the gesture, I was cowering
at the edge of that crowd.) (Of course a feijoa
cannot rival an orange.) It is tiring, this seesaw
of floods and droughts. Wild geese splatter
our neighbourhood with remnants of shoots and stems,
dormant seeds, leaves, endangered berries—
memories of the last aquatic meadows, half-digested.

JOANNA CHO

# Night-time Activities

The silver car rattles in like whatever scattered the stars over the ocean—some rice shaker gone bust. The other parks are empty but the corner bar still has its light on, the gold humming. The workers, golden fish in a glass bowl, are pulling chairs up by the legs, and out of sight, below the pier, the sea rumbles just for us. And the high street lamps gold light, the city north of the sea gold light, and us, he in navy shorts and white singlet, me in a grass-coloured bikini with silver spangles, just like a little beaded handbag, a towel thrown over shoulders, both barefoot ... The air is warm and soupy but the breeze cuts. If only we had an orange to halve, it would've looked perfect against the deep, taut sky. We smell bitumen still warm from the day, hear the crush of waves biting into crabs' legs.

    He pulls me close in to him for a moment. It's only a couple of seconds but in the distance a dog is called by its owner, a bike tumbles over gravel, an older couple speaks—and he pushes me out like we've been dancing and I am about to be spun, except its undertone is that of refusal. And we continue gliding down the path—a lone seagull overhead, purely decorative, hanging on a current with its wings spread wide. We descend to the beach, the steps laid out like a golden paper fan. The full moon managed by an invisible stage crew.

    Everything is magnified—the ocean so wide and long and far away, the sky so high, above the big rocks. I drop the towel, he says, *Not here, there's a rip*, points to the clean smooth break—a large dinner plate. I pick up the towel, hop along a bit, away from thick kelp, huge and rubbery like a colony of dead penguins. And then I drop it again and without a word we run into the water, hair flying back, pausing for a split second at the break. He holds his arms across his chest as he wades in, my arms fly out like flippers, we breathe through it. I dive in first, counting for the right wave. Then he jumps in. The cold blasts, an instant reset, the waves boxing us into large envelopes. I turn around to hop out and he yells, *Have you done three dunks!* I know this game,

have participated and put it on others, but now I say, *That's your stupid rule* and run out, kicking small waves.

I run to the lilac towel, the colour showing up softly in the dark. I wipe my face, scrunch my hair into it and then wrap it around my body. He walks up—I offer the towel, he declines, instead squats facing the water, letting it all drip. Suddenly he pops up and walks forward, stretches out his right foot and begins dragging it across the sand. He is writing my name. I say *Aw!* and laugh, walk around to the side to see it being written. When he's done he grins at me, white teeth perfect slices of the moon, and I say *Aw* again. Behind and above there is a soft patter of a bike coming to rest—a young boy who has been doing circles is watching. I look up and smile, nearly wave.

He repositions himself on the sand below my name and starts drawing his own, but five times bigger. Of course. He grunts from the heft, dragging one foot and hopping on the other, lurching along. I laugh and look to the water. It shimmers. He finishes—I laugh again but this time it's more like a question. He adds an exclamation mark to his name and then a question mark to mine. He cracks up, the sound whipping the night into shape, and looks from me to the names and back again and then goes to stand on a big rock to get a better view, hands on hips. I grip the towel around my top. He is already much taller than me, now he is a statue. *Come up*, he says, holds out his hand. His chin gold light. His nose gold light. His forehead gold light.

TIM UPPERTON

# Team

There's m-e in that motherfucker
                —Kobe Bryant

There's no I in team
says the organisation guru,
but as Kobe said, there's me,
only dispersed and going
in the wrong direction—
Don't @ me,
I'm flying apart,
alone and severally,
and there's no you
in team either,
but here we are.

*for Rachel*

CLAIRE ORCHARD

# Herd

Interestingly, zebras don't suffer from stress
the stress researcher says. Immediately
I find myself worrying at her analysis.
Surely being pursued by a ravenous big cat
would be stressful? I imagine
under such circumstances even
the fastest in the herd would experience
some degree of anxiety? It turns out
relatively little research has been conducted into
those quiet moments after the danger has passed.
If only the survivors could tell us
how they're feeling. Recently captured footage
shows them glancing obliquely at one another
before hurriedly looking away again.

# Play Dead

Jason, at eight and a half, has already mastered the art.
The first time I saw him do it, I sprinted over,

certain this was it, the dreaded day
I'd be the one to discover a student lying

dead on the Astroturf, and me on duty miles
from the staffroom. Today when he does it

right outside the classroom window
I put my mug of tea on the sill and watch

for signs of life. He's good, but eventually
his arm moves and, a moment later, his eyes

crack open just a fraction, for a sneaky check
—is anyone looking? I'd always assumed Jason

would, in time, grow out of this. But last week,
at a first-aid refresher, the woman in front of me in line

assured me her life partner and father of their three children
regularly lies prone in their bed holding his breath,

hoping this time will be the time she'll fall for it.
He's forty-four, smokes a pack a day, is carrying

a bit of extra weight. One day it'll be the real thing
and I won't realise until it's far too late,

she sighed, shaking her head, while we waited
for it to be our turn to pound on a plastic dummy's chest.

ERIN DONOHUE

# Our Little House

We pack up our belongings and get ready
to leave our little house. It is not really ours

and it is not really a house, but a poet I love
once said there is a difference between fact and truth.

In our little house, the walls are bright blue.
We have a third-hand couch the colour of burnt orange

that somehow, despite meeting the criteria, manages to fall
just shy of achieving 70s vintage chic.

In our little house, it's just us,
for the first time. And then it's just us and the cat.

Here, we talk about what we want to happen to us
when we die and whether having children is selfish

given the current global environmental and political situation.
Here, we name all of the neighbourhood cats ourselves

and report back on who we see when we are out. Here,
the landlord pushes a box of chocolates through the cat door every Christmas.

We spend the weekends scrubbing the walls
and cabinets with Exit Mould. Here, from the safety of our little house,

we watch the world end in loud, routine ways.
This is where we live when I get the diagnosis.

Where, on instruction from my psychologist, we unpick
ourselves and see it how it really is. The thread pulled and left tangled.

Where we are both, finally, undone and bearing
witness to the whole damn thing.

We have been in our little house for nearly three years and soon,
we will move to my grandmother's old house in the suburbs.

We will have a dishwasher and a garage and a garbage disposal.
We will see the ocean every day. We will buy a brand-new couch.

We will leave behind the restless noise of our discovery.
The rambling messiness of the beginning of our life.

But, say you would do it all again.
Despite the mould and the leaks.

The pneumonia and the stolen tools—say it.
Even when we wake on winter mornings and the walls sparkle

with wet. The curtains billowing as the wind passes
through the gaps in the closed door. Even when the upstairs

neighbours yell and throw dishes. When they put their washing machine on
and the whole house quivers,

the glasses earthquaking in the cupboard.
Say you would do it again—for us.

Sitting among it, unravelled,
bare. Our most honest, naked selves.

JESS RICHARDS

# Ghosts Have No Feet

I

There's a broken pair of shoes on the edge of Adelaide Road in Wellington, New Zealand. Block heels. Black elastic. Teenage girl shoes. A seventeen or eighteen year old? I don't know why I think that. The heels of both shoes are completely smashed, as if they've been run over by a car. They appeared on the same night that there was a fatal stabbing at a teenage party in Christchurch. I look for blood on the road but don't see any.

II

As a young woman I lived in Carlisle in the UK. Three different student rooms in three different terraced houses over one year. I was eighteen and I was in love with the city and wanted to belong to it. One way of doing this was to allow myself to feel it physically, and to allow the city to feel me back. This meant touching the pavement beneath my bare feet. Letting the texture of the pavement harden my soles. Occasionally releasing a spit or spot of blood, claimed by grit or glass. I walked around barefoot for months.

Strangers would walk right past me, looking downwards. Avoiding eye contact they'd say, 'No shoes.'

Just that. 'No shoes.' As if there was something deeply wrong. As if I were almost-visible.

III

2010. In Brighton, England, along all the walking routes to secondary schools and all the walking routes to pubs and clubs, shoes with the laces tied together hang from overhead wires. All these schoolkids and big kids will have had to walk home without shoes. I worry about bullying and fun and how close together these two things live.

## IV

August 2021. The voices of social media and emails:

'The teenagers all have mental health problems now. Well, I suppose everyone does.'

'I'm so sorry I gave birth to my son in the end times.'

'The birds are much louder now. Especially the tūī. Since the tree fell in the storm. Since there's less traffic. Have you noticed?'

'I had to be resuscitated. I don't think I told you that.'

'There's no immunity if someone is immunocompromised. Even with vaccines.'

'You'll be over next year though, won't you?'

'We can all move around freely now.'

'Elimination is impossible. We just have to live with it. So will you.'

'Why aren't you all vaccinated yet? I thought New Zealand was good at this.'

'Nothing is important any more. But we're still remembering stupid memories. Well, any memories at all, from before. But there's also this urgent feeling that if we don't remember them all now, soon we won't have any memories at all.'

'I am so *over* hearing people grumbling about not seeing their families for a couple of months. It's been over two years for me now. Longer for you.'

'Everyone in New Zealand must be so smug. With Covid and Jacinda and everything. I suppose there's a Jacinda in every country. Many Jacindas. But people have to vote for her.'

'I miss you.'

'Covid's come back to New Zealand. Inevitable, really.'

'When are you moving home to the UK?'

'We're not doing too well are we. Humans.'

'We have no idea, here in New Zealand, what the rest of the world is going through.'

'We just want to spend time with family this year, not make new friends.'

## V

When I was a child my family lived in a rural area in Scotland, around six miles from the nearest villages of Leswalt in one direction and Kirkcolm in the other. We lived eight miles beyond an end-of-the-line town called

Stranraer. We four siblings each had two pairs of shoes—one for school and everyday use, the other a pair of sandshoes for school gym. When I was about ten years old I got wellies for the first time. They were the brightest red. I wore them with my party dress. I wore them with dungarees. I wore them with pyjamas and with a swimming costume. I wore them in puddles, in nettles, in the woods, in the Irish Sea, on jagged rocks, on grass-cracked roads, in wheatfields, in the ruins of old cottages, in tangled brambles on verges.

VI

2020. There's a pair of work boots on the pavement beside a lamp-post in Berhampore, Wellington. Toes worn. Scuffed. Shoelaces tied into double bows. Damp from three days and nights of rain. They are arranged with such precision that no one has tried to move them, not even the wind. The worker must have placed them there after work one night and climbed the lamp-post. Then, they opened their hidden wings and flew upwards, beyond the lightbulb.

VII

Sometimes I walk around Wellington with Morgan. I came to New Zealand to be with her.

Morgan often laughs in response to my pointing out empty shoes on urban pavements, wires, fences, walls, roads.

She tells me, 'It's strange you notice shoes everywhere.'

I reply, 'It's far stranger that there *are* shoes everywhere.'

VIII

I remember binding my mother's feet when she was my daughter. I broke them at the arch, folded the toes under each foot, trying to halve her feet in length. I bandaged her folded feet tightly in wet fabric. Exactly the way it had to be done, or I would ruin all her chances in life.

There is no reason for this memory. My mother has never been my daughter. Both she and I were born in the UK within the past eighty years, not in China in the past.

Her feet aren't broken. They are one size smaller than mine. I have often bought her new slippers or the softest socks for her birthday.

When I was in my late twenties I studied reflexology at night school. When I needed to do case studies for the course, I went north to visit my mum and dad in Scotland and gave them foot massages.

Now it is 2021. My dad is a ghost. He's gone somewhere I can't find him. I haven't seen my mum for over three years. But I can still remember the frail texture of the soles of their feet.

IX

When I was around nine, I had a recurring dream about walking along the pavement of the nearest town with my family. The pavement cut my bare feet, and in this dream I could feel excruciating pain. My shoes had fallen off somewhere but I hadn't noticed. I'd cry out to my family to wait for me, but they never heard my voice. Their long silhouettes walked away through grey streets into brightness. The dilemma was always whether to go back and find my shoes, knowing I'd lose my family, or to follow them with bleeding feet. I always went back for the shoes. When I'd managed to find at least one, I would spend the rest of the dream hopping through the grey town filled with shadows, looking for my lost family.

X

Until August 2013 I lived in Brighton with my wife Z, who loved a particular brand of shoes. They were the kind of high-heeled shoes that might belong to an extrovert princess—all glitter and kitsch kittens and pin-up girls and pinstripes and polka dots and pearls. The kind of shoes that would be dropped on a grand stairway on the way out of a party to encourage pursuit.

During the fifteen years we were together, I bought Z many pairs of these shoes for birthdays, Christmases and anniversaries. She wore a pair on our wedding day, Friday the 13th of October, a date I chose for fun or thoughtless irony because it was unlucky. Z bought this brand of shoes for herself as well, on eBay, in the summer sales, in the winter sales.

We lived in a small rented flat, and by the time I left Z owned around fifty pairs. They were stacked in their shoeboxes in the bedroom, beneath our shared clothing rail, and worn only on special occasions. As Z became louder over the years, I became quieter and eventually disappeared, donating my possessions to thrift shops. I sometimes imagine the gap on the clothing rail left by my absent clothing.

All those boxes of rarely worn princess shoes, exposed.
Waiting to dance, waiting to be pursued by princes.

XI

I often walk around Wellington alone. At times I feel like a ghost because I don't belong here. In 2019 I'm a hunting ghost. I hunt for the tiny lumps of grit between paving stones. I hunt for the holes in concrete. I hunt for underground pipes and wires and dropped scarves and broken jewellery. I hunt for empty shoes and imagine they belong to people who have flown away, upwards. I hunt for boarded-up doors. I hunt for derelict buildings and broken twigs that resemble wind-swept trees, and I hunt for flax flower stems. I hunt for strands of long hair caught in wire fences and I hunt for the sound of a helicopter landing on the hospital roof. I hunt for cobwebs that have been woven so randomly they can't possibly catch anything, and I hunt for all the creatures which, like me, shouldn't be here: chaffinches, rabbits, sparrows, cats, blackbirds, rats.

I listen for native birds—pīwakawaka, tūī, tauhou, ruru—and try to learn their songs. I talk to the birds as I keep an eye out for all the things I've been subtly warned about, like black mould and patched gangs and tuneless bagpipes and racism and leaky homes and synthetic cannabis.

I hunt for the smallest cracks in walls, the ones no one else has noticed yet. Even after five years the sense of the ground shifting still frightens me. I wear boots, even in summer. But the soles of all of my boots feel too thin, too insubstantial. I try to walk as lightly as a ghost so that when the earth quakes, I can leap instead of falling.

XII

The farm across the road from my childhood home was a dairy farm, and I'll never forget the wails of cows when their calves were taken away. Beef farmers used to drive their cattle along the road beside our house. My family were vegetarians.

On winter mornings the cows' breath hung in the air.
When they walked at their own pace, their exhaled breath was a halo.
It became a phantom when they were forced to run.

XIII

My dad's empty jacket and gardening hat still hang on a hook in his empty study in Scotland.

Apart from a red silk shirt that I claimed, another hat I gave to his sister and whatever my mum or brothers might have kept, that's the last of his clothing.

After he died in 2014 his clothes were packed up and given to thrift shops, which is where most of them came from in the first place.

I keep thinking about his footwear.

His boots, shoes and slippers were all bought new and would have been worn only by him.

Now strangers walk around in his shoes.

They limp slightly as their feet fail to adjust to the indentations of his soles.

To the shape of empty space.

XIV

Morgan loves New Zealand. Walking around Wellington with her hand in the crook of my arm, she helps me see it through her eyes.

Perhaps I won't always feel like a ghost here.

Seeing what she loves about this city is like seeing floodlights go on— illuminating, adding colour.

She lights up the sunlight on tin rooftops.

She colours the distant mountains indigo and ochre.

She shows me the lights of windows rising up dark hills, the outlines of shadow-trees.

At Island Bay after a storm we can't walk along the beach because it will sting our feet. Instead, we crouch on concrete steps to look at translucent blue pieces of jellyfish scattered across grey sand.

XV

It's summer, 2018. At night-time in Duppa Street in Wellington, Morgan lights a fire in our garden. To stop the mozzies sucking our blood, we tuck our trousers into our boots.

We listen to the melancholic calls of the ruru, a small owl that belongs here.

Morgan looks up.

Above us there are stars. So many stars. More than I've ever seen.
The full moon is the centre point of a shimmering ring.
It's surrounded by a halo of its own exhaled breath.

JESSSICA LE BAS

# The Order of Things

Late in the afternoon
after I came inside with an arm of washing
I heard a dog screaming
   then not

I think I heard a car braking
but I could've been wrong
about the order of things

The afternoon was full of stillness
the valley soft and light
with heat, and the Sunday prayers lingered

The dog was screaming
not barking
   then not

At dusk, a rupe—a fruit pigeon
returned to the betel-nut palm
below my deck to eat red berries

It is dark now
and someone is singing sad songs
There is a guitar,
and across the Pokoinu hillside
a dog joins in,
howling.

SOPHIA WILSON

## I Am Reminded

—*after Katherine Mansfield*

| | |
|---|---|
| I do not know why I have | such a fancy for this little café |
| pulled as though | by |
| or you, | why I have such a fancy for |
| I vow not again | never |
| and yet | here we are |
| perhaps because | the staff don't bat an eyelid |
| at breakfast: croissant | short black |
| wine—café-bar to be precise | a fancy for this |
| 11am together | I can't help |
| but notice the malodour | of decay |
| fungating in the warmth of our | close, familiar habitat |
| a blue, bloated thing | frenzied capillary chaos— |
| we could | ask a naturopath for |
| burdock, chamomile, aloe vera | cooling antidotes |
| to the atomic self-destruction of our | ritual     but |
| *too far gone* | you bend slowly |
| lift your trouser leg | you old hopeless |
| they've told you *phase four* | —another round, no frills— |
| fleshy aberrations | protuberances that crust and ooze: |
| awful, sad spectres   metastasising | from the graveyard |
| of your shins | —time bombs— |
| I am reminded somehow | disgustingly    of mushrooms |

MARY MACPHERSON

# Lemons

We stole two lemons from a grey-dead, lichened, leafless
but still with a spray of yellow tree. We loved furtively
yanking the fruit from the bush, which stood in soft forest,
grasses and remnant hydrangeas, steadily losing
to a subdivision's glowing orange frames.

Loved the fear of being caught. Who by? Builders on roofs,
in vans, anyone we imagined who'd care about the property rights
of a fucked tree.

The lemons too with their squirt of sun-coloured sourness,
saving us from walking yet again to the town's supermarket.

Round the corner was a minor mansion afloat on a lawn-ocean,
box hedges stopping abruptly where the trimmers hit. We walked on
made photographs of what was in our minds, and what added up.

For a moment, we imagined ourselves in one of the orange frames
living far down a road in ambiguous countryside.

Instead, we went back to our motel where, on a scratched plastic
chopping board, the lemons proved half-hollow, stolen even
inside themselves.

GERARD O'BRIEN

# Afternoon Nap

It's my neighbour again. My wife calls it having a stressful time. But it is yelling, really. Quite loud. Because I am in the next house. Over the fence. Lemons on my side. Grapes on his. His grapes creep over. My lemons stay put.

He's yelling, *stop barking so loud or you'll wake the baby*. It is afternoon, early still. I guess there must be a schedule. But the dog doesn't know the schedule. Goodness. I'm smart and I don't know the schedule. I can't hear the dog, but then, it is afternoon and I had been taking my nap.

I'm partial to an afternoon nap. And I let the kids on the devices and their mum has gone shopping for the new dress and the party. So, the first I know of the dog's racket and the risk to neighbour's baby's slumber is him, reprimanding the dog. And the dog doesn't know what to do. It seems sheepish. Confused dog. Runs up the fence line. Long fence. Runs past the grapes growing on his side—quite juicy. Very delightful. Runs up towards the considerable gum trees at the back. It's got a little house there. The dog. I don't know if it sleeps there. I reckon any dog would be happy with a kennel like that. Red roof, wooden sides. Like a mini human-house with a chain. Classic.

And then the shoe. The shoe goes flying. It is raucous. Not the dog. The yelling. I'm upstairs, so I can see it all. I can hear it too. The shoe is flying, and the words are *you bloody mutt*.

I wonder if my kids are watching, because it is loud. But I remember Minecraft and think unlikely and relief. Then the dog has the shoe. The shoe is in its mouth and it's running. Away from the considerable gum trees. Back to him, shaking its tail. Then it drops the shoe. He doesn't even say drop it. Just *mongrel*, and others. Well-trained dog. Just needs to learn the schedule. But well trained.

I've not been in his house. Well, not for a long time. Not since the accidental rabbit-hutch opening incident. It's been a really long time. But I

suppose the schedule is there, printed, on the fridge, stuck down with an Eiffel Tower magnet. Red and green blocks on a neatly lined spreadsheet. Probably amber sections too. Those'd be tricky for the dog to read. Probably thinks current block is playtime. Silly dog. Needs to do better scrutiny—it's baby sleep time.

So now he—that's the neighbour—has the shoe again. Still got one on his foot. But he's got the other back in his hand. Slobbered. That's made him mad. And now he's yelling again. And he's using some choice words that I don't want to repeat because of my own children. So I'll just summarise, and he's saying, *get up in that bloody* (but it's actually more rude than that) *doghouse, if you know what's good for you* and etc. And the dog just barks a little bit and that's probably understandable, because it's just returned the shoe. Like it's been taught. And no one's sat down with it and explained the schedule properly. And it's brought the shoe back and then, without an explanation, it's been hit with it. Not too hard, I don't suppose, but hit. Just on the back of the head, and then again, tapped on the rear end, near the tail, which is not shaking happy any more. And so the dog does a little bark. But it's not as loud as you might think. More like high pitched.

But I reckon it'll be that high sound that does it. Because it's the neighbour's dog that starts up now. Not his dog, but the next dog over. Both neighbours in a row have dogs. And the one over, their section is much smaller so that dog is always barking at this and that. But that's okay. It's cooped up and he—it's a boy dog—he's friendly if you go over there.

And he—that's the neighbour with one shoe, he is really looking frantic, because he is just on one shoe and he hasn't stopped yelling for ages now. Quite loud. Face all red. Boiling over. His dog is up in the mini-house. Or heading that way. I can't see up there because of the fig tree. Silly fig tree.

Now I'm worried, because I know that the neighbour's dog definitely hasn't seen the schedule. I'm just over here and I haven't seen the schedule. But I think I need to see the schedule too because it's a nice afternoon actually and I was thinking of doing the lawns. I don't know if he's got enough spare shoes for the neighbour's dog and for me to do the lawns all in one afternoon, so I think that I better check the schedule before I do the lawns. And so now he's yelling at both dogs and at anyone that will listen and I start to get worried that he'll wake up the lawnmower and it will start barking too.

Well, I've actually got some spare sneakers over here. I retrieve them from my eleven-year-old's room. I don't think the window opens wide enough, so I go down by the lemon tree. Quite a bit of cover, and I lob the shoe. End over end. Best way for lobbing.

It goes pretty close and I duck down by the tree, good hiding spot, and the yelling stops for a bit and I reckon that me and the kids can have a peaceful afternoon. And the dog too. I'm thinking, even the baby is still asleep now.

I'm crouching, just in case, reasoning that that's one point for the dog lovers. Then the shoe comes flying back and it damn near hits me. But it hits the branch in the lemon tree. One ripe lemon falls off, and I think, if the neighbour wants to play fetch wouldn't it be funny to fire lemons instead. So, I go into the garage to get the hacksaw and I've got the old downpipe. The one that came off when the ladder blew over in the wind. Bloody strong wind. Real heavy ladder.

I've got that downpipe and also duct tape and old rubber gloves and all the things that I need to make a kind of joey gun. But it's more sizeable, big enough to launch a lemon or two, and I decide to call it a cannon when I show my eleven-year-old. He likes that name.

And now that I'm finishing it up, it's almost evening, because I did actually have to go to the hardware store. It's just nearby. I went there to get some other rubber tubing and extra bits and bobs because at first the gloves didn't have enough stretch. But now I've got the formula right. The kids didn't want to come—because devices—but we made an adventure about riding one trolley each, and they got an ice cream, so they're happy.

They don't even seem to mind about picking the lemons now, which is actually quite helpful. I said they could pick the green ones too because normally they're not supposed to pick the green ones, but for this game I think the green ones might be better. And their mum is still out, and that's probably best because I don't think this is the sort of game that she likes.

My eleven-year-old has a good arm on him, but he wants to fire the cannon, so I give him an introductory course and tell him to aim up high. I'm thinking this game will be best if we get lemons on the roof. But they need to go in quick succession, like thud, thud, thud, otherwise the game won't really be all that fun.

Well, we got the lemon tree bare, the kids, they're hard workers too. And

the eleven-year-old and his eight-year-old sister, they've cleared the tree right out and we've got two full buckets. I tell her to just watch, but she wants to join in too. I show her how to throw them in an under-arm lob, so they'll go further. But we just mime the action and do a few small ones across our own lawn. She's got a good arm too, just needs more practice.

Then I say, three-two-one-go and my eleven-year-old fires the first one and me and the eight-year-old are launching them too. And the cannon works really well, but he hasn't aimed it high enough and it's gone right through the window. Not the plan. But it is quite funny.

There's no yelling coming over the fence just yet and so I tell him—my son—to try again and I throw three more in quick succession and they go on the roof and the girl gets another two off and they go on the back porch. Thud, thud, thud. I tell her that she's doing a great job. She is. And my eleven-year-old too. He's really come into his own. And there's some pot plants that you can see on the back porch and they make great targets. Then the yelling has started and it's *bloody this* and *bloody that*, but I tell him he can have all the lemons that he wants and then we just keep firing and my kids are loving it. Cracking up, and me too.

We don't hit him. I tell them not to hit him. We don't want to make actual wallops—like him on the dog. The dog's been having a bad day ever since the baby. My wife said it's all about colic and how lucky we were to have such peaceful sleepers.

Anyway, he, that's the neighbour, has disappeared back in the door and he's not yelling any more. I think maybe he's gone to get more shoes or something. He doesn't come back out and we use up all the lemons. There's the mistake-window, but no other material damage, and he's got lots of other windows, so that's okay.

We've gone inside to our place and the kids are talking about chicken-and-cranberry pizza, which is apparently the favourite and there is a lot of please and thank you and desperation in their voices. I think that might be okay because everyone has learned good lessons about pets and military strategy, but I make a compromise with them and we decide on potato topping instead.

Pizza has arrived. They're licking fingers and smiling and there really is a lot of cheese, but I don't say anything about that. They're good kids. Now the

door knocks and it is the police there. I tell them about the dog and the shoe and make a little white lie about the mistake-window and they seem unsure, so they go away and I don't see them again. I don't know if they go to his place because we're all inside watching a movie. It's night time. But anyway, I don't hear any more yelling.

The kids are asleep, or at least pretending, and that's good because I still want to do another game, but this one I don't think I should let them play, and I'm not sure about it either, so I text my wife, their mum. She doesn't reply so I think, oh well. And it's just because I'm actually an animal lover, and anyway, I reckon he's got his hands full with the baby.

And I think if he can't cope with the dog and the baby maybe he can cope with just the baby and not to worry about the dog any more and then it's a win-win and also there will be less yelling, and I'll be able to keep next year's lemons for making lemon preserve, because now I'm feeling a bit of a pang about them being all over his porch and there's none left on the tree.

So, I jump over the same bit of fence by the tree. The dog hasn't heard me. I'm sure of that. It's all tied up and face on paws in its kennel. It looks sad and so I just go up there and stroke its soft fur into a nice line and it starts shaking its tail. I was going to let it out to run wild and free, but just while I am here stroking its fur into a line, I get a reply from my wife. It's her usual voice of logic, and it fills up the whole screen. She says she'll be home soon and we can talk about it and not to get carried away, and she reminds me about the pony club episode.

So, I give the dog the treat and sit there. He's very calm and tail wagging. And I slide one hand down his soft fur and message my wife back. I am feeling a bit better inside. Maybe that game was not the best game anyway, I say to my wife.

I finish my visit and stand up, but even though it's quite dark up in the garden I can see the dog's big brown eyes looking up at me and then I don't want to leave. I find myself reverting to plan A. I slide my thumb on the bolt and release the chain. It goes clang on the floor of the classic mini-house kennel. He lifts his neck up and is licking the back of my hand. Then I'm walking away and he's following me, tail going bonkers. I wonder what it'd be like if I go out the front and down their drive and back up our drive instead. Maybe leave their gate open a crack.

And then, as I'm walking up our drive my wife arrives behind me in a taxi. The headlights make me stop and all my anxiety is in my chest, and I jump to the side. Then she gets out and says, *hello, what are you up to?*

*Just coming back from next door*, I say, and *the dress looks nice*, because I know she likes that and also, it is a fact.

Then inside my wife is saying about taking the neighbours a casserole the next day and offering to take the dog off their hands sometimes. I say, that's a good idea but if it can be vegetarian casserole. She says she doesn't know about that, and then I remind her about the dress looking nice and she says, *okay*.

I put some kidney beans on to soak and now bed. It's too late for being awake and my wife is snoring. I can't sleep. Maybe it's because of the afternoon nap. But also, all the dogs in the neighbourhood are barking in unison and it sounds like one is right outside our window.

HARRIET SALMON

# Hum

You may know very little about degenerative eyesight,
or you may know a lot. You may know about geomorphology
or the modernists
or the immune system, specifically ostrich antibodies and lymph nodes,
or be the kind of person who can sell a broken red pen to a millionaire
or a customer service superstar with your hair in a tight bun greased with
    chip oil
or a marine biologist, or someone who's never seen the sea
or be somebody who travels to the darkest corners of reddit, Greece, the
    back yard
or maybe you have just been waiting years for this one person to call you back.
You may know Korean politics or American politics or the politics of this
    whole stupid place,
maybe you failed first-year law or pursued the wrong music degree for
    three years
or one day in the middle of a nutritionist final exam you stood up and yelled
    fuck
because you'd just then realised you actually wanted to be a poet
or you were the first one in the friend group to fall in love, get a fringe, have a
    parent die
or work gruelling night shifts,
an underpaid healthcare worker, a head bartender, a Cuba Street busker.
You might be taking Tramadol for anxiety or sunburn or heartbreak, you
    might be doing okay,
maybe your friend collects stories in a jar, but she keeps yours up close to
    her chest,
securing it with Sellotape, fastening it with pins, and eventually tattooing
    it down her tummy.

Maybe you had a brush with drugs and are still in recovery
and maybe every Monday that recovery starts again
maybe you left home at fifteen, escaped out the window
moved your entire life in an Uber through the streets of Auckland.
You may be in a cold flat or about to knock on someone's door or maybe
    you're nowhere at all.
You may know very little about classical music,
or you may know a lot
but when you hear the pianist humming alongside Bach's Goldberg
    Variations
tell me that it doesn't make you want to cry.

REBECCA BALL

# you wake to the fire of his temple on your lips

you wake to the fire of his temple on your lips milk and lemon in his hair cold slick of flannelette against your arms

the shock of your lounge in the moonlight scratched blue bucket coarse towels brown bottle from the back of the pantry these things you had forgotten

you draw trembling black lines on a piece of printer paper press a cool cloth to the crease in his brow brief chink of metal on his teeth watch the tiny panel hold your breath as if you could hold those numbers still in your lungs

you draw pink syrup to a plastic syringe press it between his silent lips stare at the red hash on his cheeks the three strands of hair stuck to his forehead stack regrets like pieces of grey schist each unbought toy each unread chapter a pledge you promise to turn off devices to pretend the floor is lava to learn more about Pokémon to stop worrying about the dishes

every cough every twitch every aching roll your own life sighing and turning on the couch disinfectant heavy in the air wet sheets piled at the door you watch the clocks the numbers the numbers pour them like warm concrete between those shaking columns on the page

low light through the trees and he shifts you leap to your knees he rubs crumbs of sleep from his eyes asks for ice cream

PETER BLAND

# The Lovers

Lookout! Tonight
the lovers are coming
on bare feet, bicycles,
scarlet Ferraris. How
fiercely they push
gentler dreams aside
desperate to lose themselves
in each other. It's
as if God let
raw lust run riot
to remind himself
of what banishment
can do. This lot
would trample
whole forests
of forbidden fruit
for a single glimpse
of what's desired.

LIZ BRESLIN

# Hot Shower Time Machine

one time you found him sat in the shower
get up said your dry hand said showers are
for standing but you lived by strange maxims
back then some that are still standing upright
her shower has three sides the fourth curtained
off you go in you come out sluiced you have
a bathroom outside now with no door be
tween you and the stars her shower is
lit by torchlight so warm so hot o stand
in the flow o flow o this is luxe core
of all the showers in all the places
you wind up in a shower like this time
machine you wind up in a shower like
this time of all the places you wind up

ERIK KENNEDY

# Talking in the Corner with the Miniature Golf Course Designer

It's one of those parties where I know almost everyone
but wish I didn't. The drinks all taste of boozy chamomile tea.
I'm in the corner with you, a miniature golf course designer.
The canapés come in 'fun' shapes (stars, triangles, bees).

We're hitting it off like two birds stuck in a bus depot overnight.
My God, there are lots of things to know about angles and caroms
and plastic grass and drainage and the elasticity of wood and cement.
What's easy for one golfer is, for another, an impossible theorem.

You design a system to produce failure to a degree that is just
titillating enough to encourage repeat trade, but not smashing-
the-ornamental-rocks-to-bits-with-a-putter frustrating. It's all about subtle
conflicts, the way golf trousers and golf shirts should be mismatching.

I've never given a relationship that starts off with a lie a chance.
I assume you're lying about your job. I mean, obviously I lied
about mine, but when I said I was *an admiral* I didn't expect you
to believe it. I reckon you didn't, because when I said 'I sail with the tide

tomorrow', as if I was about to leave, you told me to get you another
quiche star and a volatile gin tisane and to sit my ass back down.
So I do. I'm reporting for duty. I still can't tell if any of this is true
so I'm deciding: for tonight I believe you. There we're on solid ground.

But don't expect me to win a modern Jutland, and I won't expect you
to lay out a perfect par 3 where the ball has to pass through
a lumberjack's legs. Expectation management: that's the rock on which
to found a new love, a handy little chute leading to the green on hole 2.

You say that the most important force on a miniature golf course
is gravity. Everything wants to go to the bottom and stay there.
I know that's what a real course designer might say, but it's also what
I think, and I've never seen how to escape from the bottom anywhere.

JANET NEWMAN

# Camouflage

*after 'Echolocation' by Sally Bliumis-Dunn*

Strange, how I imagined my talent
when I spotted the pair of mallards sliding
across the lagoon and disguising their dappled
feathers in the rushes' mottled shadows.

How I conjured their motionless floating
as a kind of becoming with the water,
a settling in with the world such as I sought
to ease my apprehension of it.

How, when the ute crested the hill,
a toothy foxy and an Irish water spaniel
chained to the deck treading decoys,
I stopped knowing how to measure my own fear.

There, webbing the surface, those two small ducks
with their hollow bones.

ANGELA TROLOVE

# Catch and Release

Love Interest is sitting beside my father at the riverbank, juggling stones, concentrating. In the sunlight, his skin suggests he's older than I thought, or that he has made his own decisions in life. Ironically, I would get away with watching—because he is juggling; but I can't watch—because I gaze.

And then I have to tell my son, 'Torch, don't throw stones. You could hurt someone.'

'Just little ones?'

'Little ones are okay, into the water.' We throw shingle, it's soft with sand. It's black.

My son rejects his clothes—they've become waterlogged. I strip off my shirt, something dry to keep the sun off him, despite its inevitable wetting.

With Love Interest bordered off, I pick up my towel and go lie down by his wife.

She pretends not to notice me.

We watch kids scale a boulder and launch themselves from a swing rope. I tug a spare towel over my bikini for shade.

'It's fun, people-watching,' she says eventually, from under her outback hat.

I nod. 'Better than at the airport, even.'

She smiles at her feet and moves her toes in the shallows.

Their son, they have a son, he sneaks up to us like a shark.

When Torch wants to ditch my shirt also, my mother carries him up to the playground.

Presently, we all gather our belongings and join them at the swings. A toddler loiters, without her family in sight, and the men wonder whether to help her onto a swing. My mother passes around a large packet of chips. But it's lame. It's as though the credits have already rolled. We won't see each other again this summer. Stalemate, I think.

Love Interest looks impatient to go but remains politely, as always, and I don't make an effort to give or to take anything. This beautiful river is vacant. We take a chip when the packet is offered to us. We scan for the toddler's mother. Swings are swung. Car boots opened and closed. We're all loitering, but not so that something will eventuate; merely because we've spent the day together.

    A woman arrives from a set-up beyond a few poplars, her young boys race ahead to a climbing frame. As she comes, one of us lowers the toddler from the swing and the child goes off gradually to the woman.

And with that, I bid a brief and general farewell to everyone, and fasten Torch into his car seat.

As my father drives us away, Love Interest's son climbs onto their pick-up. He waves to us vigorously, his child dreadlocks tossing like the arms of Shiva; in the deadlands, this fountain of sincerity.

MADELINE REID

# Mount Eden Dubstep

Straighten my hair / in the girls' high school bathrooms / pink lipstick spread thick / blink twice if you like him / grubby hands in the rugby stands / I never blinked / red vodka cruisers / in the granny flat / walk from Epsom to Ōrākei get cat-called at / fake ID in the liquor store / bag the goods in the park / by the kindergarten / gate-crash a party in West Auckland / everyone stares at you / roll a tinny pretend to inhale / in a stranger's tent at a music festival / strap some Molly to your breasts / dance till 4am / hide cigarettes in your Doc Martens / rip your favourite poster on the wall / when you spray eau de parfum / and your mother gets suspicious / kiss a girl while the boys watch out the window / in the driveway she presses her hands against your collar / winter coat / night breath / bangers on the iPod Nano / Motorola flip top / everyone who is anyone has a Macpac / Mrs Cullen twinked on the back of it / all nighter cramming for biology exam.

Muffin and hot choco special at the dairy / bus is late / if you want to go to the ball with a girl sign this form / I heard you were a lesbian / bruised fruit in your bag / faded white pith / you're going to hell Madeline / jello shots cracked in your palm / Chlöe Swarbrick smoking at the same party / where they lit the chairs on fire / she did a lot of acid at high school / if it wasn't obvious / the mitochondria is the powerhouse of the cell / hating everyone and everything / why is everyone here a homophobe / tomato sandwiches in the tech block / teachers saying that's so gay / holes in my culottes / Romeo & Juliet is a universal love story girls / except it's white and straight / so there's that / yes your children are ugly / and you are boring / compulsive heterosexuality / ain't for me / yet the principal told all the teenage girls / one day they will have husbands / probably to be subservient to them / or else become their mothers / most of the boys I've ever lived with / have expected me to do the dishes / no more Lucky Strikes / on the balcony / that purple breath of night / kissing teenage cheeks.

DAVID EGGLETON

# An Apparition of Books

I have a hymn book in a hatbox.
I have a Bible chained to a table.
I have a book that could only have emanated
from a criminal lunatic asylum.
I have a book to bury your bonce in,
and dig it up again,
once the worms have picked it clean,
leaving a grinning skull.
I have a book larded with lunacies
and blasphemous licence—
a book on the Index Expurgatorius,
that to read is a sin against the Holy Ghost.
But a book that remains shut is just a block of wood.
I have a book with a broken spine,
lying face down on the floor.
I have a book, dog-eared, battered,
pulpy, rained-on, buckled,
that has tumbled along the street.
I have a book with lepidoptera pressed
between the pages.
I have a book with dried poppy juice
nestled lightly in its gutter.
I have a book with chapters stuck together
by the lees of a full-bodied red wine.
I have a book made brittle by the sun,
the ink printed on its paper
barely able to be made out,
even with a magnifying glass.
My multitude of books blossoms like a tree.

RUTH HANOVER

# Frost Cloth

I go to the house and I enter the house • my silent mother tries to tell me something urgent indicated in the way that she has set the table • the table is a dressing table • clutter of cold-cream • perfume • glass jars • hairbrush • the mirror of infancy tilts • swings free :: two even sets of green leaves part in a V • an immediate explicit image of bare thighs • becomes leaves lush foliage • a tropical offering laid before the mirror the apex directed into the vanishing point :: upstairs a bed covered in frost cloth • the bed is a gravemound in lawn and small bright flowers • the bed is a *bed* covered in frost cloth as opaque as frozen vapor • a muffle of sound • a truffle of anomaly • I pull back the frost cloth to find a wizened little old man beneath *live* as the pipe-cleaner Father for the tree • alert • eyes twinkling at the trick • ever so slightly frightening •

MADISON KELLY

# By and by (returns)

Polymer clay, tissue paper, graphite pencil, 2022.
Photographs Madison Kelly.

To be wrapped up in a fabric both dense and openly woven. You see light move through the fibres. To hold taura in the ocean, slack and then at once taut. You learn the currents. To hear tara calling, then to hear their kōrero reflected by the cliffs. You understand they have found their kai for the day. To dive and then to float. You time your breathing. To roll a stone, and feel water fill fresh space around your feet. There are vibrations now. There were tōtara here. You will come back tomorrow.

    The returning act is a familial act. It scales the net beyond single encounter, instead scooping up our many continuous meetings, each with their own amplitudes and interferences and multiples.

    It is also a regulating act. One visit offers time to settle or prepare our ground for the next. I have been looking to other returnees—our tides, our maramataka, our travelling birds and seeds and seasons.

    A routine of field recording demands capable objects to hold the records. In our harbour, rocks do a lot of holding. I see them gathering up and throwing out information with each new tide.

    I make maquettes of these rocks. They are filled with returnees. Tissue, hand and pencil meet the surface again and again—a lapping. Slowly they become interfaces for whakapapa, for learning the returning act.

    —Madison Kelly

RACHEL CONNOR

# Port Side

You are the vessel, then.

The unturned stone, that waits like a shard
flying from the vase when they threw it
into the hearth, pretending it doesn't matter

When pottery is everything that holds us together

Broken in the way Narcissus is broken, unable
to see beyond its own end of usefulness.

And there are times when they return to harbour.

And there are times when we are empty.

TIM JONES

# Uncles

Uncles who turn up in time for Christmas
Flashing false-teeth smiles, the glamour
Of adventure—just returned from a place the rest of us
Can barely spell—and hints of cash.

Come here, boy, they say. Come here.

Uncles who know a thing or two, glass held
At just the right angle, raffish smile,
Suggestive wink, shame blossoming
On one young woman's cheek

And anger on another's.
Uncles who clearly have spent some time
In places they'd rather not talk about,
Doing daring and secret things.

Come over here, boy. Come here.

Uncles who pay attention. To you,
The quiet one tucked away in the corner
Avoiding adult legs, adult arguments,
Adults who do not want you underfoot.

Come here, he says, come here
To see your old uncle, eh? Look,
I've got a coin for you. Can you guess
What country it's from? You couldn't

Take that and spend it at the shops—
But this one you can. You like ice cream?
Go and buy an ice cream. Come back
and let me know how it tastes.

Uncles with a wolfish smile. Uncles
With hands that get pushed away, slapped away,
And linger, moving slowly
Under affronted clothes. You watch the hands.

Nobody says a word, and uncles remain
The life of the party, spreading their charm
On every stretch of troubled water, waving goodbyes
And blowing kisses as the party ends.

Till there's just Mum in the kitchen, Dad in the garage,
And uncles, eyes narrow above a final beer,
Saying I have another coin for you, boy,
If you'll move a little closer.

Saying come here now boy, come here.

JONATHAN MAHON-HEAP

# Julia

Lately, my husband has been saying another woman's name in his sleep. It's one that doesn't belong to his usual roll call. For the past decade, his sight has continued to fade, but his libido hasn't followed suit.

The sound of other women's names in the night is something I'm mostly used to. He groans so softly, not with lust or romance—but matter-of-factly, stating names in the way one might a grocery list. Mostly, I am able to drift back to sleep again.

Some nights the name sticks with me. Until now, they have all been familiar, these women. When I roll back onto my pillow, dreams of them come to mind. Friends, secretaries, ex-wives. They would have haunted our marriage, if I had allowed them to.

When he first lost his sight, I wondered what he would do, and how it would affect, if at all, how he would continue to think about women. The mannered routine of our retirement wasn't altered too dramatically. Reading remained his favourite thing to do, and afternoons swallowed by novels now played out to the marathons of audiobooks I bought for him. The strangers' voices fill our living room as we sit, apart.

\*

Yesterday, I went out with Martine to find him a new book. He has always been unashamed of his appetite, for meals, for literature, for Martine herself (there was one time, a Christmas do at ours in 1979, where he loomed over her by the mantelpiece, she looked like Red Riding Hood, he some comical wolf). Martine has always assured me nothing has ever happened. We both believe this by now, in the way that a lie, sustained long enough, can be more powerful than any truth.

I like going out with Martine. Justine and Martine, Martine and Justine. The coils of her barely-greying hair just come up to my neck, and her size does something to empower her, instead of diminishing her presence.

Seemingly, her height gives her a forward motion—she powers into the gift shops and book shops we frequent with urgency. She extinguishes the lightly perfumed air with her assertions.

'You've got great taste.'

'This new selection—it's divine.'

'When will more of these arrive? I simply need them—you must get some more.'

For some, I know her manner of complimenting grates. I find it comforting, this fountain of opinion, and I feel like the shop assistants do too. The only way I assert my taste or favour for something is in buying it—even then, I am so likely to be coaxed into a purchase by a zealous attendant whose beauty I find intimidating.

You'd think such things would matter less, in old age, that you'd seen enough beauty for its effects to dull on you, like so many of life's former sensations. Yet it's perpetual, it evolves; as a plain-looking woman, I spend my days scouting crowds for striking faces, landing on them with a face of recognition normally reserved for greeting a loved one at an airport.

I used to collect my husband from the airports, spot him in a pinstriped suit carrying his fraying brown briefcase. I even made a sign for him once when he was arriving from a long conference in Australia. The sign stayed in the glovebox of the car that same evening, when he drove to Barbara's house on the pretence of picking up some files. She was his secretary in the 70s, after we met—a sort of sequel to the affair that had been our own courtship. Barbara was the wife of Roger, and we acquired them as friends in the late 70s when Roger came to work in the neighbouring firm.

Barbara. Always a favourite of his to moan during sleep now, though I can't fathom why. He had always treated her with the unaffected, disdainful air of an annoying pet.

Once, when holidaying in Fiji with them, I saw him turn his cheek from an incoming tipsy kiss from her, targeted while I was supposed to be inside pouring the next round of drinks. This sort of at-home espionage had become a speciality of mine. I like to think I would have made a good spy, in the pathetic way many introverted people probably do.

The same house into which he would tiptoe in the early mornings has since become his obstacle course, of sorts. Occasionally these days, I can hear

him as he stumbles around upstairs or makes a muffled thud, colliding with the bookcase at the end of the staircase.

More and more, I find myself not asking whether he is okay in such instances. I wait it out, until he resettles on his course and I can hear the shuffling footsteps again. There is something in the slapstick nature of his blindness that even makes me laugh.

*

It remains, as it has every night for the last five months, Julia.

Not Julie. That, at least, would make sense. He'd slept with her in '87, the final year of our daughter, Charlotte, at college. The parent of one of Charlotte's close friends, he'd been so readily honest when I'd confronted him about it. Julie. She with off-white hair (it had been that way since a prematurely young age), high voice, long limbs and an accent that was not quite from anywhere. She compelled a hatred in me that was so strong it was vaguely sexual.

I assumed Charlotte had never known. Her own marriage had broken up, so she knew something of these affairs. 'Combusted' might be the better word, for he had left the family home less than 72 hours after their first argument. I remember the sleepless nights and dreary days she spent living with us, her hair dangerously close to attracting the local bird life, with those new pillows of fatigue under her eyes. In one of her Tanqueray-tinged outbursts that took place over the course of her stay, she launched Julie's name into the fray at me—not her father.

'I grew up never able to speak my mind! Because you never did! Not about Julie, not about Maria, not about anyone!'

I don't know who Maria was, but she'd tottered off towards the bedroom before I'd had the chance to ask her. I don't have any regrets about not inquiring about her, not really. I suppose I never saw the point.

*

It's hard to believe that Martine was the first person I discussed any of the infidelities with. She is hardly taken seriously by the good portion of our friends, as though her stature makes her an inherently unserious person. As it turns out, she largely is.

I was walking out of a café not one week after telling her about Julia, when I overheard her sharing every detail with another friend, as they had a date on the terrace. They loved this news, the others. I was almost happy to give it to them. It provided a plot twist in their own lives so enjoyable and delicious from their vantage point, without any need of inveigling themselves directly. Instead, like an aghast crowd spotting fireworks, it grouped them together, watching this patchwork of fire play out from a safe distance, ripping through lives that were not their own.

I think that Julia is an actress from this 80s TV show we used to watch and make a note of this. Or was she the gardener back in Omaha?

I know the rest of them. They don't bother me. But Julia lingers. I imagine what their dinnertime conversation would be, the way she would dress for him, or serve the food onto his plate. She sits in the corner silently reading some days, occupying the couch, and I acknowledge her politely, like our foreign exchange student, or our daughter's friend. I nod at her, in tacit acceptance of her place there, and we go about our business in silence.

★

Now it's 7pm, time for his bath and bed. After I've tucked him into the bed, an almost inaudible exchange of goodnights later, I pour a bath for myself.

I sit. This is the highlight of my day. The neighbourhood is crypt-like in its silence. The small waves of the bath lap at the folds of my stomach. I must do more to shed them. I listen.

Julia.

I wait. An indistinct noise, the waves. He mumbles something.

Julia.

I say her name to myself, imagine Julia in bed with him, their life playing in fast-motion before my eyes.

He coughs again.

Julia.

JAN FITZGERALD

# Sea Change

This is the moment of disquiet—
waves dragging pebbles into the echo
between cove and cape,
penguins in a rescue enclosure
crying for their keepers and fresh herring.

I rise as streetlights go out
and the dawn train rumbles in,
shaking the trees of a thousand sparrows.
With my arms stretched out to the sun
like a child to a mother winding wool,
the last skeins of sleep slip
from my wrists.

Don't you hear it?
Between trucks changing gear
on their way to the port,
and gulls bickering over KFC roadkill,
something is brooding,
aching like old bones in cold weather.

I stand, electric jug in hand,
listening to the ocean's unease,
to waves talking up a storm
and something else—
like the blue jellyfish-like
Portugese man o'war—
using wind and currents to propel itself
forward

into a world we haven't known before.

VICTOR BILLOT

## Where it Returns

The glory of. And the flags.
Iskanders and Stingers. Wing'd fire.
The Nazis are there. And the Commies.
And the Democracy. And Strategy.
Geopolitics will be there, and Nations.
Justification is there, and lies everywhere.
The thermobaric which sucks air from lungs.
The acronyms will be there.
Currencies tanking. Gold is still a good bet.
Presidents on telephones. Oligarchs, too.
The blacken'd trucks, and the Security Council.
The queues for the bread. And the cash.
Convoys will be there, and the lost eyes
of the damn'd young following orders.
And where it returns, always,
to the weeping father, aged terribly and sudden,
holding onto curled hair,
wound in a dirty white sheet,
daubed with a little blood:
as if someone had cut their hand.

ANNE WEBER (TRANSLATED BY JANA GROHNERT)

# Visiting Cerberus/Cerbère (excerpt)

Every once in a while, after a long period of solitude, happiness bursts into being: floating above the road, on an elevated seat, in the back of a half-empty bus driving through a dark forest pierced by sunbeams. It is neither too hot nor too cold; the recorded voice of a woman announces the next stop appearing in fluorescent letters on the screen above the aisle.

Soon, we will be on the main road. I look in all directions at once to memorise everything as it is right now: the light, bursting through the tree tops; the fluorescent letters, whose reflections I see scutter through the forest in the window; my skin, smelling of the algae-green coloured lake water; the little boy riding his kids' bike alone on a track between the fields. All this takes a few minutes at most. Summer will be over soon. *Le fond de l'air est frais.* There is a chill in the air.

Later, after sunset, I return to the lake. Beneath murky skies, the water continues to glisten for a long time. I stand by the balustrade, trying hard not to lose my balance. Far below, a moving shimmer reflects up to me. Of the passing ships, only the lights can be made out.

Back in my room, I try to think of New Zealand. There too lives are being lived at this moment by humans (among others). As often as I have tried, I never succeed in picturing this simultaneity. The name New Zealand, like many other place names, conjures up images from dark corners of the mind— snowy mountain tops, long rugged coastlines. Yet I try in vain to translate myself to the other side of the globe and into these timeless landscapes existing at the same time as the lake that stretches out before me, swelling from the rain, concurrent with the Mexicans and the Chinese, the ant-eaters and the tulip glasses.

I will probably never set foot in New Zealand. (Will I ever set foot on new land?) Whether I jump out of the window or sit at my desk would mean little to New Zealanders. But if today all Europeans decided to jump out of their windows—while they would certainly not land on New Zealand, the wave of

shock would make landfall. My existence has importance for other people on earth, even if only to a minimal and probably purely theoretical extent. Is that enough reason not to jump out of the window?

At times, I feel like giving New Zealanders a cue, or waving to them from across the oceans, through the cities and the bush. In moments like these, I feel as though I have an important message for the people in New Zealand.

When I was a young girl, I experienced the world vanishing multiple times. I have tried, more than once, to describe the experience, but as a result of me trying to describe it, I have not had it. Because I no longer have it, it has become more and more significant to me over time. I am careful—beware!—not to deduce any general truths from this sequence of sentences. If you are able to deduce a general truth from a sentence, the sentence is suspicious. Therefore, the last two sentences are suspicious.

This is what happened: I was having breakfast or passing through the hallway or completing my homework, when all of a sudden, the world vanished. Everything hitherto seen and known began to shake. No, nothing began to shake, there was no time for shaking: from one second to the next, not only my familiar surroundings, but the whole universe was gone. In trying to describe it, I realise once again how difficult it is to find the right words. I keep trying, no doubt, because the task is impossible.

This great marvel that everything really exists—smoking chimneys, bronze beetles, howling cars moving back and forth, blades of grass—the world in the way I see and do not see it, this marvel had suddenly morphed into something else: nothing. The dizziness I felt made me close my eyes, but as soon as they were closed, the world was back again. Until the next time. For fractions of a second, I was floating in a void: not just the ground under my feet, but the whole globe had been lost, and the sky above my head, and the handrail beneath my fingers.

Decades later, I continue to orbit around this gone-in-a-flash void, and wonder why this feeling of dizziness got lost around the same time as my childhood. Do I no longer marvel at things the way I did back then? I do—but apparently it no longer stuns me. Perhaps coming of age marks the moment in which marvelling turns into mere surprise—well, how strange! People who get surprised are secure, nothing can happen to them: they stand at a safe distance from the events and raise their eyebrows, amused. Those who

marvel, on the other hand, are always in danger: if they can't believe a thing, and the disbelief takes hold, the thing risks being swept away.

Should my condition have continued, I would have fallen through the bottom of myself and further, away from no particular place towards nowhere in particular. Tired of my same old self, the doctors would have put me in a straitjacket, in which I would have continued to fall until the end of time, and even beyond that, since for me, neither time nor the end would have existed. Like a lone mummy, I would have floated in a vacuum feeding on my thoughts, seeing that even back then, in each falling moment, I always preserved myself. In retrospect, I regret this sometimes: would it not be awfully soothing to be liberated from the capsule of one's self from time to time, and be completely weightless? Instead of having your feet firmly on the ground, and being at your own mercy, and the mercy of all the impressions, sensations, trip-ups and mental challenges this world expects us to endure constantly, to be able to switch oneself off like a flickering lamp?

Dreams lack solid ground and contours. Like whiteish, translucent jellyfish they drift through the night, opening and closing to the rhythm of alternating phantasmic shapes. With lungs like these, the dreamer breathes.

GLENN COLQUHOUN

# Caselberg Trust International Poetry Prize 2022 Judge's Report

This has been the most difficult poetry competition I've ever had to judge. The longlist stretched out behind me for miles. I had to cast my eye back over it again and again to whittle it down. That's really what I want to say first and foremost. What a beautiful bunch of singers these entrants are.

But competitions are competitions. And they're cruel and joyful and nuts.

Inevitably judging poems made me ask again what it is I respond to in a poem. And so, I'll hit you up with that for what it's worth. And because it might help make sense of my choices.

After scribbling for so many years without any sensible idea of what I am doing, and resisting all the pronouncers and pronouncing, I think a poem for me is most simply a song. Perhaps a song for the spoken voice nowadays. That is how they began after all. As a reaching out with language to do a few simple things that we need language to do; ask if anyone is out there, rock a child to sleep, say goodbye to a love, make the tribe dance, tell of our histories and geographies. I can't really think of anything else.

And because they were sung then they contain a cry. Some sort of note or tone or ache or reach. Perhaps a thumping old heartbeat by which all things are listed. Perhaps an echo of children laughing. Or a storm brewing.

Those are the rough palettes.

Over time though they changed shape a little. And then it was that they developed startle and conceit. Or the riddle if you want to put it another way. And I reckon these qualities especially ramped up after poems started to get written down. It meant we could read them over again and again. And lay down elaborate curling weaving thoughts. Poems got brainier and brainer. And the pleasure and shock of looking at something taken for granted in a new and powerful way became a pleasure in itself. Poems always played with language when they were sung. But after writing rocked up they could go nuts. And did.

Sometimes it makes me sad though when I see people not engaging so much with poetry now. Or feeling intimidated by it. So, I'm a sucker for those old joys of oral poetry that were so democratic. And relied on the audience as an integral part of the interaction between a poet and their work.

That's enough of that. It might just give context to my choices. Poetry competitions unearth great poems. But they also ask us all over again what it is we are responding to.

### Winner

With those thoughts in mind my winner of the Caselberg Poetry Prize for 2022 is 'Not what you wanted' by **Yvette Thomas**. Why? Because it sang. And it hurt. And it made me recognise the hurt in all of us. And because it riddled with language. It juxtaposed words in combinations that made me think and feel the freshness of rejection all over again—no matter how old a friend it has been. And because it rose up and fought back and was beautiful. It spoke with a single uninterrupted voice. I believed the person who wrote it. My deep congratulations to them. I doff my cap.

### Runner-up

My runner-up is 'Self portrait, nude' by **Margaret Moores**. Because it made me love again all that is beautiful in what breaks. And because it redraws especially all that old bullshit about the ways women's bodies in particular are supposed to be. I cheered all the way through it. Perhaps it's the old doctor in me too that has tended bodies for years. And found so many beauties in the way they bend and nip and tuck. As if life itself is a big old chisel carving them into something so much more gorgeous than the mad values of The Bachelor.

I loved that it sang too in its own quiet way. Holding a tension from start to finish. The perfect cadence of human thought and reflection. Bloody good stuff.

### Highly commended

As for the others, God it was hard to turn them away. I rarely found anything that wasn't a great poem, or a great poem in waiting. You know, those poems you see inside poems. I found so many of them. But it's a competition eh? It's not like I can just beg you to take a single line out so the thing can soar.

I loved the poems to age. The poems scattering ashes. That someone thought to imagine a leopard loose in a city. I loved the poems celebrating old love. The poem about swimming at night. The poems talking back to other poets. The idea of writing to a bag of saline with added potassium is genius. I wish I'd thought of that. The same goes for the poems celebrating Mintie wrappers, old pianos, maps. You guys know who you are. Here's to you all. A deep bow to those who talked about illness, tumours, and to whoever sang the tidal blues. The concrete poem on the tidal zone was a cracker too.

In the end I decided to highly commend the following poems. But the list could certainly have been longer.

'A home for just us' by **Rata Gordon**
'Chicken' by **Claire Orchard**
'Too much telling' by **Paula Claire King**

Thanks to all who entered the Caselberg poetry prize—for the haunting, and for the effort of trying to tie a piece of human thought down to a piece of paper. Thanks for the urge to say. So many sayings in a way add up to something greater than any individual poem. They are a small piece of reportage into what human beings sing about in twenty-first century New Zealand. A piece of remarkable science perhaps. I loved this view of the poems too. Placing them end to end created something that was greater than the sum of their parts.

Nō reira, Ngāti Scribblers, tēnei iwi mīharo, tēnei iwi ngaoko, he mihi nui ki a koutou katoa. I loved sitting around your fires. What other sensible thing is there to do in this big old scary and beautiful world?

YVETTE THOMAS

# Not What You Wanted

I could have been your Boadicea
or blossoming lavender in July,
your secret treehouse, your starfish in a rock pool,
your dirty girl who did all the things you wanted,
whenever you wanted,
your underwater cave, your shy muse, I could have been
a sweet voice singing in the distance,
or a red helium balloon with "I Love You" written on it,
I could have been leaves doing amber backflips in the wind for you,
or an abstract painting hanging on your wall,
I could have been your Azure Window,
your lighthouse, your pyramid, your temple,
maybe even your very own Hanging Gardens of Babylon.

But I wasn't.

I was a meerkat hiding in a burrow, an insomniac,
a lover of benzodiazepines and Scrabble,
I was a dense thicket, a message in a bottle,
a used device with missing instructions,
a thrashing epileptic, a tea party for one,
a crab scuttling across the shore,
a sparrow flying with a twisted leg,
I was a frantic pacer walking up and down,
an unlikely prophet who predicted terrible things
which came true,
but most of all I was midden,
animal bone, ash and mollusc shells,
broken tools and fish hooks.

MARGARET MOORES

# Self-portrait, Nude

Drifts of sand under wooden benches, faint smell of pee, a puddle on the concrete floor where the roof leaks. The harsh scrub of a threadbare towel dried to a crisp by the sun. A shaft of light revealing goose-pimpled breasts and pale belly contrasting with tanned and sun-spotted arms and legs. A single varicose vein winding down the back of her right leg from the soft place behind her knee.

She walks home towards her brushes and paints and the challenge of luminosity, colour, skin that is always covered. The varicose vein is hers to depict or not. Smudge of blue-green pastel or watercolour pencil. She is aware of her knee, the way it creaks sometimes and the way her shoulders ache. A sudden memory of making damson jam follows, blue skins staining the yellow flesh crimson. The back of her hands wrinkling now like jam setting on a saucer.

She could depict herself as smooth and blemish free in a kind of pink glow because of the curtains she has pulled against the light. A different hair colour might make her look younger, and lipstick, if she could find the tube at the back of the bathroom drawer.

She adjusts the lamp to get the best out of her skin tone and leans toward the mirror while her belly settles on top of her thighs—as disconcerting as discovering that all the entries in her address book are out of date. The curtains billow against the open window, the pink glow pulsing, while she considers what she could reveal— scars, liver spots, newer purple plum blotches, and the folds of flesh at her waist like a badly plumped cushion. When she raises her brush to the canvas, something lightens within her.

# Landfall Review Online
www.landfallreview.com

Reviews posted since April 2022
(reviewer's name in brackets)

### April 2022
*Entanglement* by Bryan Walpert (Chris Else)
*Enough Horizon* by Carol Markwell (Helen Watson White)
*The Pink Jumpsuit* by Emma Neale (Kerry Lane)
*ināianei/now* by Vaughan Rapatahana (Erik Kennedy)
*Formica* by Maggie Rainey-Smith (Erik Kennedy)
*Middle Distance: Long stories of Aotearoa New Zealand*, ed. Craig Gamble (Sally Blundell)

### May 2022
*Kurangaituku* by Whiti Hereaka (Iona Winter)
*tumble* by Joanna Preston (Robert McLean)
*Reading the Signs* by Janis Freegard (Robert McLean)
*Slips: Cricket poems* by Mark Pirie (Robert McLean)
*Isobar Precinct* by Angelique Kasmara (Rachel O'Connor)
*The Time Lizard's Archaeologist* by Trisha Hanifin (Rachel O'Connor)
*The Forgotten Coast* by Richard Shaw (Rachel Smith)
*Wai Pasifika: Indigenous ways in a changing climate* by David Young (Rachel Smith)
*Both Feet in Paradise* by Andy Southall (Shana Chandra)

### June 2022
*A Good Winter* by Gigi Fenster (Sally Blundell)
*Goddess Muscle* by Karlo Mila (Vaughan Rapatahana)
*The Surgeon's Brain* by Oscar Upperton (Vaughan Rapatahana)
*Home Base* by Keith Westwater (Vaughan Rapatahana)
*James Courage Diaries*, ed. Chris Brickell (Alan Roddick)
*Breach of all Size: Small stories on Ulysses, love and Venice*, eds Michelle Elvy and Marco Sonzogni (Melanie Dixon)
*Whai* by Nicole Titihuia Hawkins (Jordan Hamel)
*Tōku Pāpā* by Ruby Solly (Jordan Hamel)
*AUP New Poets 8* by Lily Holloway, Tru Paraha and Modi Deng, ed. Anna Jackson (Jordan Hamel)

### July 2022
*Grand: Becoming my mother's daughter* by Noelle McCarthy (Wendy Parkins)
*You Sleep Uphill* by David Merritt (Erik Kennedy)
*Super Model Minority* by Chris Tse (Erik Kennedy)
*The Pistils* by Janet Charman (Erik Kennedy)
*Home Theatre* by Anthony Lapwood (Sally Blundell)
*House & Contents* by Gregory O'Brien (Alan Roddick)
*Museum* by Frances Samuel (Alan Roddick)
*Farce* by Murray Edmond (Alan Roddick)
*Come Back to Mona Vale: Life and death in a Christchurch mansion* by Alexander McKinnon (Kerry Lane)

### August 2022
*Raiment: A Memoir* by Jan Kemp (Wendy Parkins)
*Things I Learned at Art School* by Megan Dunn (Wendy Parkins)
*mō taku tama* by Vaughan Rapatahana (Claire Lacey)
*Rangikura* by Tayi Tibble (Claire Lacey)
*Meat Lovers* by Rebecca Hawkes (Claire Lacey)
*The Birds Began to Sing: A memoir of a New Zealand composer* by Dorothy Buchanan (Rachel O'Connor)
*Unposted, Autumn Leaves: A memoir in essays* by Stephen Oliver (Rachel O'Connor)

### September 2022
*Arms & Legs* by Chloe Lane (Sally Blundell)
*Actions & Travels: How poetry works* by Anna Jackson (John Geraets)
*Down from Upland* by Murdoch Stephens (Craig Cliff)
*Tūnui | Comet* by Robert Sullivan (Siobhan Harvey)
*Another Beautiful Day Indoors* by Erik Kennedy (Siobhan Harvey)
*Ravenscar House: A biography* by Sally Blundell (Max Oettli)
*Road People of Aotearoa: House truck journeys 1978–1984* by Paul Gilbert (Max Oettli)

The Landfall Review

# This, that
Kate Duignan

**Mary's Boy, Jean-Jacques and other stories** by Vincent O'Sullivan (Te Herenga Waka University Press, 2022), 240pp, $35

What methods, what images, what voices are available to fiction that wants to examine the psychology of the coloniser? Vincent O'Sullivan's glittering, intelligent, layered collection, *Mary's Boy, Jean-Jacques*, comprising the titular novella and several shorter stories, makes forays on this tricky question, while also exploring the tendernesses, betrayals and inheritances of families.

'Ko Tēnei, Ko Tēnā', written in a pastiche of mannered nineteenth-century prose, holds us in the psyche of Mason, younger son of Sir Jack of Quercus Park who 'had done well in the plantations of the West Indies, where his slaves, he boasted, were treated as if part of his family, while sweetening the lives of his fellow Englishmen'. Mason, the ultimate privileged and swaggering young son of empire, wantonly transgresses on bodies, both living and dead, whipped on by a toxic brew of sexual desire, disdain for legal and moral limits, and a dead capitalist eye that reduces humans to objects and commodities. Wanting to fuck his unacknowledged sister is the least of the wrongness here. 'How far would he go, he thought, with a quickening that was itself pleasure. How far might a man dare go to reach his own boundaries?' Shock, titillation and transgression intoxicate Mason; depravity is his drug. The apotheosis of his addiction is the purchase of a human head. (We're tipped off in the book's cover note, a warning from the publisher, I suspect.)

Mason's motivations are clear. But what about O'Sullivan's? Is this a story that forces us to look at the sickest acts of colonisation, which we should all be made to see? Or is it a tired reinscribing of an old and terrible insult? What if this fiction trades in exactly the same hunger for something *more* obscene, something *more* depraved, that Mason himself is turned on by? Perhaps that's the point. Readers (some readers) catch themselves in the compromised position of *wanting to be appalled*. Who is the voyeur now? Who is the purchaser? It's risky stuff: literally a high-wire act. If the shock is purposeful and worthwhile, and each reader will have to decide this for themselves, it's due to the symmetry and reciprocity of the story. The final twist is exquisitely choreographed and precisely calibrated. 'Ko Tēnei, Ko Tēnā' tilts on the fulcrum of its title, the balancing of two elements, in two different hemispheres. *This, that.* This, therefore, that. *This here, that there.* We get catharsis and the debt is paid, measure for measure: the rapacious coloniser gets his comeuppance. It's a fairy tale we're in, not history.

*This, that.* The principle runs through the whole book. In 'The Young Girl's Story', a daughter is taken to her mother's academic conference in France. Early in the piece, she stands behind her father's chair, 'a hand on each of his shoulders'. It reads as filial affection. At the story's close, she makes the same gesture toward the academic rockstar who will make or break her mother's career, 'her left arm across Kelvin's other shoulder so that hand too touched the papers as she leaned over him, laughing'. This time though the girl is throwing a little bomb, wanting it to be read as sex, just as the bus of conference delegates pulls up with faces 'like a row of plates on a shelf'. The rhyming action of the girl's gesture is subtle, and the plates image is striking. Still, this story felt like a rare weak spot in the collection. Even taking account of the girl's narcissistic mother, I couldn't believe in either her naïvety or her sudden knowingness.

Everywhere else, O'Sullivan is excellent on women, including the exhausting facade of motherhood. 'Not a thing you'd say to a soul, but even your own daughter could bore you,' says Emily, playing draughts once a week with her schoolboy grandson while her stressed-out daughter gets rich off real estate. One of my favourites in the collection, 'Splinters', is sardonic and tender and complex. Like an Alice Munro story, it holds a tight kernel of secret history in its domestic interior, the nap of a velvet tablecloth tipping us into the illicit memory. 'She ran her hand over the faded plush she had stroked for as long as she remembered.'

In 'Good Form', a middle-aged brother and sister gather in their renovated childhood home, where they sit gently with the past. 'The woundings of time. Alison and Andrew speak of it sometimes.' The word *wound* is precisely placed. A Jesus-loving mother inflicts ghastly stigmata on herself. It shatters Andrew, leaving something that can never quite be repaired. In the previous generation, men took out their pain on each other, women on themselves, but Alison isn't prone to martyrdom and Andrew is seeing a therapist: is this progress?

In several of these stories there is a recurring motif of sexual betrayal across family lines, love triangles of the most wincingly painful kind. Whoever is the most forbidden fruit in a tight social network—your neighbour, your husband's best friend, your brother-in-law—is the one the character is going to tangle with. The fallout ranges from guns to weddings. Sometimes it's just fun. Mason's sister-thirst in 'Ko Tēnei, Ko Tēnā' is flipped at the last minute by O'Sullivan, so that 'sleeping with the person you shouldn't' becomes a playful, queer and joyous proverbial finger to the patriarchy.

In 'The Walkers', we're in a world of male gentleness. A father and son pairing provides a tonic to revolting Sir Jack and Mason. Eric, who might be autistic, is our viewpoint. We come to

realise that his father, Tommo, has woven a thin protective veil over his boy's vulnerability, inscribing in him a geography and a community in which he might survive. This is his inheritance. It was a treat to walk through Dunedin in this story.

'Mary's Boy, Jean-Jacques' opens in 1818, the year that Mary Shelley's *Frankenstein* was both written and set. Through his eyeglass, Englishman Captain Sharpe observes his crew endeavouring to bring a living being off the Arctic ice, and into his boat: '[T]he ragged figure he looked at so gave the impression of burrowing, convulsing, as if its entire drive was not to be rescued, but to escape further away, as if *into* the ice itself.' Shelley's novel leaves the unnamed 'creature', 'wretch', 'monster' setting out from a boat back to the Arctic wasteland, planning to immolate himself on a funeral pyre, tormented by the murders he has committed, grieving for the death of Victor Frankenstein, crying 'he is dead, who called me into being'. Is it a rescue or a kidnapping we are witnessing in O'Sullivan's scene? The creature is no one who wants to be saved.

On the 200th anniversary of the book, Jill Lepore wrote in *The New Yorker*: '*Frankenstein* is the story of a creature who has no name, has for 200 years been made to mean just about anything.' The novel, she says, has been read as 'a cautionary tale' for the unleashing of science, a tale of overweening ambition, a referendum on the French Revolution, and an analogy for slavery. She points out that the creature is also, perhaps most simply, a baby. Shelley first conceived of the story one famous summer at Lake Geneva, where, at only eighteen herself, she mothered her five-month-old baby, barely a year after she had woken to find her unnamed firstborn infant dead beside her. Shelley wrote in her diary: 'Dream that my little baby came to life again; that it had only been cold, and that we rubbed it before the fire, and it lives.' Shelley's creation from that fevered time—baby, monster, slave, artificial life—lives on as a vessel for whatever feels morally and politically most urgent to interrogate. In our century: colonisation.

In O'Sullivan's hands, the creature quickly becomes the focus of the imperial energies of Captain Sharpe and his nephew, Lieutenant Jackson: after hauling him onboard the two men cannot resist their drive to categorise him, name him, measure him, educate him, convert him and sexually exploit him: 'They baulked at going so far as to call it "civilise", although that was what at heart each meant.' Sharpe and Jackson chuckle as they name the creature Jean-Jacques: 'your natural man'. The creature takes it all rather gently. 'Companionship' is what he feels in the Captain's cabin, the implied violence veiled. Brute force crouches waiting, in the muzzled dog purchased in Sydney, trained to kill blacks, and in Jackson's quest to hunt a moa, for which purpose

his men set out with 'firearms and machetes, the coiled extensive ropes that would hold the captured prey, the fetters and chains that might be called for … and the iron bars, the height of a man, whose uses might range from belaying on rough slopes to whatever emergencies might come in moving or confining something whose dimensions could only be guessed at'. It's a brilliant and chilling description of technology and imagination leading each other on. The twin drives of science and empire go hand in hand. The dangerous ambition of the mad scientist in *Frankenstein* has transmuted here into the ambition of Englishmen bashing through Fiordland bush with the single-minded aim of caging, controlling and owning a wild being.

*This, that* is visible everywhere in the titular novella. The ship is on a journey from the north to the south pole, a vanity project of Captain Sharpe's. Two portraits hang on the Captain's wall, the Virgin Mary and James Cook. 'Your Rousseau, my Aquinas', Sharpe says to Jackson, as the two men spar, Catholicism's original sin pitted against Enlightenment's original innocence. You feel the energy of the text arguing with itself in a dialectical shuttle, ricocheting from pole to pole, furiously engaged, as Damien Wilkins says in the blurb, in 'a kind of philosophical tussle'. The reader is the audience watching the ball fly back and forth, dazzled and entertained by the level at which the game is being played.

The novella gets metafictional when a copy of *Frankenstein* arrives onboard the ship, which the Captain reads, coming to an understanding of the creature's murderous past. The presence of the book gives Jean-Jacques not only a history, but an author-mother, whose name happens to chime with the mother on the wall. The creature is, after all, word made flesh. *Mary's boy*. Dr Victor Frankenstein in his white coat barely features: the focus is all on maternity. But he is still a thought-child: 'a word that need never be, but then a mark is made on an empty page. *And I have begun.*' Because of the novella's insistence on the character's *fictionality*, despite the colonising instincts the Englishmen practice upon him, and despite his Rousseauean name too, Jean-Jacques (crucially) does not stand in the place of an indigenous person in the story.

She exists elsewhere. Her name is Va. She is a girl stolen from her Pacific home, transported, raped, injured, traded and left for dead in the deep south and yet she is surviving, nourishing herself, enduring. Her body, burned down one side, both harmed and unharmed, again evokes *this, that*; ko tēnei, ko tēnā: 'Seemingly one woman from this side, another from that, as she moved and turned … I am this and that, her appearance said to him.'

Va's survivalist situation seems to be imagined in the tradition of Robinson Crusoe. That did give me an awkward hiccup as a reader. I can see that the

novella does need the presence of tagata o le moana. I wonder if shearing Va off from her community made it feel possible for O'Sullivan to write that without going beyond his ken? But the risk is that Va is left floating, insubstantial, mythical, unreal. The move of isolating an indigenous character from their family is one I've made in fiction myself, and I've seen other Pākehā writers make it too. If it's meant as a way of getting around the ethical complexity of representation, I'm not convinced it helps. O'Sullivan may have had other motivations for giving Va this story, though, including the historical facts about the kidnap and trafficking of Pacific people by European ships.

In any case, the infinite loneliness of Va and the creature is both amplified and mitigated by being together, as a tender coda plays out between them. Jean-Jacques becomes both lover and mother to Va. There is the sense of more story cycles to come, the unfolding violent history of the land, as he anticipates 'that the black ship with the covered guns will come again' and cries out a rageful vow to his maker: 'Mother', he says, 'write this: there will be blood'.

We are left finally with the small resonant sounds that the woman Va and the creature utter: 'Je and Va and Ma'. They have only these three syllables of language between them: her name, his name, their love. Is it a stretch to hear the individual in the French *je*, the relational in the Pasifika *vā*, and the human universal *mother*? Nothing feels accidental in the dense intellectual landscape of O'Sullivan's fiction. When we close the book we leave Shelley's creature, O'Sullivan's own creature, to live on, alone in a dark, wet, lonely fjord, where 'he will make the sentence last forever'.

# Difficult Histories
Emma Gattey

**Kārearea** by Māmari Stephens (Bridget Williams Books, 2021), 146pp, $14.99;
**Fragments from a Contested Past: Remembrance, denial and New Zealand history** by Joanna Kidman, Vincent O'Malley, Liana MacDonald, Tom Roa and Keziah Wallis (Bridget Williams Books, 2022), 184pp, $14.99

One of Aotearoa's swiftest birds of prey, the kārearea (New Zealand falcon or sparrowhawk), is beautiful, lethal and a threatened species. Māmari Stephens (Te Rarawa) named her blog after this bird because 'the kārearea's flight above has a comforting distance from the ground', a distance she wished to gain through publishing her opinions anonymously. Thankfully, this initial anonymity gave way to self-identification. Her writing in *Kārearea* exemplifies the whakataukī, 'Ehara taku toa i te toa takitahi, engari he toa takitini' ('My success is not mine alone, but is the strength of many'). As a legal scholar, writer, Anglican priest and wahine Māori, Stephens is incredibly aware of her social reproductive, intellectual and emotional debts to her community. This is a humble book. Through writing these pieces, Stephens realises the extent to which her 'writing needs the people and experiences I come from, if my words are to make any sense at all'.

*Kārearea* is a nest, really, of the essays posted on Stephens' blog between 2016–2020. A many-feathered nest, it also includes sermons, essays written for e-Tangata, and academic publications. Whether writing about devastating casual racism, legal fictions, welfare and sentencing laws, the ethical issues of building marae on foreign soil, rangatiratanga, or her own mother, Stephens is gritty, thoughtful, sardonic and earnest.

While urging that 'grievance is not a state of grace we should hold onto', these essays detail the prevalence of cultural essentialism and racism in Aotearoa. Sadly, she notes, 'just like the violent and heavy histories,' stories of 'everyday ignorance and racism are indigenous to Aotearoa as well'. These stories contain ellipses, silences that gesture towards a wealth of unwritten content. These silences are deliberate. In 'The Only Māori in the Room', for example, Stephens writes, 'Of course, a lot of things had to happen for me to have been the only Māori in that room.' Decades of personal experience and scholarship inform this sentence. But there is no further explanation. There is no need because the target audience knows, or ought to know, this backstory.

Culture, here, is a 'marvellous double-edged sword', both empowering and imprisoning Māori, depending on its definition and deployment. The obsession with culture can lead to the veneration of 'an ossified understanding of Māori culture', one which sees Māori

people as innately practical, as naturally illiterate. This is the type of deep cultural stereotype that projects such as Te Takarangi, and Stephens' own Legal Māori Project, have been combatting.

Flowing from mātauranga Māori (Māori knowledge) and Christian faith, *Kārearea* abounds with homilies, honesty and hypothesis, including Stephens' theorising about the weakness and strength of human nature, the social needs behind bigotry, and the 'relational citizenship' practised by Māori, which balances the pursuit of the common good and rangatiratanga. Stephens is honest, too, about her own internalised misogyny and racism, admitting that it took years 'to realise that male leadership and breezy male authority in all matters are not written in the stars'. Thoroughly socialised through literature and movies to see only white faces, only male heroes, she saw 'no narrative of Māori life' until she was an adult.

The legal system, too, is something Stephens only gradually comes to see as socially constructed and contingent. This 'poisonous exotic' had 'never been inevitable and was not immutable'. Having grown up in Ōtautahi/Christchurch, detached from her hapū, one essay recounts Stephens' 'journey into Māori law', to te ao Māori, and also to the Western legal system imposed on Aotearoa. Starting with a slap on the leg for breaching tikanga, this essay is a bildungsroman of Stephens' passage from whakamā (shame) to mātauranga. This is a journey 'defined by absence, understanding of loss, whakamā, accident and a sense of coming in from the cold'. As a child, she 'had no clear idea that there was such a thing as tikanga Māori'. To her tūpuna (ancestors), this would have been unthinkable. Stephens speaks of the hurtful, harmful non-transmission of knowledge and custom to urban-based wāhine Māori, the burning shame associated with not knowing the reo, the tikanga, or how to karanga. Through intimate vignettes, Stephens shows the 'haphazard development' of her 'understanding of the existence of mātauranga Māori: in particular, the way in which tikanga Māori comprises law'. The long process of understanding Aotearoa as having a properly bicultural, bilingual and bijural legal system, a journey both personal and professional, is an important one for any New Zealander to read. It will resonate with many Māori and should show Pākehā readers the alienating power of their colonial legal system.

Any review of Stephens' work should hew closely to Mana Wāhine (the mana of Māori women), which shapes Stephens' professional and personal life. As a research framework, legal project, and kaupapa of social transformation, honouring Mana Wāhine is imperative in Aotearoa. Although it doesn't explicitly emerge until the final essay, Mana Wāhine suffuses the entire book. Her writing is lit up by the mana and mātauranga of Māori women, and a fierce love and respect for her late

mother. The final essay, titled 'Mana wahine, the legal system and the search for better stories', exposes the legal system as the source of many false, harmful stories about Māori, rendering invisible 'the mana, needs and rights of Māori women' in New Zealand society. Focusing on a 1914 Supreme Court decision and its recent re-writing through the Feminist Judgments Project Aotearoa, Stephens shows that judges can change the stories they tell. And they ought to. Mana Wāhine-based readings of the law were possible in 1914, 'even within the strictures of the colonial legal system', and they are possible now. The rewriting of these stories 'gives hope that the story of Māori women, and Māori generally, and the legal system, can change'.

Mana Wāhine and the rewriting of history also undergird *Fragments from a Contested Past*, a rewarding early publication from Joanna Kidman (Ngāti Maniapoto, Ngāti Raukawa) and Vincent O'Malley's (Pākehā) Marsden-funded project, 'He Taonga te Wareware?: Remembering and Forgetting Difficult Histories in Aotearoa New Zealand'. With Liana Macdonald (Ngāti Kuia, Rangitāne o Wairau, Ngāti Koata), Tom Roa (Ngāti Maniapoto, Waikato) and Keziah Wallis (Kāi Tahu), Kidman and O'Malley have produced a poignant, preliminary exploration of the 'memory wars' that are still fought over the New Zealand Wars (1843–72).

Using a powerful combination of historical and ethnographic methodologies, the researchers investigate the commemoration (or lack thereof) of these wars and how these acts of memory have shaped the nation. They recap Māori struggles to tell their versions of violent historic events, visit human remains buried under forgotten battle sites, and witness racist Pākehā outrage over the petition to commemorate the New Zealand Wars. They road-trip down the Great South Road, explore the history of Kihikihi and the state's neglect of Rewi Maniapoto's cottage, and consider refugees and raupatu, closing with a reflection on silences between Roa and Kidman. They visit locations of massacre and great violence in 'states of neglect and decay', places forgotten and renamed and overlaid by highways in 'deliberate acts of cultural erasure: not just forgetting but destroying the tangible reminders of that history'. Evident in all former colonies, such erasure is encoded in colonialism and imperialism.

Each chapter fuses archival research, field notes and interview transcripts, expressly inviting the reader 'to look over our shoulders at our notes recorded at the battlefields and listen in to conversations that took place … on the road'. This is an intimate book, full of mamae (pain) and maumahara (remembrance). But it is not a book without hope. Part of its kaupapa is making the case for 'a wholesale shift in the way that Pākehā New Zealand engages with the history of the wars fought on our own shores'. The

transcribed field notes are revelatory, both glorious and inglorious. We are witness to great pain, wanton racism, and the exercise of rangatiratanga. (Charming and poetic, Kidman is also very funny.) Interspersed with narrative analysis, these notes record each researcher's observations of 'historical memory in action'. The authors trace the vicissitudes of official and public memory throughout the nineteenth, twentieth and twenty-first centuries, tracing the rise and fall of colonial 'gutsy champions' and the themes over which the 'competing streams of Māori and Crown memories' chafe and strain.

A timely publication, considering the now mandatory teaching of New Zealand history in schools, Fragments explores how to teach these difficult, sanguinary histories, how to improve the accessibility and user-friendliness of important knowledge, and how to use kōrero tuku iho (history) to start undoing the structural harms of racial capitalism and colonialism. Each chapter considers how history can serve as a 'beacon for the future'. If we knew our past better, there would be less Pākehā fear and racist backlash against the perceived rewriting of New Zealand history. Observing that 'we live in a time of radical historical reappraisal', the co-authors reveal this global and local revisionism as something to embrace. The divide over revisionist history is posed as largely generational, with older Pākehā men being most resistant to Māori versions of history. Kidman and O'Malley propose that rangatahi, or youth, may be the necessary agents for change, prompting the nation to a 'deeper historical consciousness' capable of unsettling settler colonial narratives. Teaching New Zealand history as part of the curriculum has great potential for these agents of change.

Against the settler state's 'art of forgetting' or of misremembering (the nurturing of 'distorted or false memories'), key weapons in the 'memory wars', the co-authors advocate for alternative forms of remembering. 'What a nation or society chooses to remember and forget speaks to its contemporary priorities and sense of identity.' Reconciliation, therefore, requires an 'ethical remembering', the ongoing, deep dialogue and understanding of Māori and Pākehā pasts. Fragments is ethical remembrance in practice.

The last chapter is a standout. Somehow, through only black marks on the page, Kidman and Roa's conversation offers the kind of quiet that makes you lean in, straining to hear more. Reflecting on his King Country childhood and the intergenerational transmission of stories of invasion, Roa contemplates the 'silences that travel with Māori communities at times when historical memories become too painful to put into words'. If the recitation of oral history is a form of resistance and survival, the embrace of silence is a shield: another, more complex form of record-keeping. Together, Kidman and Roa think through the pain and

memories embedded in silence, how to find tribal archives in those silences. They consider the histories carried in the 'quietness' around the atrocities at Rangiaowhia. They situate silence as part of Te Wāhi Ngaro, something 'very tangible' that is 'an essential part of mātauranga'. Silence, too, resonates over time. Echoing the pain across centuries, carrying on the afterlife of violence. Silence, too, must be a part of teaching and learning history.

*Fragments* forces us to reckon with the type of peace we are living with. Peace should mean securing both memory and land and ensuring better outcomes for all. Is the peace we have—one characterised by distorted national memory—one we want? Can we reimagine peace, through deeper knowledge of our history, and attain a peace that is more rewarding for all? The authors do not pretend to have the answers, but prompt us to think deeply on these issues.

Both texts grapple with New Zealand's 'messy, contested and uncertain history' (*Kārearea*), the stories that have 'shaped us' (*Fragments*). They are also bound by what is unsaid or cannot be said. Silences, the tiny gaps or vast chasms between kōrero, are fundamental to history. Silences are a way of storytelling, a way of life, a form of research methodology. A blend of kōrero, writing, and silence, history has always been immensely important to national, local and individual senses of identity. We need to share histories more often, to pay more attention to who we are, who others are, and to be more comfortable sitting with silences. There is trauma in these histories. But the secondary trauma of national forgetting, the mamae of memory distortion, only aggravates that initial injury. Mauri ora, he taonga te wareware.

# Earthquakes and Echoes
Lawrence Patchett

**Devil's Trumpet** by Tracey Slaughter (Te Herenga Waka University Press, 2021), 251pp, $30

In her superb recent book on reading poetry, *Actions and Travels*, Anna Jackson asks what makes poems 'powerfully resonant'. Is resonance a quality of the poem itself, or something that belongs instead to the person who reads it? Both, is how I read her answer. There can be 'all kinds of reasons' why a poem might resonate with a particular reader, she writes—to do with who we are and what we bring to the poem—but it's the precise technical work the poet's done beforehand that sets off a vibration within us. Concreteness, precision of scene and particularity of feeling: these are some of the key elements of the poet's technical work. If these elements are laid down expertly, the reader can interact with the poem in such a way that the moment becomes 'incandescent', loaded up with meaning and suggestiveness beyond the work itself. Resonant reading experiences like these, Jackson says, can drive a reader 'on and on, never forgetting that first transformative encounter'.

Why have I started this review of a short story book with Jackson's analysis of poetic resonance? Because I experienced this resonance many times while reading the startling *Devil's Trumpet*, and I wanted to find out what generated it. And because the book constantly made me aware of my own background, influencing these moments.

As a reader and writer of short stories, always learning about the form, I was very eager to read Slaughter's work. A writer and teacher of vast experience—the list of prizes and placings at the back of *Devil's Trumpet* runs for more than two pages—Slaughter has a facility I wanted to study and learn from. Technically, what decisions go into the shaping of stories of such urgency and force? How are they structured? These are the technical questions I wanted to pursue before opening the book.

But in fact, once inside, content took my attention first. Again and again, I was drawn to scenarios I'm familiar with, the fiction reflecting back my reading biases: middle-aged and happily partnered, a cisgender male with a liking for sport, a parent of adult kids, etc. In 'the receiver' a father keeps an eye on his son's eighteenth party and simultaneously cares for his ill wife, while out by the mailbox a young guy stresses about connecting with a woman via text. These multiple zones of action and, as it turns out, mirrored character journeys, are held together expertly. The protagonist mocks and then upbraids the kid for his failure to live in the moment. But he's alert to the irony, because soon he's 'lost' in flashbacks to his own loved-up phone calls, hearing again the 'tremor' of his wife's voice down the landline of his

youth. Slaughter's close writing of sensory detail makes this immediate, delivering the 'pressure of her breath' against his ear, the 'semi-puffs' and purrs her body makes on the other end of the phone.

The title of '25–13' promised sport, and so, not unlike one of the story's characters—plodding where conditioning told me to—I went there next. In fact, it was one of many stories that delineated starkly—for me, at least—the options that a particular form of patriarchy still offers people, without oversimplifying it. The protagonist is married not only to a rugby-head but to the club itself: her house adjoins the home ground, and her son grows up running across the field to her husband's roars of 'be dominant'. The story gives bitter expression to the outcomes of such a set-up—a rugby injury paralyses the son forever and traps his mum in the carer's role forever too—but it doesn't go down the easy route of dismissing it all as toxic. The 'boys' are decent enough: they come round with timber and tools to build a wheelchair ramp, and it's barely their fault they're inarticulate. Rather, the story shows what's lost when you must experience human life within a rectangle of side-line paint, when all you've got is boozy team chants to articulate joy or grief. 'There are traditions that aren't up to me', Slaughter's character says. 'If they have to thump their grief against their sternums, if they have to stomp and bellow it, then so be it. Grief is not a language I understand any better.' As her world-weary friend at the club says, when they see her son's girlfriend hard at it with a new boy: 'It is what it is.'

In fact sex, affairs, illicit longing for a teenage son's mate: these all offer urgent, vital experience for Slaughter's characters. In the first and last stories, and many in between, the drive is towards the animating, wrecking moment of a 'rough-as-guts fuck': 'Lying in sheets, blown out, dedicated to sweat, not a single thing feels regrettable … Their vocation is to fuck.' In 'cicada motel', the character pursues an affair with a married man with relentless purpose, shrugging off the wreckage it causes his family, even when his teenage son turns up. And even then, she's not 'done with [her] nymph skin'. The story makes me think of all those narratives I've absorbed where it's male characters occupying positions like this, pursuing their own desires no matter what.

Slaughter's writing about sex and desire is so vivid because it refuses romantic schmaltz and anchors characters instead in the concrete now of sense experience. Her focus is on the specific and precise, and that's where we get not just sentences that jolt but fictional moments that live as realised drama. One example is when Slaughter slows the reader's rhythm to linger with her character's eye, longingly, on the body of a forbidden youth: 'Horizontal, as he leant, there were tiny clefts in his abdomen, the shade of dirty honey, and as he chatted he itched them, slow, with his trigger finger.'

But the entanglements of desire are seldom uncomplicated. There's anticipation of discovery and domestic blow-up, or the alternative slow catastrophe of living on in a stifling partnership after a passionate liaison with someone else. In 'if there is no shelter' an affair with a husband's workmate is a slowly building earthquake, 'pulling our home down around his head … eating away our foundation'. When the lover is killed, the husband paralysed, and a miscarriage occurs in a portaloo, the quake seems an outsized, Old Testament-level punishment. 'It happens', the protagonist says, 'because you are trying to do wrong'. Of course, it's more complicated than this, but I was fascinated at the pull in many stories between the urgent contact of sex and the forces that hold strong against every such rupture. In the end the roles that are available, the institutions they bulwark, seem reluctant to collapse and form anew. 'Put your clothes back on', concludes one story. 'Affairs are for sluts like you.'

Structuring techniques fascinated me in *Devil's Trumpet*. Slaughter frequently uses repeated phrases and numbers for shape, irony and punch. In the earthquake story, lines from emergency procedures sound at the start of every section break, often in ironic counterpoint to what is actually possible. '*Leave in a calm, orderly manner*' starts one section. Yeah, right. With her father too quake-traumatised to live indoors and her husband unable to wipe himself, there's no easy departure for the narrator. Instead we get to feel intimately the long aftershock of the quake through the lives of these characters. (I'll never forget the experience of listening to this story, superbly dramatised by RNZ, while walking across redzone land a few blocks from where we lost a family friend in the earthquake, the fiction giving me new ways to shape that event.) In a similar structural technique, the last story uses a postcard conceit, the narrator writing constantly from her couple's holiday to the other lover whose body still haunts her.

In the shorter pieces, lists provide a perfect vehicle for Slaughter's extreme skill with language. In 'some facts about her home town', a list technique enables Slaughter to build up a picture of a whole place, free of the linear plod of paragraphed narrative, but with a thread of story and character change, and a stunning range of registers and rhythms. One section talks about a lucky 'fingerfuck' behind a war monument; another gives the sound and smell of companied desolation: 'In the TAB the radio was always tuned to brown loneliness. Pens hung on slack abdications of string. The old blokes smoked their wins and losses.'

This ability to slay a sentence allows too for some devastating ironies and switchbacks, especially in the flash fiction, of which there are many arresting examples in the book. The first ride in 'three rides with my sister' is all full-

throated youthful empowerment: 'My sister's car was a powder-blue deathbox. It smelt of heavy-petting and eyeshadow, spermicidal silver sachets and leaded petrol.' The second ride has the awful, ironic drop: 'It's hard to lift her into the car today. I relay her feet in, still icy in their ward slippers.' Similarly, a killer last line in 'extraction' links visits to the dental nurse as a kid—and those cotton-wool buzzy bees they used to hand out—with the abortion clinic.

One of the greatest challenges of short story collections, I reckon, comes from readers—or readers like me, at least—wanting two things at once. As a reader I want an element of thematic unity, a sense that the book is broadly 'about' something, interrogating a central question, perhaps. This is what makes a collection a book, not just a gathering of stories. But I also want a certain variety, a range of emotional states and character transformations. Yet as a writer I find this tough, because my most urgent fiction tends to pick repeatedly at the preoccupation that bothers me most, carrying the risk that, across a collection, stories keep hitting the same note.

In *Devil's Trumpet*, this preference for a sort of variety took me to 'holding the torch', which reanimates a window of childhood holiday bliss. For the narrator, this moment is still so vivid she can smell it. Away from 'nightmares' at home, she and her bestie and their mums unspool into beachy relaxation at the bach, learning how to do this unaccustomed thing: take a break. The precise focus on sensation delivers their vacation with rare immediacy, as the girls tangle into sleep, their smells and sounds mingling on the woven wire bed: 'Whose hair was whose as we snored and nuzzled? We both stank of dune days, sheep shit and seaweed and salt, and big hunks of sunburnt white bread.' Through the character's eyes and ears we see the easing of her mother's body, hear the tightness leaving her voice: 'My mother with no daylight-is-running-out swish, no huffy don't-bother-me-edge … no don't-be-lates and make-sures.' It's a stunning evocation of two places at once, and two people—a harried farmhouse mother becoming an entirely different person as the atmosphere and restrictions of that place slough off at the bach. When 'the fathers' arrive the impact is all the more intensely felt for the respite that's preceded it. The sounds they make, with their fists and rebukes and noises about 'reputation', return the percussive rhythms of stunted opportunity, of love gotten lost.

In 'if found please return to', we follow memory via a different path, this time through an older woman in a rest home, whose days are now spent forgetting: her own house, her language, her grasp of time, her wayward charmer of a husband. But some physical experiences transcend, like kisses in the threshed barn, or bathing a baby and then 'laying him out on his shawl to babble'. And there's a kind of prayer to go with these moments: 'her face above him teasing up squeals and kicks, his fingers waggling for ends of her stray

hair—just let her remember this—wordless gurgles of love'. An experience so precisely noticed and conjured that it lasts in the mind that way: impossible to forget, resonant. You can't ask for more from short fiction than that.

# Genre Trouble
Airini Beautrais

**The Verse Novel: Australia and New Zealand** by Linda Weste (Australian Scholarly Publishing, 2021), 310pp, $44; **Escape Path Lighting** by John Newton (Te Herenga Waka University Press, 2020), 183pp, $30; **Song of Less** by Joan Fleming (Cordite Books, 2022), 86pp, $25

What is a verse novel? The 'verse' aspect of the term 'verse novel' highlights the relatively unusual nature of this approach. Verse can be defined as language in lines; a novel is generally accepted to be a book-length work of fiction, usually written in prose. 'Verse novel' is itself a slippery term with uncertain boundaries: at what point does something stop being a novel in verse, and start being a 'long narrative poem', a book-length poem sequence, an autobiography, biography or history in poetry? 'Probably when the poet says so', is Australian poet, Alan Wearne's answer to this question.

Linda Weste's *The Verse Novel* does not offer an authoritative definition of the form; rather, it includes interviews with thirty-five writers, including Wearne, each of whom has their own perspective on it. Some of their opinions overlap, others diverge. Some writers describe having a problem with the term: 'I write poetry, not verse', explains Jennifer Compton. Poetry as a genre is also

notoriously hard to define, frequently plagued by false dichotomies—poetry versus prose, poetry versus fiction, or poetry versus narrative—where all of these categories overlap and mesh in different ways. Likewise, 'lyric' and 'narrative' are not necessarily separate; as Weste argues in her introduction, 'Lyric poems or lyric passages are present in verse novels in varying degrees.' Many of the writers she interviews do touch on a struggle between the verse novel's poetic and narrative aspects. Stephen Herrick describes this as a 'push and pull'; Maureen Gibbons as a 'tug-of-war … or, on a more productive day, a give and take'. However, this tension is ultimately rewarding for both writer and reader, offering different modes of crafting and of interpreting narrative, outside of conventions that for some have become all too well-worn.

Who would attempt such a task? Wearne argues that the verse novel 'is the domain of poets not novelists'. Similarly, Tim Sinclair advises, 'If you want to cut a novel into line breaks, don't pretend that's poetry. Your reader is smarter than that.' The verse novel can certainly do things a prose novel cannot. As an enthusiastic reader of the form, it is the array of possibilities offered by poetry in all its iterations that makes it a particularly rich creative ground in which to explore narrative. Contemporary novels in verse are as diverse in form, structure and content as novels in prose—there are just fewer of them.

The verse novel or book-length sequence can appeal to those who want to employ anti-narrative, or foreground gaps, spaces and omission. Some of Weste's interviewees describe an aversion to popular fiction as a motivation for their use of the form. Brian Castro writes: 'I think the verse novel, if we fling out its obsessive versifying, is the great enemy of storytelling. I say this positively. It returns the reader to rhythms and presences and to the archaeology of words. It slows down time through compression and storage.' For Sherryl Clark, it is 'about the spaces and gaps. Not spelling everything out.' Paul Hetherington describes the verse novel's ability to 'achieve immersion in the circumstances, thoughts and feelings of the main characters'. However, sometimes the nature of the form can draw attention to its artificiality, rather than commit to being natural, argues Hetherington. 'Most verse novels are as interesting', Hetherington says, 'for the way their "voice" is inflected, or the voices of their characters are inflected, as they are in terms of the events they narrate.' John Newton, whose verse novel is discussed below, describes the experience of storytelling through verse as a commitment 'to a certain base-line of absurdity'. Thus, the form is an ideal fit for a self-reflexive narrative, one that employs a range of literary influences and in-jokes, which, as we will see, Newton does well.

Many of the writers showcased in Weste's book write for children and young adults. These writers have very

different motivations, often stemming from a desire to appeal to reluctant readers, or to readers who have previously been allergic to poetry. The shorter lines and lower word counts of verse novels can make them a more readable option for students with learning difficulties and/or short attention spans. Michelle A. Taylor describes verse novels as 'a way to introduce poetry to young people, especially if they hate reading and hate poetry!' It's something of a 'gateway drug', says Tim Sinclair.

But these motivations may not be limited to writing for younger readers. Diane Brown describes her experience of growing up in a working-class environment and being the first in her family to get a degree. She explains: 'It is important to me that I don't alienate readers who haven't had that advantage; they can be introduced to poetry and realise it has something to say to them.' Likewise, David Mason argues that verse novels might act as an antidote to the aesthetics that may alienate readers: 'Verse novels are often read by people who claim not to like poetry at all', says Mason.

The form is not without its problems. Weste describes how the verse novel does not clearly belong to any of the conventional genre categories, and several writers describe experiences with publishers who are concerned with the lack of commercial viability: where do they put it in a bookshop? How can it be entered into an award if it doesn't quite fit the parameters of the categories? Taylor exemplifies the negative attitudes towards the form in her verse proclamation:

> Why I hate it? / wank / get to the point / don't know
> what you mean / self indulgent / what is it? / low sales
> /no section in the bookstore for verse novels / where's
> the story?

Despite these setbacks, and despite the difficulties in working with the form identified by many of the writers, the verse novel remains popular. Australia has been a hotbed for the verse novel for some time, with John Tranter, Les Murray and Dorothy Porter being influential proponents during the 1980s and 1990s. The verse novel has less of a following in New Zealand; however, there are many writers of long narrative poems and book length sequences here, a trend that shows no signs of abating. The four resident New Zealanders featured in Weste's book—John Newton, Gregory O'Brien, Diane Brown and Mark Pirie represent only a small sample of New Zealand writers working in and around the form.

While *The Verse Novel* showcases a diversity of approaches and attitudes, it does not hold up to scrutiny in terms of the diversity of the writers themselves. Those represented are mostly white Australians, and while Weste acknowledges Aboriginal writers, Ali Cobby Eckermann, Sally Morgan and Kirli Saunders in her introduction, as

well as Māori writers, Albert Wendt and Robert Sullivan, none of these practitioners are among the interviewees. Weste describes having approached Eckermann, Morgan and Saunders, but this comes across as the familiar 'we invited some' fallback excuse. In order to adequately represent diversity, anthologists must employ diverse approaches. This may mean going beyond a cold-call form email to writers and publishers, and involve putting time and effort into building networks and trusting relationships.

Widening the scope of the project could also have facilitated a more inclusive methodology. While the verse novel is a specific subset of narrative poetry, this anthology covers a range of contexts including historical, biographical and documentary. I can imagine works such as Chris Tse's *How To Be Dead in a Year of Snakes*, Robert Sullivan's *Cassino, City of Martyrs* and *Captain Cook in the Underworld*, and Tusiata Avia's *Bloodclot* being very much at home in this company. There is certainly a lot more to be written about verse novels, narrative poetry and book-length poetic sequences, and I hope that in future anthologists and critics will address the possibilities left open by this collection of interviews.

Newton's *Escape Path Lighting* is one of the verse novels featured in Weste's book. Framed as a satire as well as a 'rococo tragedy', it is described in the jacket blurb as 'a throwaway epic, a romp, a curmudgeonly manifesto'. It could certainly be argued that *Escape Path Lighting* fits all of these descriptive terms. It sits towards the more coherent end of the narrative–anti-narrative spectrum, although it utilises a range of character perspectives with very limited backstory. The reader is left to fill in blanks and colour in the missing details, but this is not an impossible task. While the novel presents a relatively conventional plot, its aims are primarily satirical. This is evident from the outset, with a list of characters including 'Marigold Ingle, Herbalist' and 'Justin Anodyne, poetry instructor'.

The main premise of the story is that a lack of adherence to aesthetic trends in poetry is a crime punishable by 're-education' at a location ominously named the 'Isle of Drunks'. Hence, the pivotal character, Arthur Bardruin, is introduced to the reader naked and washed ashore, having escaped arrest by the Continence Police. In interview with Weste, Newton states that his novel 'became a more or less genial polemic against the technocratic, anti-Romantic attitudes that "creative writing" discourse encourages'. Bardruin, whose name is an almost-anagram of A.R.D. Fairburn, paraphrases statements from the Red Mole Manifesto, and his character would be at home with Alan Brunton, Ian Wedde and their contemporaries. But here, there also appears to be another type of false dichotomy: the generational divide between 'romantic' Boomer poets, and the younger millennials and Gen-Z newcomers currently emerging from

creative writing programmes. The latter group is represented by students William Chang and Mei-Lin Chin. Mei-Lin is described as wearing six-inch heels, a violet leather miniskirt and fishnets, peeking out from under bangs. At the novel's climactic poetry competition, she reads a poem, titled 'What the Fuck Are You Looking At?'

While this character plays into some fairly blatant and not necessarily pleasant stereotypes, I can't help wondering where the actual conflict is. I imagine Arthur and Mei-Lin would get along— the Bardruin-style boomers of the *Big Smoke* era share an exuberance, a lack of aversion to political content, and a kind of romanticism with the current 'new generation'. The real villains of Newton's novel are the creative writing instructors, Christian Bogdanovic, Justin Anodyne and Harriet Whitbread, who represent the opposite: a tendency towards difficulty, irony and obscurity. I get the point of the satire: I enjoyed the joyful over-50s love scenes between Bardruin and his girlfriend Marigold, and the dramatic monologues of former addict Bridget O'Dwyer. However, I did feel that some of the targets of the satire had been unfairly skewered, and the novel risks being interpreted as a complaint by a white male writer of being sidelined in favour of younger writers, particularly women and writers of colour. Bardruin is forced to quit poetry, while the youthful and sexually confident Chin wins accolades and approval. There is a lot to unpack here.

Joan Fleming's *Song of Less* sits at a different point on the narrative spectrum. Ostensibly, it is a post-apocalyptic story about a world decimated by climate change. In her preface, Fleming describes the 2019 United Nations Climate Conference as a 'moral failure on the part of those who could have made change'. This failure becomes the starting point for a fictional narrative about extreme consequences and loss on a grand scale.

But *Song of Less* does not read as overtly polemical; rather, it is a difficult parable. The sequence of poems centres on a band of human survivors who inhabit a 'green-desert' of dust and hollow rivers. The characters have, for the most part, given up their original names and adopted the names of birds: Groundpigeon, Butcher, Frogmouth. There are fragments of story: Cousin Twig is impregnated by Butcher and dies of an ectopic pregnancy; a child arrives and is later lost.

The search for an overarching narrative is frustrated by the inclusion of multiple unknown references, named yet undefined: the Instrument, the Don't-Berries, the Rashing, the Almanac, the Radius. Songs have meaning, but their meaning is unclear. The lack of definition, and of linearity and causation, pushes this work towards anti-narrative. This feels deliberate: the loss of literal meaning mirrors the real losses possible in worst-case climate change scenarios.

*Song of Less* is not a narratively satisfying or an aesthetically pleasant

read. Its stories are horrific, its language is harsh and discordant. Like many book-length poems, it rewards re-reading, exploring the fragments to look for links, to detangle sense. If *Escape Path Lighting* fits comfortably under the verse novel umbrella, *Song of Less* is out in the rain, dispensing with plot in favour of uncertainty, with coherence in favour of loss. Like many verse novels, it is a successful example of the mirroring of form and content, but with a different approach and purpose.

    Both Newton and Fleming's books illustrate Weste's description of the verse novel or narrative poem as 'fresh and full of pluck'. Each has an argument of sorts, but is ultimately also a self-reflexive commentary on form. These widely differing approaches offer an insight into the myriad possibilities of combining poetry and narrative, pushing beyond boundaries and conventions.

# Writing Ourselves Into Existence

Laura Toailoa

**Sweat and Salt Water: Selected works by Teresia Kieuea Teaiwa**, edited and compiled by Katerina Teaiwa, April K. Henderson and Terence Wesley-Smith (Te Herenga Waka University Press, 2021), 221pp, $40

How does one begin to describe the enormity of Teresia Teaiwa? How does one begin to describe the history of this great thinker, writer, teacher, activist and poet? How does one pay a worthy tribute to the woman who made us laugh and cry and feel and fight, in a place where too many Pasifika minds go to die? How does one begin?

    The piece in this collection I return to most often is 'Charting Pacific (Studies) Waters: Evidence of Teaching and Learning', which was published posthumously. The opening paragraph alone fills me with a sense of her:

> How does one begin to describe the enormity of the Pacific Ocean? The most prominent geographic feature on this planet, it occupies one-third of the Earth's surface area [...] How does one begin to honour and respect the layered, oceanic histories of peoples whose descendants today are some of the world's most misunderstood and misrepresented groups? Where does one begin?

    The book has three sections: Pacific Studies, Militarism and Gender, and Native Reflections. The essays are

arranged so that related topics are grouped together. As a result, we constantly jump across her timeline, time-travelling to the different moments of her academic journey.

Teresia was dedicated to the rigour of academic study while rejecting its status symbol. In conversation with her, I once lamented that academic journals are inaccessible, irrelevant, and not where 'real people' are; that's not what 'real people' read. She smiled, that patient and knowing smile that's met so many young, earnest, and perhaps single-minded baby academics. 'If we stop publishing in academic spaces', she told me, 'that's less brown voices there. How is that better?' As she writes in 'Charting Pacific (Studies) Waters', 'Had it not been for finding the solitary article published on Pacific Islands studies by that time (Wesley-Smith 1995), I would have been lost and floundering in this vast ocean of knowledge.' Writing and publishing is a way of writing ourselves into existence, putting ourselves on the record.

Teresia lived her academic philosophies. She gave her time, work and attention to community and activist groups, unions, churches and everywhere that 'real people' were, all the while researching, supervising master's and PhD students, teaching, and making time for a leisurely chat about my feelings of inadequacy in a class where I could not get above a B+.

Teresia constantly interrogated what we as people, academics, writers and thinkers value as knowledge. She saw the importance, the urgency, of looking at how knowledge is framed:

> The university is undoubtedly part of our colonial heritage in the Pacific. But the paradox of colonialism is that it offers us tools for our liberation even as it attempts to dominate us. Education is the perfect example of this colonial paradox. I value my 'colonial' or 'Western' education, even as I attempt to use it to help myself and others discover more about our precolonial heritage and fashion futures for ourselves that are liberating.

In my ongoing journey to learn what decolonisation looks like, I've discovered that it's not about trying to 'go back' to a precolonial society. It is not productive or helpful to try and deny the realities and opportunities we currently have to achieve true liberation. What can we learn from our precolonial societies? What structures did we live under before capitalism became so ubiquitous? What does it mean to genuinely value human life beyond how much money people can earn or generate? What tools do we have to understand and challenge how governments and corporations dictate our world? Teresia's writing always brings up these questions and addresses them with the integrity that was paramount to her way of being in the world.

I look at Teresia's writing and reflections on the role of a teacher and remember what it was like to sit in a classroom with her; a place she saw 'not as a static space but as a vehicle on a journey. This reconceptualisation creates the opportunity for interactive learning to

generate energy for the journey'. Teresia did not romanticise the pursuit of knowledge but saw it as a pragmatic step towards reframing her reality and, in turn, empowering people to move towards liberation. She acknowledged that 'today's students do not always want to share responsibility for their learning, but even though it can be burdensome, it will be more productive for them in the long run'.

In *Sweat and Salt Water*, Teresia reflected on her time at Te Herenga Waka University. She wrote that students who identify as Pacific Islander come to Pacific studies assuming they are there to draw on their own understanding of the Pacific, while those who don't identify as Pacific Islander assume they are blank slates for knowledge to imprint onto. She explained, however, that 'both sets of students should be prepared to swap places at some point in the course, when they will confront new knowledge, not just about the Pacific but about themselves'.

As someone new to the teaching profession (specifically secondary education), I am constantly exploring my teaching philosophy and what it means to be the adult in the room expected to deliver curriculum and facilitate genuine learning. At university, I often got the sense that academics were people who had studied their field deeply, while the teaching part of the job seemed to be obligatory. Teresia, on the other hand, took teaching very seriously. She wrote that it's not possible to become an expert in the Pacific, but it is possible to constantly work in a way that builds more expertise by keeping one's mind open. Teaching remained an integral part of this for her.

There is an anecdote in the book that reminds me of the stories Teresia would tell over a glass of wine or in a hushed tone in the Wan Solwara section of the library:

> Back in Hawai'i, I had the good fortune to be one of a wonderful cohort of East-West Centre grantees from the Pacific Islands. As Islanders tend to do, we spent a fair amount of time enjoying each other's company over beer and potluck dinners. The loud music and singing at our regular parties were not appreciated by some grantees who I guess liked to study or sleep at night and we tried our best under the circumstances to accommodate them when they complained. What I will never get over is hearing that two white women who often took advantage of our hospitality had made some comments about how the Pacific Islanders could not be serious scholars since we spend all our time partying. In their opinion we did not deserve the grants we had. My friends and I discussed the reputation we were earning and decided we did not have to prove ourselves to these two. The parties continued. And our forked-tongue critics continued to partake heartily of our food and drink.

In this piece, Teresia went on to describe how they did, in fact, take their studies seriously and how they were sometimes criticised for it. When the Pacific Islanders at the East-West Centre organised weekly seminars and began to explore the politics and possibilities of scholarship that involved the Pacific specifically, they were met with responses from white men that they

shouldn't take studies too seriously; that they should write any dissertation about a topic they didn't care about, get their PhD, then go on to do 'real work'. Teresia lamented, 'How could these men tell us that we were taking the academy too seriously, when we knew that it was the academy that was not taking us seriously enough? When we organised parties we were accused of not being serious students, when we organised seminars we were accused of being too serious.'

Teresia wrote with honesty and vulnerability, constantly aware of her position as an academic studying, writing and teaching about the Pacific. She did not claim to take an objective view of any subject matter but acknowledged that as a person, she inevitably brought her subjectivity. She suggested that being honest about who we are and what we believe, and being willing to put that on the table to interrogate, makes our academic reflections more grounded and transparent.

Teresia's writings are a cornucopia of wisdom, anecdotes and reflections, with the occasional regret and a delicious sprinkle of humour. Each essay becomes fuller and deeper with every re-read. I find myself wishing I could interrogate her about the parts I revisit over and over again. The difficulty of writing this, apart from needing to blink through tears every now and then, is that I could spend hours and thousands of words on each essay in this collection. I have to live the rest of my life without any new words from her, and so I have the rest of my life to pour through the magnitude of literature she leaves behind.

As her students, Teresia encouraged and even pushed us to question her own judgements and statements. She didn't want us to accept everything she said as gospel—she wanted us to decide for ourselves what we believed in. She hated being put on a pedestal or for us to fangirl over her. But you're not here to stop me now, Teresia—this is my one act of defiance. I will continue to fangirl over you. I understand you were a complex human with flaws and insecurities and failings. But you were also the best teacher I've ever had. You impacted so many of us in deep and personal ways. You were one of the most popular academics in your field, yet you made each of us feel like we had a unique connection with you. You remembered all our names, and all of us, around the world, will never forget yours—this fine collection will make sure of it.

behind the scenes of a bookshop

# UNITY BOOKS

57 Willis Street, Wellington | 19 High Street, Auckland
unitybookswellington.co.nz | unitybooksauckland.co.nz

# Writers find their inspiration at...

# ScorpioBooks

Christchurch Central City

03 379 2882

scorpiobooks.co.nz

# NEW FROM OTAGO UNIVERSITY PRESS

**O me voy o te vas /
One of us must go**
Poetry by Rogelio Guedea
With translations by Roger Hickin
ISBN 9781990048425
Paperback, $25

**Naming the Beasts**
Poetry by Elizabeth Morton
ISBN 9781990048388
Paperback, $25

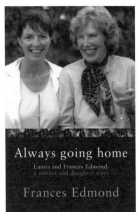

**Always Going Home**
*Lauris and Frances Edmond: A mother and daughter story*
by Frances Edmond
ISBN 9781990048432
Paperback, $40

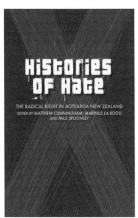

**Histories of Hate**
*The Radical Right in Aotearoa New Zealand*
Edited by Matthew Cunningham, Marinus La Rooij and Paul Spoonley
ISBN 9781990048401
Paperback, $50

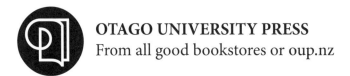

**OTAGO UNIVERSITY PRESS**
From all good bookstores or oup.nz

## TE HERENGA WAKA UNIVERSITY PRESS

'*The Axeman's Carnival*
is a compulsive read
and flat-out brilliant.'
—Elizabeth Knox
Nov, p/b, $35

'I had no idea Gaylene
was so hilarious …
Her book is irresistible.'
—Jane Campion
Nov, p/b, $40

'A work of great significance,
integrity, craft and poise.'
—Alison Whittaker
Nov, p/b, $30

---

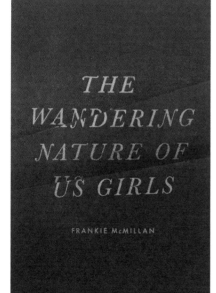

## The Wandering Nature of Us Girls
### *Frankie McMillan*

$29.99, PB, 128pp

In vivid, poetic writing, Frankie McMillan explores all kinds of wandering: children wander, adults drift into unexpected relationships and footholds can never be certain. Water, too, meanders like a river through these small stories, a powerful presence linking disparate lives in a collection that is poignant, revelatory and bitter sweet.

Available from all good bookshops

**UC CANTERBURY UNIVERSITY PRESS**
www.canterbury.ac.nz/engage/cup
Published with the support of Creative New Zealand

**READ YOUR WAY**

**VOLUME**
INDEPENDENT + ONLINE
www.volume.nz
books@volume.nz

UNIVERSITY
**BOOK SHOP**
For all booklovers, *everywhere.*

*Visit us soon in our newly refurbished store*

378 Great King Street, Dunedin | Open 7 Days
Ph 03 477 6976 | unibooks.co.nz

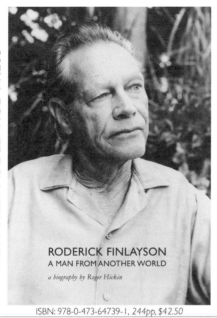

**RODERICK FINLAYSON**
A MAN FROM ANOTHER WORLD
*a biography by Roger Hickin*

ISBN: 978-0-473-64739-1, 244pp, $42.50

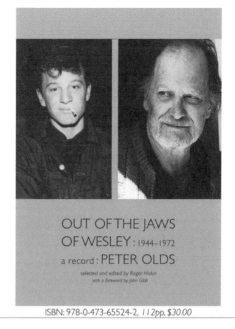

OUT OF THE JAWS
OF WESLEY : 1944–1972
a record : PETER OLDS
*selected and edited by Roger Hickin*
*with a foreword by John Gibb*

ISBN: 978-0-473-65524-2, 112pp, $30.00

## The **Kathleen Grattan Award for Poetry** 2023

PRIZE: $10,000 CASH AND A PUBLISHING CONTRACT

JUDGE: ANNE KENNEDY

ENTRIES CLOSE 31 JULY 2023

Entry details at
oup.nz/competitions

 OTAGO UNIVERSITY PRESS

## **Charles Brasch** Young Writers' Essay Competition **2023**

PRIZE: $500 + A YEAR'S SUBSCRIPTION TO LANDFALL

JUDGE: LYNLEY EDMEADES

ENTRIES CLOSE 31 MARCH 2023

Entry details at
oup.nz/competitions

 OTAGO UNIVERSITY PRESS

CONTRIBUTORS

**Rebecca Ball** is a teacher based near Ōtautahi Christchurch. She has had poems published in a range of places, including *Landfall*, *London Grip*, *Turbine|Kapohau* and *Poetry New Zealand Yearbook*.

**Airini Beautrais** lives in Whanganui. She is the author of four collections of poetry and a collection of short fiction. She also writes essays and reviews.

**Victor Billot** is a Dunedin writer. His poetry collection *The Sets* was published by Otago University Press in 2021. He writes satirical verse for the Newsroom website.

**Lucinda Birch** is a writer and artist. She has had short stories published in *takehē*, *JAMM* and *Sport*. In 2015 she won the Sunday Star Times Short Essay Competition. Her latest work is *Somewhere Else*—a book of drawings and descriptions of imaginary islands. She lives in rural Wairarapa.

**Peter Bland**'s collection of short fiction 'The Portable Pond' is due out from The Cuba Press early next year. Now in his 89th year, he is working on a new collection of poems entitled 'Today'. He lives in Auckland.

**Cindy Botha** began writing poetry at nearly 60. She is published in NZ, the UK and USA and was awarded first place in The Rialto Nature and Place Poetry Prize 2020.

**Liz Breslin** is the author of two poetry collections. *In Bed with the Feminists* (Dead Bird Books, 2021) won the 2020 Kathleen Grattan Prize for a Sequence of Poems.

**Diana Bridge**'s eighth collection of poems, 'Deep Colour', is forthcoming from Otago University Press. *Encountering China*, an anthology of personal experiences of China published to mark the 50th anniversary of diplomatic relations between China and New Zealand, includes a selection of her China-based poems.

**Joanna Cho**'s debut book *People Person* (Te Herenga Waka University Press, 2022) is out. Her hobbies include playing at the pools, practising bike riding, and talking on the phone with her BFF.

**Rachel Connor** is a medievalist. She is writing her doctoral thesis on Middle Scots poetry at the University of Otago.

**John Dennison** was born in Sydney in 1978. He is the author of *Otherwise* (Carcanet/Auckland University Press, 2015), *Birdman* (Fernbank Studio, 2022) and the critical work *Seamus Heaney and the Adequacy of Poetry* (Oxford University Press, 2015). He lives in Tawa, Wellington.

# CONTRIBUTORS

**Erin Donohue** is a Wellington-based writer and editor. Her first novel was published in 2017 and was a finalist in the NZCYA Book Awards. She is currently working on a collection of personal essays.

**Kate Duignan** convenes the fiction workshop of the MA in Creative Writing at the IIML, Te Herenga Waka. Her most recent novel is *The New Ships*.

**David Eggleton** is a poet and writer living in Ōtepoti Dunedin. A new collection of poems, 'Respirator', is forthcoming from Otago University Press.

**Emma Gattey** is a writer and critic from Ōtautahi. She is working on a PhD in New Zealand history at the University of Cambridge and is a Research Fellow for Te Takarangi at the University of Otago Faculty of Law.

**Jan FitzGerald** is an established NZ poet with publications in mainstream NZ and UK literary journals. Shortlisted twice in the Bridport Poetry Prize, she has four poetry books published.

**Miriama Gemmell** (Ngāti Pāhauwera, Ngāti Rakaipaaka, Ngāti Kahungunu) washes yoghurt pots and feels closer to her tīpuna. Her poetry has recently been published in *Atua Wāhine*, *Kapohau* and *Te Whē*.

**Jana Grohnert** is a PhD candidate in Literary Translation Studies at Te Herenga Waka.

**Kirsty Gunn** is co-editing, with Delia Da Sousa Correa, 'Selected Letters of Katherine Mansfield' for Oxford University Press and is Royal Literary Fellow at Brasenose College, Oxford.

**Isabel Haarhaus** is a writer and lives in Tāmaki Makaurau. She has published short stories, poems, essays and reviews and is working on a novella.

**Michael Hall** lives in Dunedin. Recent poems of his have appeared in the *New Zealand Listener*, *1964: Mountain Culture Aotearoa* and *Love in The Time of Covid: Chronicle of a pandemic*.

**Ruth Hanover**'s writing can be found in *Manifesto Aotearoa: 101 Political Poems* (Otago University Press), New Zealand Poetry Society anthologies, *London Grip*, *a fine line*, *Poetry New Zealand* and *takahē*. A chapbook of seventeen poems, OTHER, was published in 2019 by Cold Hub Press. A first novel was longlisted for the 2022 Michael Gifkins Prize for an Unpublished Novel.

**Claudia Jardine** is a Huntaway enthusiast. She juggles several arts-adjacent jobs in Ōtautahi and is working on her first full-length poetry manuscript. Her debut chapbook, 'The Temple of Your Girl', was published in *AUP New Poets 7* (2020).

**Tim Jones** has had four poetry collections, two short story collections, one novel and one novella published. His most recent poetry collection is *New Sea Land* (Mākaro Press, 2016).

**Madison Kelly** (Kāi Tahu, Kāti Mamoe) graduated from the Dunedin School of Art in 2017, with a BVA(Hons First Class) in drawing. Grounded in processes of observation and duration, their Ōtepoti-based practice works to explore multispecies histories and futures.

**Sam Kelly** is a jeweller-cum-sculptor known for her work with cow bone. Kelly's practice is driven by the material itself, plus the unexplored adaptability of the material into new forms.

**Erik Kennedy** is the author of *Another Beautiful Day Indoors* (2022) and *There's No Place Like the Internet in Springtime* (2018), both with Te Herenga Waka University Press.

**Lyndsey Knight** is an Aucklander with Christchurch roots. A sometime textile artist, Zen Buddhist and English teacher, her work has appeared in *Landfall*, *a fine line* and *The Kiwi Diary* among others.

**Claire Lacey** lives in Ōtepoti. They are the author of *Twin Tongues* and *Selkie*. Claire's most recent project was a creative/critical PhD about their lived experience with brain injury.

**Jessica Le Bas** has published two collections of poetry: *incognito* and *Walking to Africa* (Auckland University Press). In 2019 she won the Sarah Broom Prize for Poetry. Her prescient novel for children, *Staying Home* (2010), was rereleased by Penguin Random House as *Locked Down* in 2021. She lives in Nelson.

**Michele Leggott**'s *Mezzaluna: Selected poems* was co-published in 2020 by Wesleyan and Auckland University Presses. A new collection, 'Face to the Sky', is due from AUP early in 2023.

**Mary Macpherson** is a Pōneke poet, photographer and art writer. Her first poetry collection is *Social Media* (The Cuba Press) and her work appeared in *Best New Zealand Poems 2021*.

**Jonathan Mahon-Heap** is an Auckland-based writer whose work has appeared in *Metro*, *INDEX*, *AnOther Magazine*, and *Man About Town*.

**Tina Makereti** is author of *The Imaginary Lives of James Pōneke*, *Where the Rēkohu Bone Sings* and *Once Upon a Time in Aotearoa* and co-editor of *Black Marks on the White Page*. She teaches creative writing at the IIML, Te Herenga Waka.

## CONTRIBUTORS

**Frankie McMillan** is an award-winning poet and short story writer. Her latest book is The Wandering Nature of Us Girls (Canterbury University Press, 2022). Her work has been included in the Best Microfiction and Best Small Fiction anthologies.

**Cilla McQueen** has lived and worked in the southern port of Motupōhue, Bluff, since 1996. Her motive power is poetry, in all its manifestations.

**Zoë Meager** is from Ōtautahi. Her work has appeared abroad in publications including Granta, Lost Balloon and Overland, and locally in Hue and Cry, Landfall, Mayhem and Turbine|Kapohau.

**Anuja Mitra** lives in Auckland. Her poetry has appeared in places like Poetry New Zealand, takahē, Sweet Mammalian, Mayhem and Starling, with essays and fiction in Cordite and recent anthologies.

**Margaret Moores** lives in Tāmaki Makaurau Auckland where she and her husband own an Indie bookshop. Her poems and flash fiction have been published in journals and anthologies in New Zealand and Australia.

**S.A. Muse** lives in Tāmaki Makaurau.

**Janet Newman** has had poetry and short stories published in Headland, Landfall, Poetry New Zealand Yearbook and Sweet Mammalian, and won the 2017 Kathleen Grattan Prize for a Sequence of Poems and the 2015 NZ Poetry Society Competition. She was a runner-up in the 2020 Poetry NZ Prize and the 2019 Kathleen Grattan Award. Her first poetry collection, Unseasoned Campaigner, was published by Otago University Press in 2021.

**Mikaela Nyman** writes poetry, fiction and nonfiction in Swedish and English. Two collaborative poems with ni-Vanuatu writers appear in the climate change poetry anthology No Other Place to Stand (Auckland University Press, 2022).

**Gerard O'Brien** is a Wellington-based author who has worked as a professional DJ, IT consultant, photography assistant, business owner and personal trainer. He's now turned his enthusiasm to writing and brings his sense of humour and varied life experiences to his work. He holds a master's in creative writing from the IIML.

**Claire Orchard**'s work has appeared in various journals and anthologies. Her first poetry collection, Cold Water Cure, was published by Victoria University Press in 2016.

**Rebecca Reader** has an MA in creative writing and a PhD in medieval monastic

history. She has published poems in Landfall, Turbine|Kapohau and takahē, and in Mexican and Colombian anthologies. Her short stories have appeared in UK journals.

**Neil Pardington**'s practice has been described as 'straight photography with a twist'. He works in the space between documentary photography – where the defining principle is to capture the truth about the world – and conceptual photography, which contends that such a truth can never really be depicted.

**Lawrence Patchett** is a writer and editor living in Christchurch. His books include the short-story collection I Got His Blood On Me (Te Herenga Waka University Press), which won the NZSA Hubert Church Award for Best First Book of Fiction.

**Richard Reeve** is an Otago poet based in Warrington. Since 2001 he has published six collections with various presses. His seventh collection, 'About Now', has recently been submitted for publication.

**Madeline Reid** (she/they) is a queer disabled writer. She has an MA in Creative Writing with Distinction. Her short film about her experiences with psychosis, 'Worry People', is in advanced development.

**Jess Richards**'s novels are: Snake Ropes, Cooking with Bones and City of Circles (Sceptre). Her new writing is from her creative nonfiction manuscript on the theme of birds and ghosts.

**Harry Ricketts** is a poet, literary biographer and essayist. His Selected Poems was published last year by Te Herenga Waka Press. Stella in these poems is imaginary but feels real to him.

**Ruth Russ** lives in Nelson and writes around four sons and a husband. Her work has appeared in various literary magazines.

**Harriet Salmon** is a full-time English literature student at Te Herenga Waka and part-time elderly care worker, but a writer and poet whenever she gets the chance.

**Elizabeth Smither**'s new collection, 'My American Chair', will be published by Auckland University Press and MadHat Press (USA) later this year.

**Maggie Sturgess** resides in Pōneke where she works as a clinical psychologist and writer.

**Yvette Thomas** is currently a student in the Masters of Creative Writing course at Auckland University. She has also written a short story The Lost One which was published in takahē and Pendulum

(Australia). *The Lost One* was subsequently adapted into a short film which was shown at the New Zealand International Film Festival (2007) and in a number of other international film festivals.

**Laura Toailoa** is a high school teacher and writer with work published on *Pantograph Punch* and *e-Tangata*. They also have a short story published in the anthology *Vā: Stories by Women of the Moana*.

**Angela Trolove** loves writing about the seasons. Living in Dunedin with her Italian-Kiwi family, she reviews the arts and tutors both creative and academic writing.

**Tim Upperton**'s *The Night We Ate The Baby* was an Ockham NZ Book Awards poetry finalist in 2016. He won the Caselberg International Poetry Competition in 2012, 2013 and 2020. Tim's third collection is *A Riderless Horse* (Auckland University Press, 2022).

**Anne Weber** is an award-winning self-translating writer and translator living in Paris.

**Sophia Wilson** is based on Maungatua. Her poetry and flash fiction have appeared in journals and anthologies in Aotearoa and internationally.

### CONTRIBUTIONS

*Landfall* publishes original poems, essays, short stories, excerpts from works of fiction and non-fiction in progress, reviews, articles on the arts, and portfolios by artists. Submissions must be emailed to landfall@otago.ac.nz with 'Landfall submission' in the subject line.

For further information visit our website oup.nz/landfall

### SUBSCRIPTIONS

*Landfall* is published in May and November. The subscription rates for 2023 (two issues) are: New Zealand $55 (including GST); Australia $NZ65; rest of the world $NZ70. Sustaining subscriptions help to support New Zealand's longest running journal of arts and letters, and the writers and artists it showcases. These are in two categories: Friend: between $NZ75 and $NZ125 per year. Patron: $NZ250 and above.

Send subscriptions to Otago University Press, PO Box 56, Dunedin, New Zealand. For enquiries, email landfall@otago.ac.nz or call 64 3 479 8807.

Print ISBN: 978-1-99-004848-7
ePDF ISBN: 978-1-99-004849-4
ISSN 00–23–7930

Copyright © Otago University Press 2022

Published by Otago University Press
533 Castle Street, Dunedin
New Zealand

Typeset by Otago University Press.
Printed in New Zealand by Caxton.

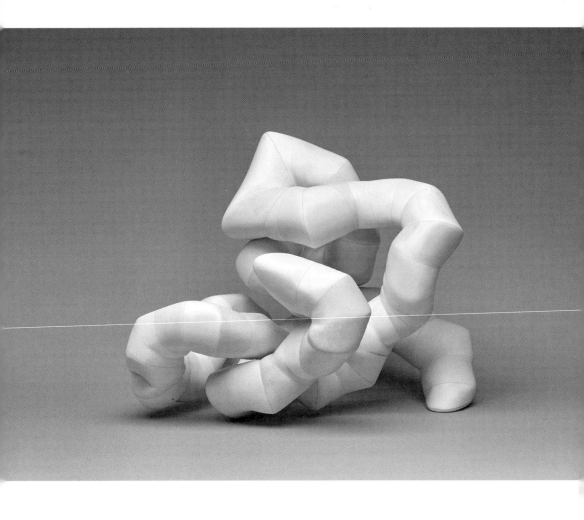

Sam Kelly, *Standing Sculpture #2*, 2021, Cow bone, 23 x 33 x 24cm (approximate). Image courtesy of the artist and Laree Payne Gallery.